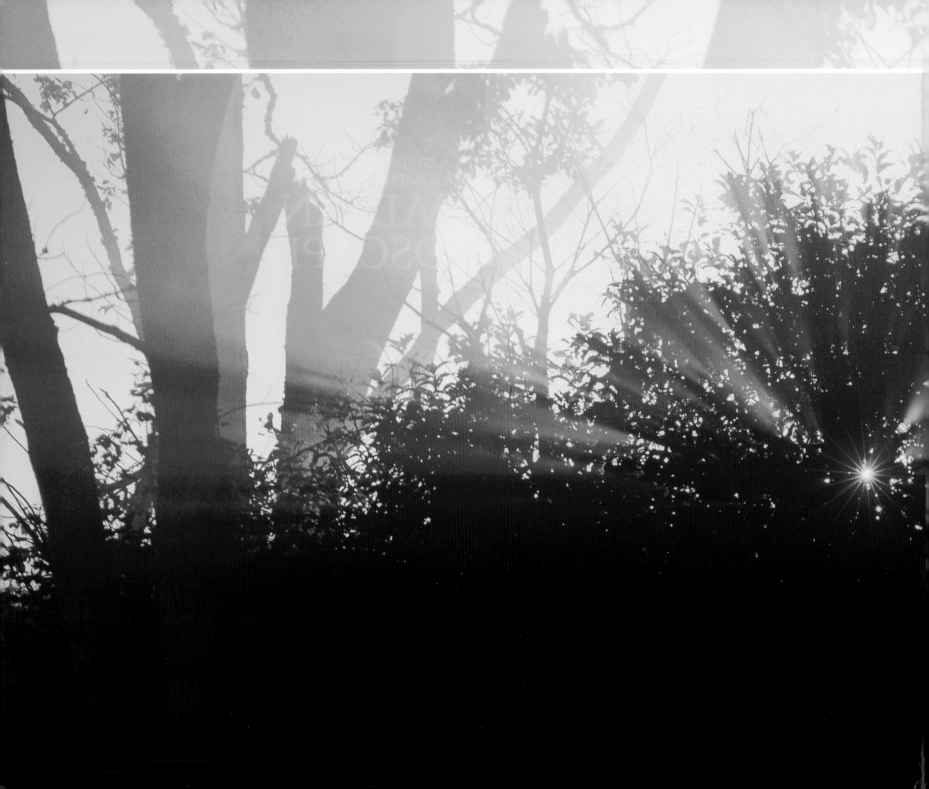

A GUIDE TO PHOTOGRAPHING THE
CANADIAN LANDSCAPE

text and photography by
Daryl Benson
and
Dale Wilson

©Dale Wilson

Cullor
Books

Cullor Books
1011-55 Street
Edmonton, Alberta
T6L 1Y8

Design by: Nova Graphics, Dartmouth, Nova Scotia
Edited by: Don Galbraith, Sainte-Foy, Quebec
Printed and bound by: Friesens, Altona, Manitoba

Canadian Cataloguing in Publication Data
Benson, Daryl.
 A guide to photographing the Canadian landscape
 ISBN 0-9684576-0-6
1. Canada- Pictorial works. 2. Canada- Guidebooks. 3. Landscape photography- Canada. I. Wilson, Dale. II. Title.

FC59.B46 1999 917.1 C98-950254-6
F1017.B46 1999

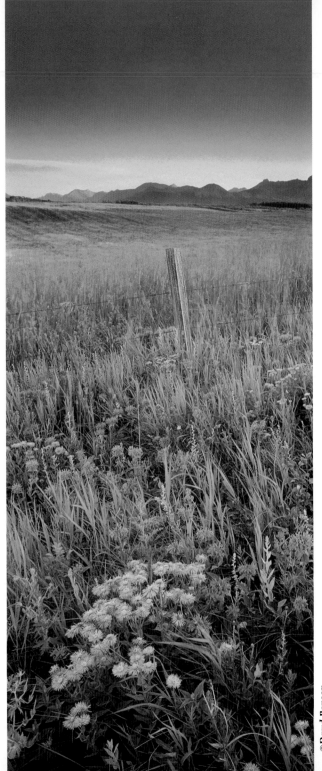

COVER PHOTO: *Highway 11, near Kootenay Plains, Alberta.*
 ©Daryl Benson

PREVIOUS PAGE: *Belmont, Nova Scotia.*
 ©Dale Wilson

THIS PAGE: *Near Waterton Lakes National Park, Alberta.*

OPPOSITE: *Cape Breton Highlands National Park, Nova Scotia.*

©Daryl Benson

Printed in Canada.

©Dale Wilson

CONTENTS

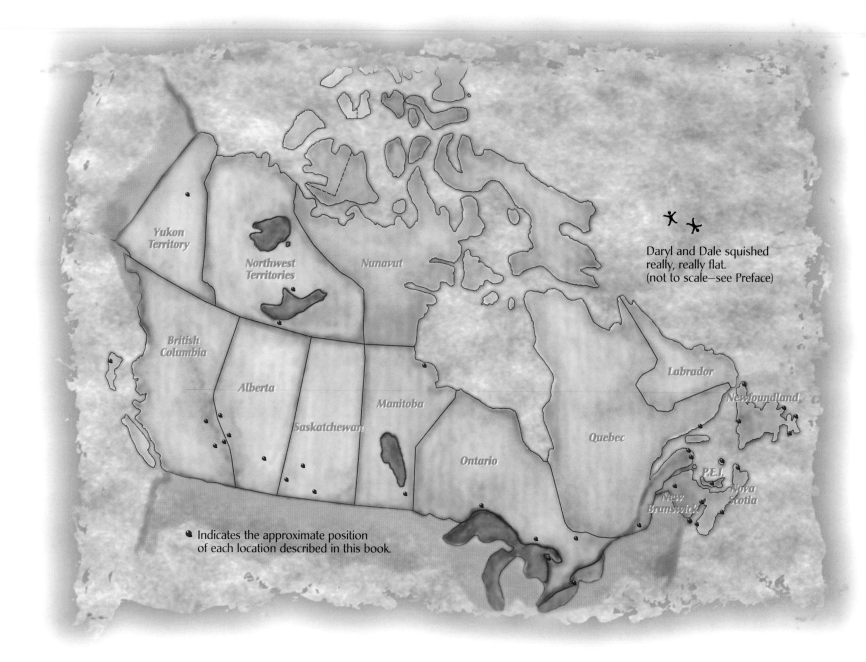

Daryl and Dale squished
really, really flat.
(not to scale–see Preface)

Yukon
Territory

Northwest
Territories

Nunavut

British
Columbia

Alberta

Saskatchewan

Manitoba

Ontario

Quebec

Labrador

Newfoundland

P.E.I.

New
Brunswick

Nova
Scotia

● Indicates the approximate position
 of each location described in this book.

PREFACE

"An Incomplete Guide to Photographing the Canadian Landscape" was the original title of this book, but very early in the project our ace marketing, research and development team told us that no one would buy a guide book that admitted to being anything less than comprehensive. Bowing to this wisdom, we renamed our book, but deep down we know that really it is incomplete.

Why so? Well, Canada covers 9,970,610 square kilometres and if you squished the two of us really really flat we would cover about eight square metres (see map opposite). It's simply impossible to cover the vastness, the diversity and the natural beauty of Canada in any finite work, so even an ambitious guide book like this one will forever be incomplete. Having said that, know that we've done our very best to describe and share with you some of our favourite locations distilled from years of travel, discovery, exploration and photography across Canada.

Due to the immensity of this project we combined our forces (and our egos) to put this book together. Each section and photo has been credited appropriately so you will know who is responsible for what (actually we just like to see our names in print a lot). If credits are lacking anywhere it may mean that neither of us wants to lay claim or, more likely, that we worked on that section jointly.

A Guide to Photographing the Canadian Landscape has been created to make it easier for you to "hit the ice with sharp skates," so to speak; this is a Canadian metaphor that means, roughly, to arrive prepared. Interestingly enough, in the Russian language the same metaphor appears as "punch some vodka with a shaving device," which could be a good suggestion if your vodka is old and growing fur.

This guaranteed hair-free and clean-shaven book is not intended to be a definitive photographic guide to the areas listed—each one of them is worth a book itself—but merely a starting point at the head of the trail.

We both strongly encourage you to hike and explore further on your own, using this book and its information as a key to open the front door; what lies beyond is infinite!

Daryl Benson
Edmonton, Alberta
January 1999

Dale Wilson
Eastern Passage, Nova Scotia
January 1999

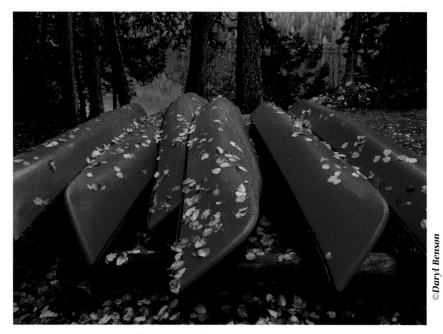

Overturned Canoes, Autumn, Wells Gray Provincial Park.

OPPOSITE: *Rogers Pass,*
Glacier National Park.

BRITISH COLUMBIA

Haida Gwaii
(Queen Charlotte Islands)

Haida Gwaii ("Islands of the People") is one of the more remote locations visited in this book. The remoteness and distinctiveness of the species that evolved here have given these islands yet another name: "Canada's Galapagos." Regardless of what you call the islands, they are well worth the effort to visit.

The usual way to reach this archipelago is via a 6-hour ferry trip from Prince Rupert, B.C., which lands you just outside Queen Charlotte City on Graham Island (the largest in the archipelago). If you're anxious to start shooting as soon as you land, take Highway 16 (it's the continuation of the Yellowhead Highway on the mainland) east toward the town of Skidegate. Just a kilometre outside of town you'll see a sign announcing Balance Rock. A very short walk from the side of the road is a large, glacially deposited boulder precariously perched on the rocky shoreline. It's best shot at low tide, silhouetted against an early morning sky (try including yourself or some object of recognizable size in the composition to show scale).

As you continue along the highway following the shoreline, you'll find Misty Meadows Campground. It's at the southern entrance to Naikoon Provincial Park and it offers easy access to a nice mosaic of gravel beaches, sand beaches and partially vegetated sand dunes. This spot is primarily a sunrise location, but if you're fortunate enough to have a low tide at sunset the long, gradually sloping beach will be transformed into a huge tidal flat with beautiful wide-open views in all directions.

Something else to keep in mind while travelling in these islands: if you have a high tide at sunrise or sunset, try shooting just inside the forest, facing the low sun and near the water's edge. The warm light cast by the setting or rising sun reflecting off the high water will throw beautiful fill light up under the cedar trunks and boughs, creating a unique and gorgeous lighting effect.

Farther along Highway 16, at the north end of Graham Island, is Masset, the largest village on the Charlottes. Take the 26-kilometre drive east of Masset into the northern part of Naikoon Provincial Park and to Tow Hill. This drive carries you through tall stands of primeval-looking Sitka spruce bearded with lichens and weighed down by heavy mats of moss. Tow Hill itself is a 120-metre-tall basalt landmark that can be seen for kilometres. There are two short trails from the parking lot at its base. The steeper Tow Hill Trail provides nice views over both the South and North Beaches that flank its sides, but there's a more interesting location at the end of the easier Blow Hole Trail, which takes you out to the north face of Tow Hill with its exposed basalt columns positioned well to catch late afternoon and evening light. Both the South and North Beaches are photogenic, especially at low tide. South Beach is mostly

Skung Gwaii (Anthony Island), Gwaii Haanas National Park – Haida mortuary poles in morning light.

Pentax 645, 200mm lens at f/32 for maximum depth of field, 81B warming filter, Fuji Velvia film.

©Daryl Benson

sand and beach gravel (smooth, elliptical, fist-sized rocks, polished by continual tumbling in the tidal flow). North Beach (my favourite) is sand (of course) skirted by huge piles of bleached white driftwood. North Beach is a good sunset location, especially using Tow Hill as a background (see image on page 12).

The road from Masset ends at Tow Hill, but you can continue to drive along North Beach all the way to the Rose Spit Ecological Reserve. If you want to do this, take a four-wheel-drive vehicle with a winch and make sure you have a clear understanding of the tides. It would be sad to watch the incoming tide slowly claim your vehicle, hopelessly stuck in the sand.

Moresby Island is also well-endowed with photographic opportunities. You can get there directly from Vancouver (there are daily flights to the airport at Sandspit) or, if you're already on Graham Island, via the 20-minute ferry from Skidegate to Alliford Bay. There are hundreds of kilometres of roads on the island, but most are narrow, winding, private logging roads, and the monster-sized logging trucks that come barrel-assing down them are bigger, faster and meaner than whatever it is you may be driving. The best public roads make up the approximately 50 kilometre "Loop Drive" from Alliford Bay to Sandspit, Copper Bay, Skidegate Lake, South Bay and back to Alliford Bay. This mostly gravel road takes you dramatically past lush, scenic second-growth forests with views along the beautiful Copper River flowing through the dense coastal rain forest. There's a great sunrise location in Copper Bay, near the roadside cabins and the boat launch. A 20-kilometre side road goes east of the Loop Drive to a crescent-shaped, sloping sand beach at Gray Bay, where there are several pleasant secluded campsites. Before taking the Loop Drive, stop by the Visitor Information Centre at the airport in Sandspit to get current travelling information and a free map detailing the Drive.

Gwaii Haanas National Park Reserve and Haida Heritage Site in the southern Charlottes was set aside as a protected area in 1988.

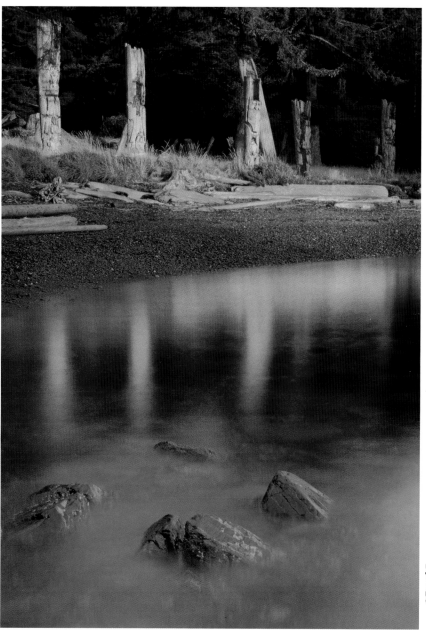

Skung Gwaii (Anthony Island), Gwaii Haanas National Park – The first warm rays of dawn illuminate these mortuary poles. A five-stop neutral-density filter (see "Filters" on page 136) dramatically increased the exposure time to allow the incoming tide to create a wash of soft colours over the foreground boulders and to blur reflections.

Pentax 645, 45mm lens at f/22, five-stop neutral-density filter, Howard Ross Colour Enhancing filter, exposure time two minutes, Fuji Velvia film.

There are no roads into this wild and remote park: the only access is by boat, kayak, float-plane or helicopter. Before visiting Gwaii Haanas ("Place of Wonder"), travellers are required to take a 1-1/2 hour orientation session administered by park staff at the Visitor Centre in Sandspit or in Queen Charlotte City. There are several licensed commercial tour operators who offer a variety of guide and transportation services into the park, ranging from half-day power-boat or helicopter tours to 14-day sailing or kayaking expeditions (see the B.C. Tourism listing in "Resources and References" on page 150).

For me, the highlight of Gwaii Haanas National Park was a location I had wanted to visit for many years, the Haida totem poles at Skung Gwaii (Anthony Island). This spot is said to have the world's finest remaining display of Haida mortuary poles, all of which are more than 100 years old. UNESCO declared this spot a World Heritage Site in 1981.

Burnaby Narrows (also known as Dolomite Narrows) in Gwaii Haanas National Park has one of the highest concentrations of marine life anywhere on the planet. For example, Bat Stars (a type of Sea Star) can be found here at densities of 74 per square metre (a typical figure elsewhere is 7). The marine life is so rich and concentrated here that it is strongly recommended (read "mandatory") that you view this unique area only from a boat or a kayak. At low tide it is impossible to put a foot down anywhere without squishing

something. The views here are even more to be appreciated in light of the fact that before the area became a National Park it was slated to become a log dump.

Another area rich in marine life is Rose Inlet, a 10-minute Zodiac ride from Rose Harbour on Kunghit Island in southern Gwaii Haanas Park. The entire inlet is a beautiful place to photograph coastal rain forest, inter-tidal zones and—at the far end of the inlet—a rare open, grass-filled flatland. Rose Harbour itself is an abandoned whaling station that has been rustically converted to a guest house (the food here is great—I'm not a vegetarian but I highly recommend Susan's Vegetarian Pizza).

Another highlight in Gwaii Haanas is Gandla K'in (Hotspring Island), more for the indulgence of relaxing in the outdoor natural hot springs than for photographic reasons.

—DB

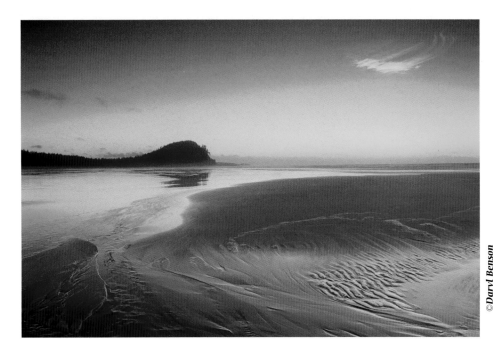

©Daryl Benson

Sunset, North Beach, Tow Hill in the background, Naikoon Provincial Park, Graham Island.

Pentax 645, 45mm lens, Cokin blue/yellow colour polarizer, Tiffen two-stop soft-edge graduated filter, Fuji Velvia film.

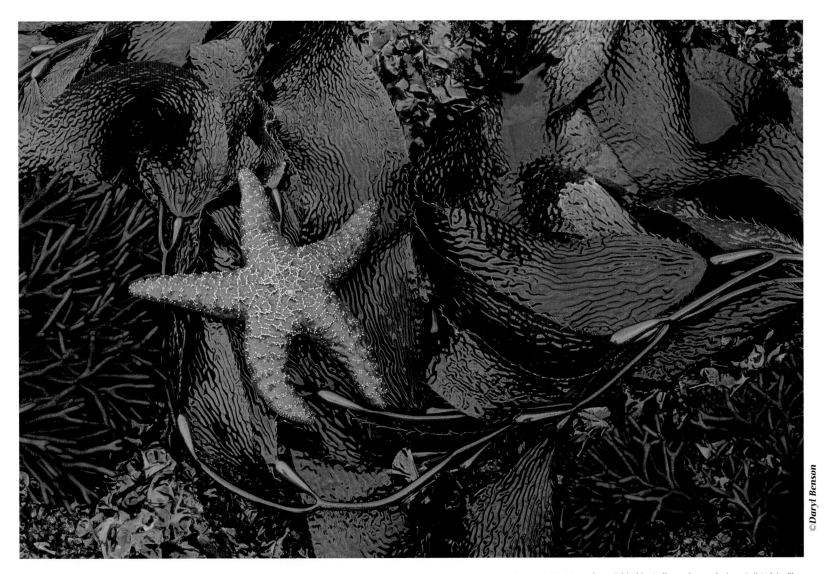

©*Daryl Benson*

Sea Star and Kelp, Low Tide, Rose Inlet, Southern Gwaii Haanas National Park –
The concentration of marine life in Gwaii Haanas is among the richest in the world.

Pentax 645, 120mm lens, Cokin blue/yellow colour polarizer, Fuji Velvia film.

Wells Gray Provincial Park

British Columbia

Wells Gray Provincial Park

There are five roads into Wells Gray Park, but by far the most scenic is the Clearwater Valley Road, which heads north off Highway 5 (the Yellowhead Highway) at the Visitor Information Centre. The actual park entrance is 40 kilometres up this road, but before you get there stop at Spahats Creek Provincial Park, a small area on your left with a dramatic 75-metre-high waterfall. Check out both viewpoints: one for the creek and waterfall and the other providing a great outlook over the Spahats Canyon and its tall, five-sided basalt columns.

Just north of Spahats park is the turnoff for the Trophy Mountain Meadows, one of the most dramatic spots in Canada to see and photograph mountain wildflowers. The road is fairly well marked (keep your eyes open for the posted signs), but it's rough and can be very wet. At the top there are excellent long-distance views in almost every direction. From the parking lot it's a relatively easy 45-minute hike to the wildflower meadows. The best times to photograph here are late June (there could easily still be snow) for the carpets of bright yellow Glacier Lilies, and mid-July to early August for the big multi-coloured wildflower displays.

Back on the Clearwater Valley Road just inside the Wells Gray Park entrance is a turnoff to Green Mountain Lookout. You can drive right to the summit where there's a sturdy

10-metre viewing tower with an excellent view of the surrounding topography—a good spot to shoot at either sunrise or sunset.

Wells Gray Park is full of waterfalls, and Dawson Falls, just a few kilometres north of the Green Mountain turnoff, is the most accessible of them all. It's a beautiful, wide cascading torrent tumbling over ledges of exposed lava.

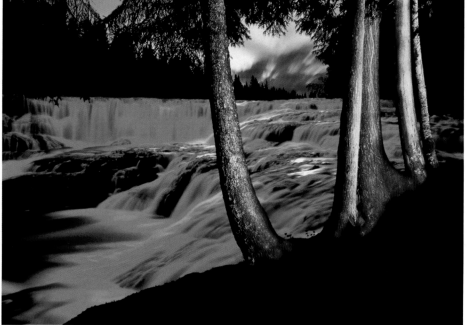

©Daryl Benson

Dawson Falls – An exposure of about 15 minutes at dusk gave me enough time to illuminate the foreground trees using a flashlight (see "Light Painting" on page 131 for an explanation of this technique).

Pentax 645, 45mm lens at f/22, exposure time approximately 15 minutes, Fuji Velvia film.

Explore the shore for good compositions along its entire length.

The "Big Kahoona" at Wells Gray is definitely Helmcken Falls, whose 141-metre drop (the fourth highest in Canada) is a few kilometres up the road from Dawson Falls. There is a large parking lot here and some good views of the falls. Don't shoot just from the platform, though; there are good compositions of the falls and the canyon to be found downstream.

The Clearwater Valley Road to Helmcken Falls is open all year, and in the winter the huge ice cone formed from freezing mist can be very dramatic (it's biggest in February).

The road is gravel after Helmcken Falls and continues another 26 kilometres into Wells Gray Park, with many photographic points of interest along the way: an abandoned homestead at Ray Farm, a great view right from the road looking down Shadow Lake toward Garnet Peak (2,860 metres) and Zellers Lake (more a pond than a lake), beautifully tucked away in a tiny forest setting.

At the very end of the road is the Clearwater Lake Campground and boat launch, where a canoe can be rented or water-taxi service obtained. Using either you can spend a day or two camping and photographing in the more mountainous northern regions of Wells Gray at any of the eleven campsites on Clearwater and Azure lakes. There are not a lot of established trails—and most of them follow the shorelines—but the scenery is great.

—DB

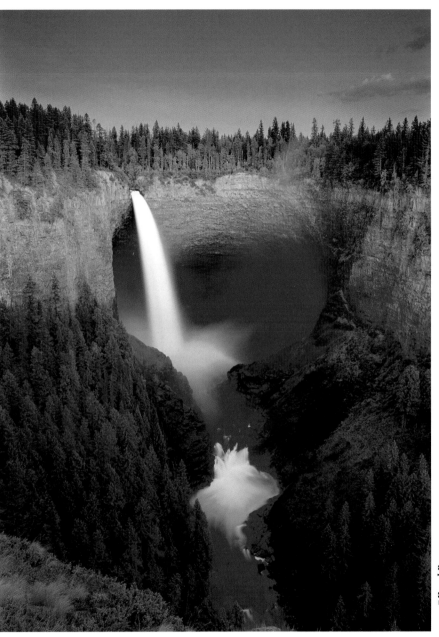

©*Daryl Benson*

Helmcken Falls – This view of the falls is from the platform near the parking lot.

Pentax 645, 45mm lens, Cokin two-stop mauve graduated filter, Fuji Velvia film.

Mount Revelstoke and Glacier National Parks

British Columbia

Mount Revelstoke and Glacier National Parks

Mount Revelstoke is an easily accessible site whose summit meadows are renowned for their summer wildflower displays. The "Meadows In The Sky" Parkway is a paved road that takes you 26 kilometres from the Trans-Canada Highway just outside the town of Revelstoke to the 1,938 metre summit of the mountain. From the summit parking lot it's a 1-kilometre hike to the wildflower meadows. Should you need it, there's even a shuttle bus from the lot to the meadows that runs from 10:00 a.m. to 4:30 p.m., seven days a week, in season. In season? The prime time for good wildflowers is late July to early August, but like all shows in nature, the displays vary in timing and intensity from year to year: lots of moisture and warm weather are needed for a good display. The tiny Balsam Lakes near the summit parking lot provide excellent reflection ponds at sunset.

Glacier National Park lies a few kilometres east of Mount Revelstoke along the Trans-Canada Highway. The park receives heavy, deep snowfall each winter, especially in the Rogers Pass area. There are many great views, right from the road, of pine forests so heavily laden with snow that the individual trees appear as thin white Styrofoam cones poking through a white cotton blanket.

One of my favourite spots in Glacier Park is briefly visible from the highway. As you head west on the Trans-Canada, just before you get to the first

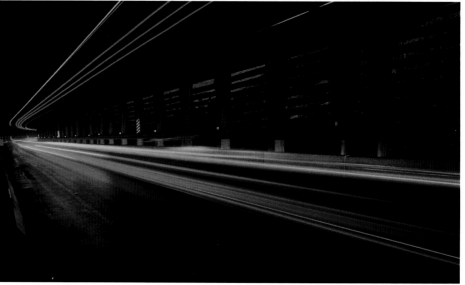

©Daryl Benson

Vehicle taillights through Tupper 2 Tunnel, Rogers Pass, Glacier National Park – A long exposure at dusk was used to capture these streaking vehicle lights near the entrance to the Tupper 2 snow shed. It had been raining for a few hours, so the wet pavement reflects the passing vehicle lights (see the "Artificial Light" section for an explanation of this technique).

Nikon FE, 28mm lens, f/8 at approximately one minute, Fujichrome 100 slide film.

set of tunnels (snow sheds), if you're observant you'll notice a beautiful old stone bridge spanning a waterfall (Cascade Creek) halfway up the hillside on your right. To get there stop at the last little pull-off before you enter the first tunnel. Hike up the old rutted road for a kilometre. The trail opens onto the old stone bridge with an excellent perspective on a beautiful waterfall and a nice view of the surrounding landscape—a great spot for lunch. Be careful while on the bridge: there's nothing to keep you from falling, and there are plenty of twigs and stumps to trip over.

–DB

Travel Tip

The Maple Leaf is the national icon of Canada. Scattered throughout this book are 34 tiny Maple Leaf images similar to the one shown here. If you're driving across this huge country and your travelling companions (kids) are getting restless, hand them this book and challenge them to find all 34 Maple Leaves. If you would like to keep them occupied even longer tell them there are 35!

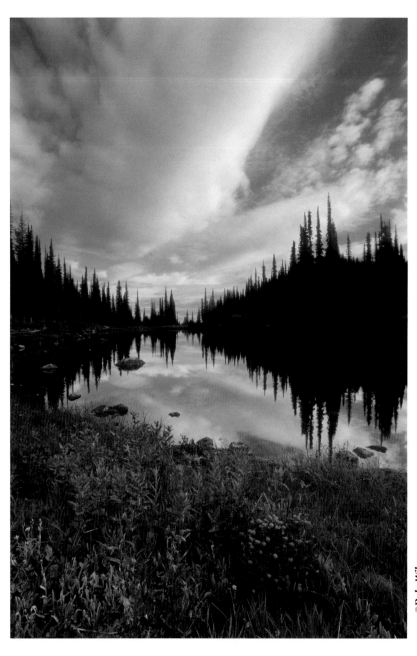

©*Dale Wilson*

Balsam Lakes, Mount Revelstoke – The major attraction of Mount Revelstoke is the prolific colour to be found in the numerous species of prevalent flora. Although the sky is certainly the dominant force in this photo, the red hue from the Indian Paintbrush provides balance. This is a classic situation that calls for graduated filters; please refer to page 136 for a discussion of their use.

Nikon F90, 28mm lens, f/22 at approximately one minute, Cokin blue/yellow colour polarizer and two-stop mauve graduated filter, Fuji Velvia film.

Yoho National Park

My favourite spot by far in Yoho National Park is Lake O'Hara. The turnoff for the lake is 15 kilometres east of Field, on Highway 1, but visits to this area are controlled in order to reduce the impact on the fragile alpine environment, so the 13-kilometre access road is closed to public vehicles. A bus leaves the parking lot near the highway three times a day, and I strongly recommend you phone ahead to book a seat; it's quite a hike up to the lake and lodge if you can't get on the bus (bus and campground information: phone 250-343-6433).

There are over two dozen emerald-coloured lakes in the region, bracketed by dramatic mountain peaks and glaciers. The Lake O'Hara Circuit (an easy 2.9 kilometres) and the Lake Oesa Trail (a moderate 3.6 kilometres) are popular hikes. My favourite area is the Opabin Plateau, dominated by tiny emerald pools and huge larch trees (check out the Opabin Prospect overlook for a dramatic aerial view of Mary Lake and Odaray Mountain). When the larch are in full golden autumn colour (mid to late September), this whole area is absolutely gorgeous.

Another photographic highlight in Yoho is Takakkaw Falls (TAH-kuh-kah, Cree for "it is wonderful"). Access is via the narrow, winding 14-kilometre Yoho Valley Road, located 22.3 kilometres west of Lake Louise or 3.7 kilometres east of Field.

At 380 metres, Takakkaw Falls is the second highest waterfall in Canada, behind Della Falls on Vancouver Island. In summer Takakkaw is sunlit from late morning to early evening, and rainbows can be seen and photographed in the mist at its base (rainbows are always centered 180° from the sun).

Another easily accessible photographic location in Yoho is Emerald Lake, at the end of the 8-kilometre Emerald Lake Road, just west of Field. Take the 5.2-kilometre Emerald Lake Loop Trail, a beautiful scenic stroll along this the largest lake in

British Columbia

Yoho National Park

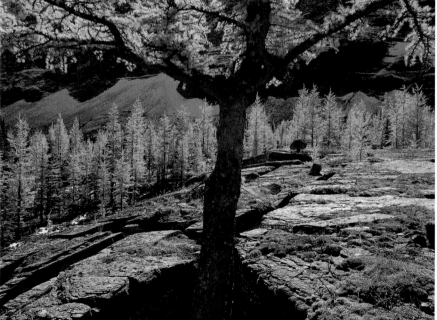

©Daryl Benson

Backlit Autumn Larch, Opabin Plateau.

Pentax 645, 45mm lens, circular polarizer, 81B warming filter, Fuji Velvia film.

Yoho National Park. The view from the small wooden bridge near the parking lot is beautiful in all directions and frequent fog adds to the J.R.R. Tolkien–*Hobbit* look this area often has. Canoes can be rented near the parking lot. And check out the small walkway that crosses Emerald Creek: the forest and creek provide a nice foreground and framing for Mt. Burgess, rising in the background.

Emerald Lake Lodge affords nice views in winter with icicles and Christmas lights on the cabins and with the snow-covered Rocky Mountains in the background.

–DB

Autumn larch reflected in one of the many emerald pools on the Opabin Plateau – When composing a big landscape image it's often helpful to get in low and close on a strong foreground subject with a wide-angle lens. This technique will help exaggerate scale and convey a greater sense of depth in a two-dimensional medium like photography.

Pentax 645, 45mm lens, circular polarizer, Fuji Velvia film.

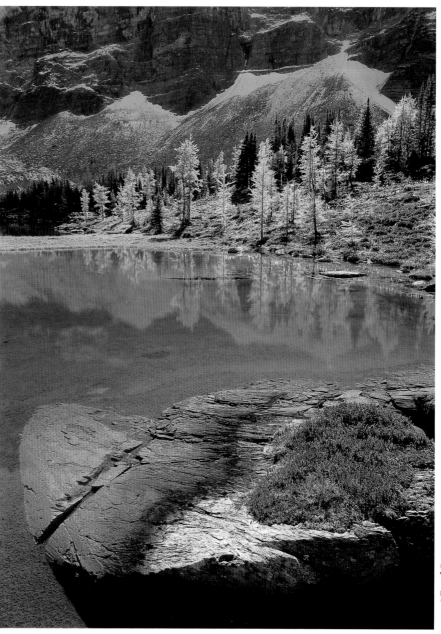

©*Daryl Benson*

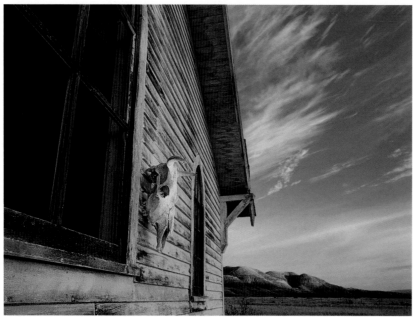

Abandoned Church, Dorothy.

OPPOSITE: *Drumheller Badlands.*

ALBERTA

Banff National Park

Mountain peaks reflected in lakes and rivers await you around almost every bend of the road in this the oldest and most visited of all Canada's parks. In fact, you may find that even the first couple of frames you shoot accidentally while loading a roll of film here will turn out. There are so many dramatic locations to see and photograph that several books and several lifetimes could be exhausted describing them all, so I'll try to mention just a few favourite spots to get you started.

To get yourself oriented first stop at the Banff townsite. But beware: Banff is not a quaint, sleepy little mountain village; it's a large, bustling tourist town with every amenity at your disposal—and the crowds that go with them. Visit the Banff Information Centre at 224 Banff Avenue. You can get maps, permits, brochures, weather and trail information and back-country reservations here, and your questions about bear sightings—or any subject related to the park or the town—can be answered.

The 14-kilometre Minnewanka Loop Road lies just to the northeast of the Banff townsite. Lake Minnewanka (the largest lake in the park) provides a pleasing foreground for the mountain peaks of the Fairholme and Palliser Ranges. My favourite spots along this loop road are the roadside viewpoint above Two Jack Lake and the entire 3-kilometre shoreline around Johnson Lake. Both of these sunrise spots provide very scenic—and less-often photographed—views of Mt. Rundle.

Another scenic drive right outside Banff is the short, switchbacking Mt. Norquay Road. There's a pullout near a large open grass meadow just 4.7 kilometres up the road with a great aerial view of the Banff townsite, Vermilion Lakes and the Bow Valley. This is a popular sunset spot (especially with newlyweds).

Definitely the most popular drive near Banff—and easily my favourite—is the 4.5-kilometre Vermilion Lakes Road. Stop exactly 2.2 kilometres down this road, get out and walk down to the water's edge. You'll notice numerous little dimple marks in the moist soil at your feet: the result of many years' worth of tripods being set up here. This is the icon spot! If you have spent any time at all visiting the gift shops in Banff you'll recognize this view of Mt. Rundle reflected in Vermilion Lakes. There are good sunrise and sunset views all along this road. The ponds at the road's end are more sheltered from the wind and often provide nice reflections. The third Vermilion Lake is fed by a warm underground spring, allowing for some sparkling open-water, winter reflection shots of Mt. Rundle.

As you leave the Banff area and head west on the Trans-Canada Highway (Highway 1) the first decision you'll have to make is whether to continue on it (scenic, but congested with commercial truck and tourist traffic) or take the slower, more leisurely route: Highway 1A.

Some of the photographic highlights along the 1A include a beautiful drive through tall aspen stands between Fireside and Hillside Meadows (gorgeous in autumn, from the end of September to the beginning of October). Another is the polished limestone and dolomite Johnston Canyon, which is a moderate 2.7-kilometre hike. The gorge is best photographed in overcast, flat light, but if you hike along it on a sunny day look for subjects that are lit by sunlight reflecting off the warm-coloured canyon walls. Make sure to go all the way to the Upper Falls. A very short side trail just before them takes you to a multi-hued (browns and greens) travertine-covered canyon wall (travertine is an organic combination of algae and calcium carbonate). Use a polarizing filter here to eliminate the wet reflections and to intensify the streaking colours. In winter there are guided tours up the canyon bottom where the creek and its numerous waterfalls freeze, creating impressive daggers of hanging blue ice (check for times at the Visitor Information Centre in Banff).

The best viewpoint along Highway 1A is Morant's Curve (made famous by the Canadian Pacific Railway photographer Nicholas Morant, who first popularized this view). Use the Outlet Creek parking lot (4 kilometres south of the junction of Highways 1 and 1A, by Lake Louise). The overlook here provides clear views of Mt. Temple, the Bow Range and the Bow River, with good light from sunrise to mid-afternoon.

If you choose to stay on Highway 1 as you leave the Banff townsite, watch for good views of Castle Mountain with the winding Bow River in the foreground. There are numerous vantage

Alberta

Banff National Park

points all along the road, especially in the area of Castle Junction (where Highways 1 and 93—westbound—meet). My favourite is 4 kilometres north of Castle Junction where the Bow River flows right beside the highway. Best shot at sunrise in summer; it is good at both sunrise and sunset in winter.

Copper Lake offers a less common view of Castle Mountain. At Castle Junction turn onto Highway 93 and take an immediate left to Smith and Twin Lakes Trailheads. From there hike the 0.7-kilometre trail to tiny Copper Lake and walk around to its south side for views back to Castle Mountain (Smith Lake also provides a fair foreground for Castle Mountain).

One of the more accessible alpine meadow hikes in Banff National Park is Sunshine Meadows. Turn off Highway 1 at the Sunshine Ski Village interchange (9 kilometres west of Banff) and drive to the parking lot at the end of the road. There is a shuttle service (White Mountain Adventures) that can take you the rest of the way up this private road to Sunshine Village (make arrangements in Banff before you drive out). Sculpted snowbanks can linger in this alpine meadow into late July, wildflowers are usually at their best in mid-July and the larch turn golden yellow in mid-September.

Lake Louise is the highest community in Canada (I mean in terms of elevation), so it's not surprising that it receives piles of snow every winter (that's why there's a world-class ski-hill here). The road from the village up to Chateau Lake Louise is open all winter, and because it's usually calm in this area it's idyllic winter-wonderland stuff to shoot in. Trees are heavily laden with snow and the many buildings in and around the Chateau are always generously trimmed with Christmas lights. In summer, the views from the Chateau's walkways out over Lake Louise, Mt. Victoria and its glacier are world-famous and grace hundreds of post-cards.

If your time in this area is limited, however, I'd recommend you take the 12-kilometre side road up to Moraine Lake instead. Moraine Lake and the Wenkchemna Peaks (Stony for "ten") or

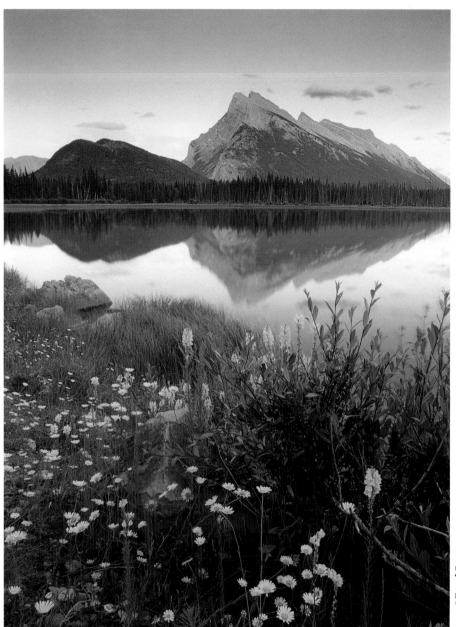

©Daryl Benson

Sunset, Mt. Rundle, Vermilion Lakes – There are beautiful, classic views of Mt. Rundle reflected in Vermilion Lakes all along the 4.5-kilometre Vermilion Lakes Road, just outside the Banff townsite.

Pentax 645, 45mm lens at f/22, Cokin blue/yellow colour polarizer, Tiffen two-stop soft-edge graduated filter, Fuji Velvia film.

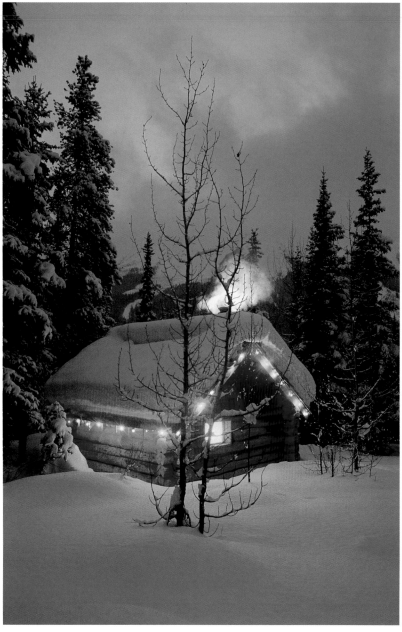

Valley of the Ten Peaks is a far more appealing spot photographically. Get there in plenty of time for early morning light and explore the shoreline near the parking lot, the canoe launch, the outlet to Moraine Creek and the large boulder pile at the north end of the lake. All of these spots will provide classic views of this iconic lake and its mountain peaks. In autumn (mid-September) hike up to Larch Valley (4 kilometres) from the Moraine Lake parking lot. It's a great place to photograph golden larch (and if it's larch you're after, check out Sunshine Meadows and Lake O'Hara in Yoho National Park at this time of year).

Herbert Lake lies just outside Lake Louise along Highway 93 north and it doesn't get any better or easier than this. I've hiked all over the mountain parks and this spot is one of the best anywhere—and it's literally right beside the road! This gem of a location is nice at sunrise when morning's first light hits the Bow Range and reflects beautifully in the lake's calm surface. In summer, wildflowers skirt the edge of the lake, increasing its photographic potential. Another nice thing about this spot, besides the easy access, is that it is usually devoid of tourists, especially early in the morning (they're all up photographing Lake Louise). Pull into the picnic spot here for great views through the lodgepole pines around the shoreline.

Farther north along Highway 93 are Bow Lake and Crowfoot Mountain. This whole area holds great potential. Pull into the Num-ti-Jaw Lodge parking lot and scout out all the trails and little bridges that crisscross the shoreline here. All the viewpoints of Bow Lake along Highway 93 are great, and I recommend hiking along the entire eastern and northern shoreline of the lake. This is definitely a sunrise location, but if the winds are calm the reflections of Crowfoot mountain are spectacular all day.

Peyto Lake is the next icon spot along Highway 93 north. I have to admit it's my least favourite of the Rocky Mountain landmarks: it's just another panoramic view of mountains reflected in a blue-green lake. But don't let my jaded opinion sway you from visiting: for best light it's a morning to mid-afternoon spot. Have a look around, you may find something fresh to shoot in a landscape I take mostly for granite. I actually prefer the tiny little circular pond in the field across the highway from the Peyto Lake turnoff: it may not

© Daryl Benson

Rampart Creek Youth Hostel – This rustic hostel with several out-buildings is nicely nestled in the woods a few kilometres north of Saskatchewan River Crossing on Highway 93. This image is a good example of how powerful the creative use of light can be in making a photograph. With the help of an underpaid assistant (my brother), I attached Christmas lights to the outside of this small hut, placed a Coleman lantern inside near the window, and used a flash to back-light the chimney smoke.

Pentax 645, 45mm lens, 15-second exposure at dusk, Fuji Velvia film.

be nearly as dramatic, but it seems more friendly and it's definitely not as crowded.

Waterfowl Lakes is yet another in-your-face "mountains reflected in lake" spot, right beside the road! When the waters are calm, impressive Mt. Chephren reflects dramatically in Waterfowl Lake. Best light here is definitely at sunrise. Beautiful blankets of ground fog are not uncommon here on July and August mornings (if there's fog here, there's also likely to be fog back down the road at Bow Lake, presenting a dilemma: which spot to shoot? I recommend Bow Lake and Crowfoot Mountain, there's more variety there).

The Howse River Viewpoint is just one kilometre before Saskatchewan River Crossing (the junction of Highways 93 and 11, the David Thompson Highway). This viewpoint is so close to the side of the road it'll only take you 60 seconds to walk in and assess it for yourself. The light is good here all day.

Most visitors to the mountain parks never even see one of my favourite locations to photograph, the Kootenay Plains (not to be confused with Kootenay National Park, which is in B.C.). At Saskatchewan River Crossing (gas up here) turn east onto Highway 11 and follow it out 14 kilometres past the Banff park gate to the beginning of the Kootenay Plains Ecological Reserve. The landscape opens up here to fields of grass and beautiful stands of aspen, with the always-impressive Rockies as a backdrop. Approximately 24 kilometres east of the Banff park gate is a turnoff for Two O'clock Creek Campground. Take the road directly across the highway from this campground. It's rough and it branches several times, but it doesn't matter which branch you take—they all eventually come to the edge of the North Saskatchewan River. Hike along the cliffs and down to the river's edge here for gorgeous big-landscape views.

One of my favourite waterfalls in all of Alberta is the double plunging Crescent Falls. Its turnoff is 41 kilometres east of the Two O'clock Creek Campground along Highway 11. Don't photograph this waterfall only from the fenced viewpoint; hike down to the flat rocks at

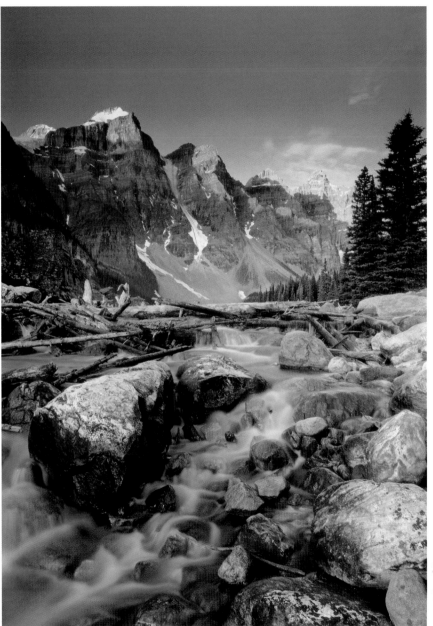

Sunrise, Wenkchemna Peaks (Valley of the Ten Peaks), Moraine Creek – The whole area up at the end of Moraine Lake Road is one of my favourite locations in Banff National Park. There have been many beautiful images made here over the years, but there are also many undiscovered views yet to be found. Explore the entire shoreline near the parking lot and the lodge, the canoe launch and the outlet to Moraine Creek. And check the view from the large boulder pile at the north end of Moraine Lake.

Pentax 645, 45mm lens, Cokin blue/yellow colour polarizer, Singh-Ray two-stop reverse blue graduated filter, Fuji Velvia film.

©Daryl Benson

Travel Tip

The Cascade Effect

You've spotted an absolutely gorgeous landscape while driving along the highway. You pull well over to the side of the road, unpack your camera equipment and begin to set up your tripod (the larger your camera and tripod, the larger the cascade effect will be). Within about 30 seconds of setting up, another vehicle will stop, and its passengers will eagerly scan the landscape looking for "the animal." This will immediately cause other vehicles to slow down or stop. Soon a tour bus will pass, slow down and stop. The Cascade Effect is now in full swing, and before long (only a couple of minutes in peak tourist season) you and your tripod will be in the midst of a major traffic bottleneck.

There is only one remedy I'm aware of to prevent the Cascade Effect from ever getting started. Before you set up your camera equipment, get out a huge piece of cardboard and in big bold letters write "There Is No Animal! I Am A Landscape Photographer; it's OK to Feed Me!"

the base of the upper falls for the best compositions.

Back in Banff National Park and farther north on Highway 93, 12.8 kilometres past the Saskatchewan River Crossing, there's a small turnoff on the left. There is a large reed flat and a shallow pond just a few metres in from the side of the road. It's often calm here, allowing the tiny pond to hold nice reflections of the surrounding mountain scenery.

Even farther north on Highway 93 you'll pass the Weeping Wall, which is more interesting to photograph in winter when it freezes and becomes a popular spot for ice climbers. Natural phenomena such as autumn colours, fresh snowfalls, hoar-frost or storm light change all the rules photographically. Areas that are only marginally interesting can be absolutely stunning in the right environmental situations.

Last are The Three Nigels! Travelling north, still on Highway 93 and after the Weeping Wall, you'll cross a bridge spanning a narrow but deep gorge. Over the bridge there's a small turn-off on your right, just after the end of the railing. Hike across the small meadow there toward the sound of rushing water. This is the first Nigel. There's a very steep gravel embankment here, and at the bottom is a dramatic gorge, rapids, waterfalls and great views up and down Nigel Creek (the path down is very steep and it is not an official trail, so don't tackle it unless you're sure of your climbing ability). This would be a great place to bring a couple of models dressed as hikers and have them pose among the rocks and waterfalls. Mountain streams, rivers and waterfalls run at their fullest in the spring, but I find these locations are all more approachable and photographable in the autumn when there is less water, less spray and more exposed stream bed to photograph around.

Back on Highway 93 north, after you round the big curve and come up the big hill, take the second turnoff with the sign pointing to Bridal Veil Falls (3.5 kilometres north of the first Nigel). The most photogenic falls here are Panther Falls, just a few metres into the bush at the upper end of this pullout. There's an array of interestingly eroded potholes along Nigel Creek at the top of the falls, but the best area to shoot is down the trail at the *bottom* of the pullout. This trail is steep but short (1.5 kilometres return) and divides in two, one branch staying high and the other going down to the base of the Panther Falls. In spring and summer the mist from the falls can get you wet before you even see them. The higher branch is my favourite, especially in late autumn or early winter. You can get right in behind the falls and shoot through the spray with the mountains in the background and icicles dangling from the rock that overhangs in the foreground; it's great!

That was the second Nigel. Less than a kilometre north of this pullout is the Nigel Creek parking lot. Turn in here and take the first parking spot you come to. Walk back down the highway a few metres, looking over the edge of the road, until you see a series of small cascading waterfalls: the third Nigel. Hike down the gravel slope and explore the falls and many potholes eroded in the stream bed here. This is the least dramatic of the Three Nigels, but is the safest to explore.

Continuing north along Highway 93 from the Third Nigel will get you to the Columbia Icefields and Jasper National Park.

—DB

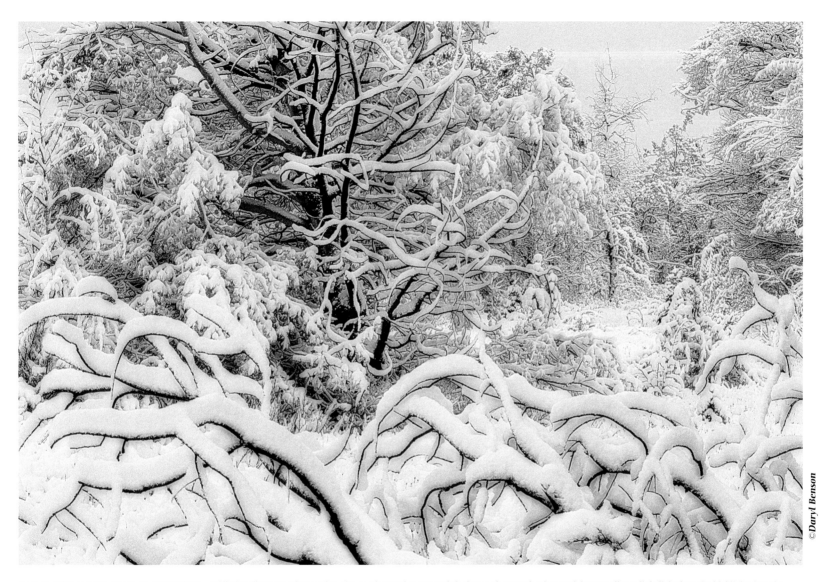

Fresh snowfall, autumn colours, Kootenay Plains – Diffusion filters are often used to give a soft, pastel or romantic look to a photograph. They work by spreading a little light from the highlights into the shadows or darker areas of the scene. But in this image I created the soft look digitally by selecting the dark areas (tree trunks and branches) and diffusing them into the brighter areas. A similar effect can be obtained using a diffusion filter over the enlarger lens when printing (if you're printing from a negative). Original image shot with a Nikon FE, 28mm lens, and little toe-heaters stuffed in my boots.

Jasper National Park

As you cross the park boundary between Banff and Jasper you might wonder: So, what's the difference? You're still surrounded by gorgeous mountain scenery. The difference lies in the fact that Jasper receives fewer than half the visitors Banff does, so it's far less crowded.

I'll discuss some of the more accessible and photogenic highlights from south to north, as you drive along Highway 93 from Banff.

The first trail you'll encounter is at Wilcox Pass, a 4-kilometre hike (each way) that offers dazzling views of the Athabasca Glacier and surrounding area. The trail becomes a little less distinct after the pass, but it continues another 7.2 kilometres through an open alpine meadow to finish at the Tangle Creek Falls parking lot. Wilcox Pass is a particularly good spot to photograph the broad, open carpets of spectacularly coloured willow and bearberry bushes in autumn (because of the altitude, colours are at their best around the beginning of September).

The next location you'll encounter along Highway 93 is The Columbia Icefields. Do the tourist thing and stop in at the Visitor Information Centre here. Although a ride up onto the glacier in one of the 20,000 kilogram Sno-coachs is a worthwhile personal experience, the short hike up to the toe of this receding glacier through its moonscape moraine may prove more rewarding photographically.

Tangle Creek Falls couldn't be more conveniently positioned than it is, right beside the road. It's a very attractive cascading waterfall well-worth exploring (be careful: the rocks are slippery). It's gorgeous in early winter when the falls begin to freeze.

Just to the north of the Beauty Creek Hostel parking lot there's a classic view from the roadside looking down the Sunwapta drainage toward Mount Kitchener (see page 30).

Sunwapta and Athabasca Falls are both definitely worth photographing (get there early—or go in the off-season—to avoid the crowds). Explore both falls from all the walkways and bridges that circle the gorges; look for interesting detail compositions around the boot-worn exposed roots and bedrock near the bridge at Sunwapta Falls. Both areas are fenced, and although I can understand the desire to move in close for that perfect shot, exercise caution and common sense: too many individuals have fallen fatally into these gorges.

Mineral Lick and Goat Viewpoint (17 kilometres north of Sunwapta Falls) is a premier outlook over the Athabasca River and is definitely worth a stop. But hey, there are gorgeous views and overlooks all along Highway 93. Don't try to race through this area; give yourself time to explore photographically, you won't be disappointed.

The narrow winding road to Mount Edith Cavell turns off Highway 93A. The classic photo here can be made from the bridge over Cavell Lake. From the Highway 93A turnoff it's 12.1 kilometres up Edith Cavell Road to the Tonquin Valley trailhead parking lot. Take this trail for about 100 metres to the bridge. If you're even the slightest bit lucky with the sunrise you'll be guaranteed a postcard image here. My favourite spot, however, is at the very end of Edith Cavell Road. Take the Path of the Glacier Trail (2 kilometres, round trip) right to the base of Mount Edith Cavell and Angel Glacier. There are usually mini-icebergs floating in the small glacial-melt lake here. The longer Cavell Meadows Trail (8.4 kilometres, round trip) also starts at the parking lot. A profusion of wildflowers here in mid-July, combined with the great views of Mount Edith Cavell and Angel Glacier, make this a very popular and photographable trail. It's best seen and shot in morning light.

The 8-kilometre Pyramid Lake Road behind the town of Jasper is a great, easy-to-reach morning location. If it's calm, there are gorgeous postcard reflections of Pyramid Mountain in both Patricia and Pyramid Lakes. There's also a beautiful stand of aspen along this short drive (the only other stand of aspen that's as scenic is at the beginning of Celestine Lake Road, 9 kilometres east of the Jasper townsite off Highway 16, just under the bridge).

Alberta

Jasper National Park

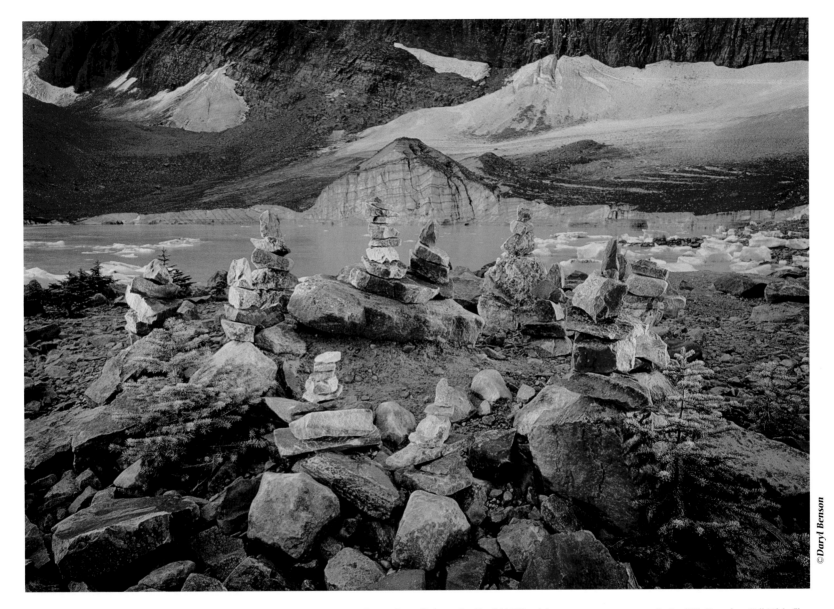

©*Daryl Benson*

Cairn Town, Path of the Glacier Trail, Mount Edith Cavell – A cairn is a pile of stones used to mark a trail along a boulder field. This mini-town of Cairns was playfully constructed by a couple of hikers who had a bit of creative free time on their hands. I used a million-candle-power flashlight to selectively illuminate the cairns during a two-minute exposure in the early morning (see "Light Painting," page 131).

Pentax 645, 45mm lens, Fuji Velvia film.

My favourite drive in all of Jasper National Park (and possibly in all of Canada) is the 44-kilometre, open year-round, Maligne (mah-LEEN) Lake Road. Your first stop here should be at the Maligne Canyon parking lot (6 kilometres up Maligne Lake Road from the Highway 16 turnoff). From there, an easy 45-minute hike (if you don't stop to shoot anything, which is highly unlikely) takes you along and through a dramatically carved limestone canyon, with numerous narrow chutes and waterfalls. Hike all the way down to the 5th Bridge to see *all* the canyon has to offer photographically. Maligne Canyon is spectacular in winter when the waterfalls and river freeze. Stuff some pocket warmers in your boots and gloves and traverse the canyon in reverse, starting at the 5th Bridge parking lot and hiking along the bottom of the canyon (licensed guides can be found in Jasper to take you safely through the canyon in winter).

Farther along Maligne Lake Road is Medicine Lake. There are two small parking lots just before you reach it. Below them, by the lake's edge, there is a large, uniquely eroded boulder field that, with the lake, provides an interesting foreground to the Queen Elizabeth Range Mountains. Medicine Lake is an interesting spot in late September as it dries up to become a broad, braided stream meandering through the mud flat that was its bottom. There are several good compositions from the mud flats themselves and from all along the side of Maligne Lake Road, looking across Medicine Lake.

Maligne Lake Road crosses the Maligne River several times as it continues, with views of large glacially deposited boulders left in the river's path. The punctuation mark at the very end of this road is its namesake, Maligne Lake, the largest natural lake in the Rockies. Classic views can be photographed from the bridge, the boathouse and from the shoreline near the boathouse. This is a sunset location in summer; in winter it's good at both sunrise and sunset.

The scenic icon of Jasper National Park is Spirit Island, on Maligne Lake. The only access is by boat, either canoe (a 3-hour paddle) or tour boat (a 30-minute ride). Unfortunately the tour boats stay at the island for only 20 minutes. When you purchase your ticket, quietly explain that you are a serious photographer (because you are) and ask to stay longer and catch a later boat back, so you'll have more time to shoot (and have fewer people in your compositions). You can rent a canoe from the boathouse, and there's a good campground near Spirit Island where you can stay for up to two days.

From the Jasper townsite it's a 46-kilometre drive east to the park gate along Highway 16. The country opens up a bit here and you have good views of the mountains over the Athabasca River and Jasper and Talbot Lakes (there's often fog here in the early summer mornings). Near the end of August, Jasper Lake begins to dry up, exposing its sandy bottom and revealing interesting sand patterns and old gnarled tree stumps (see photo on page 138). This area is also less likely to be overcast than around the townsite or along Highway 93.

—DB

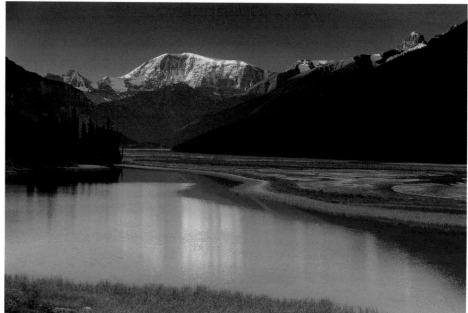

Morning light on Mount Kitchener, near Beauty Creek Hostel – This scenic location is literally right beside Highway 93. Go down the road's embankment and explore the reflections in the small pools and streams. Best photographed in morning light.

Pentax 645, 120mm lens, circular polarizing filter, Fuji Velvia film.

©*Daryl Benson*

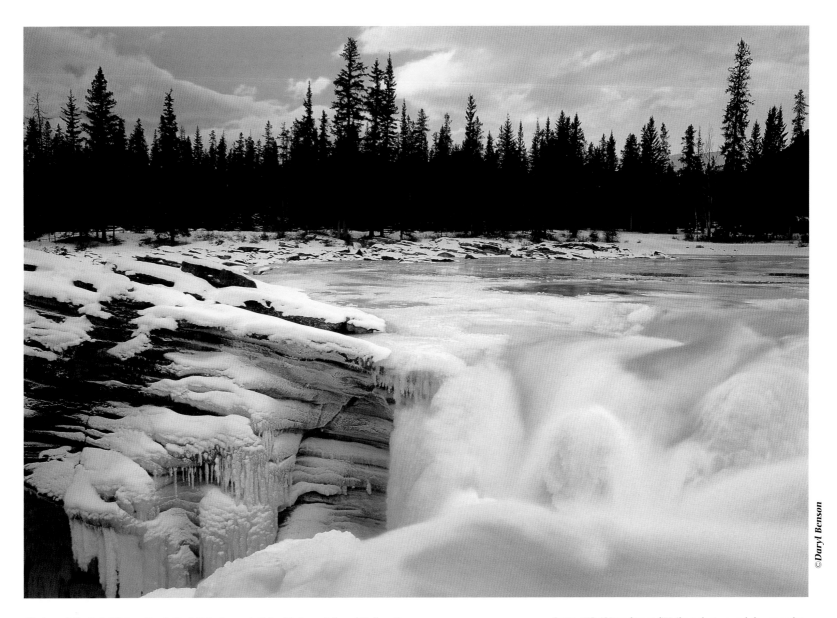

©*Daryl Benson*

Athabasca Falls, Early Winter – Tangle Creek Falls, Sunwapta Falls, Athabasca Falls and Maligne Canyon are all great places to shoot in early winter when the water begin to freeze and before everything is buried in snow.

Pentax 645, 120mm lens at f/32 (for a shutter speed slow enough to blur the waterfall), Cokin blue/yellow colour polarizer, Singh-Ray three-stop reverse-graduated filter, Fuji Velvia film.

Southern Alberta

Alberta, the province with 110 kilometre-an-hour highways—you gotta love it! One can have an early breakfast in Edmonton and be almost anywhere in southern Alberta, shooting, by mid-afternoon, via Highway 2 (if you're not in a hurry and would prefer a more scenic drive, take Highway 22; the stretch between Cochrane and Lundbreck is especially nice).

Southern Alberta has so much to offer photographically that rather than focusing-in on one spot or park I'll briefly mention several of the best locations and encourage you to explore them more on your own.

A favourite area is Dry Island Buffalo Jump Provincial Park, 30 minutes northeast of Trochu. The flat, level prairie plummets into a valley here with a suddenness and drama that make the spot drop-dead-gorgeous to photograph. Explore the entire length of the canyon rim. There's a stunning overlook of rolling aspen parkland and the Red Deer River, especially spectacular in autumn. The area is best shot at sunrise, but dramatic views can be found in any light.

The Alberta Badlands extend for about 300 kilometres along the Red Deer River valley, starting south of Red Deer, and can be seen from almost every road that approaches or crosses the river. The Badlands landscape is most accessible in the Drumheller region and at Dinosaur Provincial Park, northeast of Brooks.

Near Drumheller, take the 48-kilometre Dinosaur Trail circle drive. Stop and spend time at Horsethief Canyon, Midland Provincial Park and The Royal Tyrrell Museum of Paleontology. On Highway 9 west of Drumheller check out Horseshoe Canyon. About 45 minutes southeast of Drumheller along Highways 10 and 573 is the interesting ghost town of Dorothy. Several weathered buildings, an old grain elevator and two long-abandoned churches invite photo exploration here (see photo on page 20).

Writing-On-Stone Provincial Park is 43 kilometres east of Milk River, with dramatic Hoodoo formations against a panoramic backdrop of the Milk River canyon and the distant Sweetgrass Hills (in Montana).

A relatively unknown spot—a favourite of mine—is Red Rock Coulee, 25 kilometres south of Seven Persons on Highway 887. This Natural Preserve is unique because of the dozens of large red spherical boulders that have eroded from its hillsides. These oversized marbles and the coulees where they lie are positioned to catch evening light best. I don't recommend visiting this site in rainy weather: when wet, the Bentonite clays that make up this eroding landscape have surface properties that make you feel as if you're walking or driving on finely polished marble covered in banana peels.

The big Kahoona in this photo hit-list for southern Alberta is Waterton Lakes National Park. Anchoring the southwestern corner of the province, this park—along with Glacier National Park in Montana—is a must for any landscape photographer. The entire drive south

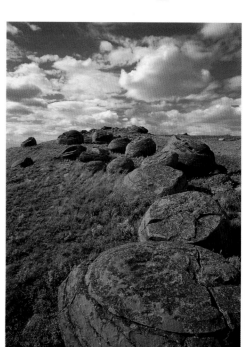

Red Rock Coulee Natural Preserve.

Pentax 645, 45mm lens, circular polarizer, Fuji Velvia film.

©Daryl Benson

along Highway 6 from Pincher Creek is scenic, but the best photo spot is the Pine Ridge Lookout about 10 kilometres north of the Waterton park entrance (there are two other well-marked and worthwhile viewpoints along Highway 6: both are past the park entrance toward the U.S. border crossing at Chief Mountain).

At the entrance to Waterton Lakes National Park, the Rocky Mountains rise abruptly and dramatically 3,250 metres from the surrounding prairie, without any pretense of foothills. Take the Red Rock Canyon Parkway drive. The beginning of this winding 15-kilometre road takes you through beautiful rolling open prairie and stands of aspen punctuated by the "right in your face" Rocky Mountains (this drive and the previously mentioned lookouts are all excellent spots for early-morning shooting). The exclamation point at the end of this road is the uniquely layered and very, very Red Rock Canyon and creek (don't miss it). The Akamina Parkway is a 16-kilometre road that starts just after the Waterton Park Visitor Centre and ends at picturesque, sub-alpine Cameron Lake, back-dropped by Mount Custer (which is actually in Glacier National Park in Montana).

A final favourite little spot in southern Alberta I'd like to mention is The Burmis Tree. This dramatically wind-sculpted, 735-year-old Limber Pine is a well-known local landmark. You'll find it easily right beside Highway 3 (the Crowsnest Pass road) near the towns of Frank, Bellevue and Hillcrest. It makes a nice silhouette when shot against the morning sky.

—DB

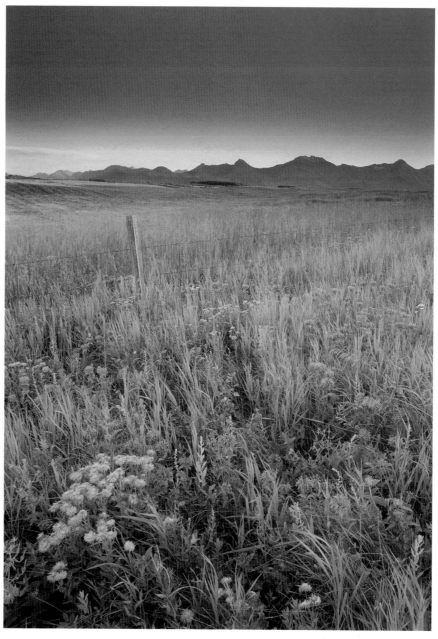

Asters and Western Wild Bergamont, Sunset, Near Waterton Lakes National Park – Beginning photographers are often disappointed when the images they get back from the photo lab don't match their memories of the scenes they photographed. There are several reasons for this: one is that the mind has a tendency to exaggerate or embellish memories over time, and usually the longer the passage of time, the greater the effect. Second, and more to the point, film does not see things the way the human eye does, not even close. The creative and knowledgeable use of filters helps to translate what you see to the camera and its film, and this image is a good example. I used a Tiffen two-stop soft-edge graduated filter to balance the bright sky with the foreground, and a Cokin blue/yellow colour polarizer to capture and enhance the warm colours in the original scene.

Pentax 645, 45mm lens at f/22, filters as mentioned, Fuji Velvia film.

©Daryl Benson

Your Own Back Yard

"I live in the middle of a huge grey city"; "I don't have a vehicle"; "my dog ate my tripod." Recognize any of these? They are all excuses. Within 30 minutes of your back door are images as unique as those to be found anywhere else on the planet. They may not seem so to you because you see them every day, but to someone 1,000 kilometres away they can be fresh and exciting.

A landscape doesn't have to be huge in scale: it might be a single group of trees in a nearby park or an urban scene in the centre of the huge grey city you live in.

Your own back yard is the location you are the most intimately familiar with. You know which way the winds blow the summer thunderclouds, you know the best spots to view a sunset, you know where the nearest vet is (for the dog that ate your tripod), you know where all the best foregrounds are for silhouetting that brief shaft of evening light, you know where and when the flowers bloom and where the trees and bushes are that turn the most dramatic colours in autumn. And if you don't know all these things, you should.

I spend at least six months each year travelling around North America and the rest of the globe shooting on assignment and gathering landscape images for stock, but by far my favourite images are those I capture within 30 minutes of my back door—it's the place I know best; it's home!

—DB

Spider web and Western Dock at sunrise near Edmonton, Alberta – I live right at the edge of town in Edmonton and a few minutes' walk or drive from my back door puts me in the middle of an infinite variety of prairie and farm landscapes.

Nikon FE, 20mm lens at f/22, Singh-Ray four-stop reverse-graduated filter, Fuji Velvia film.

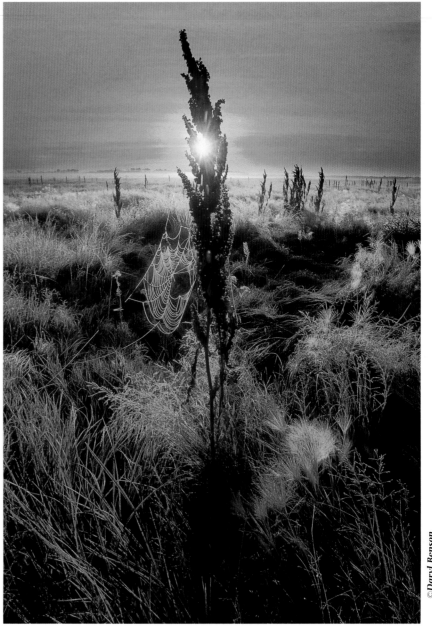

©*Daryl Benson*

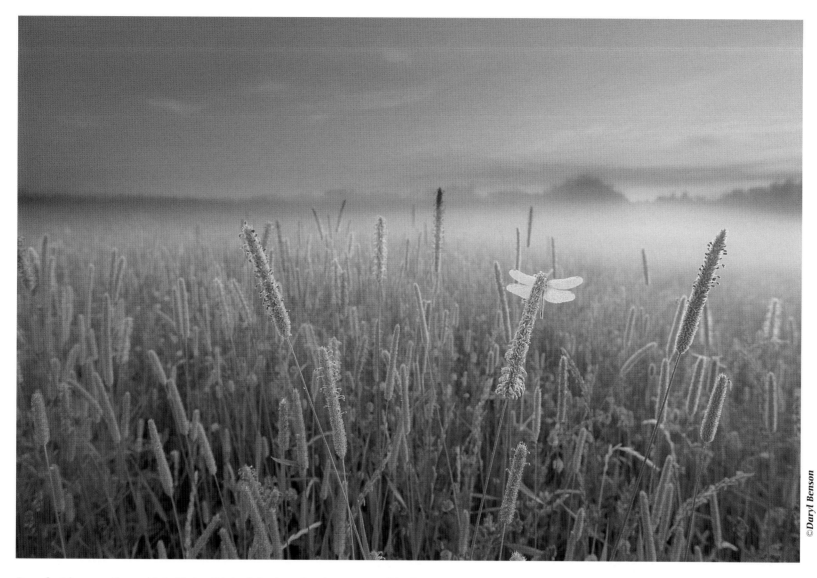

©*Daryl Benson*

Dragonfly at dawn, near Sherwood Park, Alberta – This dew-laden dragonfly waits atop a stem of Timothy grass for the morning sun to dry its wings so it can begin another day. The image was captured one June morning around 4 a.m., only 30 minutes from my back door.

Nikon FE, 20mm lens at f/22, Singh-Ray two-and-one-half-stop reverse-graduated filter, Fuji Velvia film.

©*Daryl Benson*

Passing Storm, near Marshall.

OPPOSITE: Windswept Trees, Lookout Point,
Cypress Hills Interprovincial Park.

SASKATCHEWAN

Cypress Hills Interprovincial Park

Cypress Hills Park is divided into two sections: West Block, which is shared by Alberta and Saskatchewan, and Centre Block—about 28 kilometres south of Maple Creek—which is completely within Saskatchewan. Both protect dramatic flat-topped plateaus that rise like huge islands 600 metres above the surrounding prairie.

My two favourite spots are Bald Butte and Lookout Point, both in Centre Block, just a couple of kilometres apart. They provide dramatic panoramic views with aspen forests in the foreground and prairie as far as the eye can see. Although both locations face north, each provides vistas looking east and west, making them ideal for sunrise and sunset shooting.

A "Gap Road" connects Centre Block and West Block. It's a primitive, 20 kilometre path that is not suitable for travel in wet weather (and don't take this warning lightly!). If it's wet, take the longer but safer Highway 21 back to Maple Creek and then Highway 271 to West Block.

The first part of the road into West Block is steep and winding, but once you make the ascent it's truly like being on an island above a prairie sea.

My preferred spots in West Block are Conglomerate Cliffs and Fort Walsh National Historic Site. The Cliffs overlook Adams Lake and provide yet another dramatic view of the prairie below. The rock formations (which look like outcroppings of concrete) provide an effective foreground to the prairie vista.

Saskatchewan

Cypress Hills Interprovincial Park

© Daryl Benson

Autumn near Fort Walsh National Historic Site – The Cypress Hills can be visually stunning in the fall. Unfortunately the area is usually quite windy, and the colourful leaves don't stay on the trees for long. Pentax 645, 45mm lens, circular polarizer, exposure 1/15 s (1/15 of a second is approximately the speed at which we perceive the world. If you want to show motion photographically–falling snow, raindrops, leafs in the wind, etc.–in the same visual manner as you see it, use a shutter speed from 1/30 to 1/8 s), Fuji Velvia film.

Move in close to the cliffs with a wide-angle lens and use them as a strong foreground subject in the composition. Including something dominant in the foreground really helps convey a sense of scale and distance in broad panoramic scenes; the closer you move into the scene to exaggerate the foreground-to-background scale difference, the more dramatic the result will be (see the "Swallowtail Light" image on page 83, for example).

Fort Walsh National Historic Site contains Fort Walsh—a North West Mounted Police post from the late 1800s—and its cemetery, beautifully nestled among rolling hills and stands of aspen. This spot is worth the short drive just to have a look and, if you're so inclined, to tour the Fort.

Highways 271 and 615 provide many views of the rolling ranchland and aspen forests typical of the area, but everything outside the park is private land: show respect and get permission before hiking.

If you can be in the Cypress Hills area during prime autumn-colour, the vistas will border on the orgasmic. Unfortunately this area is usually quite windy, so timing is critical, as the wind will strip the leafs from the aspens very soon after they turn colour. The best time for autumn colours is usually the first of October.

—DB

Dusk, Cypress Hills area, just off Highway 615 south.

Pentax 645, 45mm lens, Howard Ross Colour Enhancing filter, Fuji Velvia film.

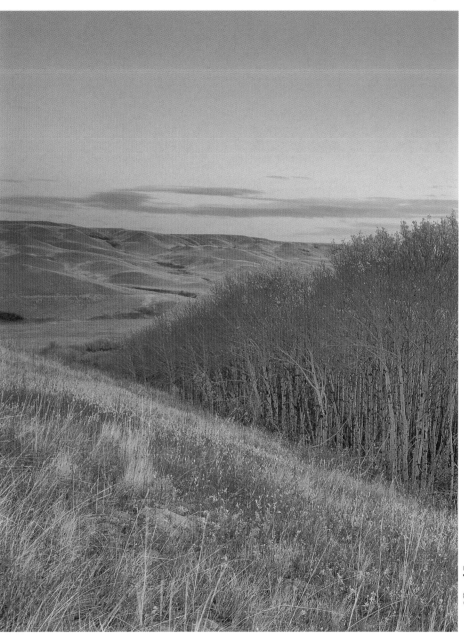

©*Daryl Benson*

Great Sand Hills and Herschel Petroglyphs

Saskatchewan

Great Sand Hills

The Great Sand Hills are active, bare dunes—some being 15 to 25 metres high—that extend over 1,900 square kilometres of southwest Saskatchewan.

The area is not well marked, but sketch maps are available from the Great Sandhills Museum in the nearby town of Sceptre or at the Esso gas station on the corner of Highways 21 and 32 in Leader. Essentially, travel 0.2 kilometres west of Sceptre on Highway 32, then south on the grid road (unfortunately it's not marked) for 18.6 kilometres to the Great Sand Hills. A half to 1 kilometre hike west is needed to reach some of the larger dunes. This is all private land, so respect the posted signs, park in designated areas and don't harass the cattle (as tempting as that may be).

Be very careful changing film on the dunes: the sand here just loves to jump into open camera backs to scratch film and do nasty things to tiny camera parts.

This area is one of the driest and hottest in Saskatchewan. Carry plenty of drinking water and make mental notes of landmarks as you hike so you won't get lost.

Two interesting manmade landmarks in the area are the Cowboy Boot Fence, with over 20 pairs of weathered boots nailed to it, and the Fitterer's Ranch Gate, with a couple of dozen mule-deer antlers attached to it. Both are on the same grid road as the Great Sand Hills.

One of the best petroglyphs (ancient rock carvings) I've ever seen is less than a two-hour drive north of Sceptre, 2.5 kilometres southwest of the town of Herschel. The site is not well marked, but there is a piece of plywood up on the fence (Energy, Mines and Resources Topographic Map 72N/9 is helpful here). Follow the worn cattle trail in, past two tepee rings, for about half a kilometre; you should then notice a triangular rock, the most dramatic and photographic petroglyph at this site. It's estimated to be at least 1,650 years old. The markings on the rock face east and are thus best photographed late in the afternoon when the sunlight creates strong shadows across its surface.

There's an Interpretive Centre and Tea Room at the top of the hill in Herschel. Stop in for more specific directions and for information on the history and geology of the area.

—DB

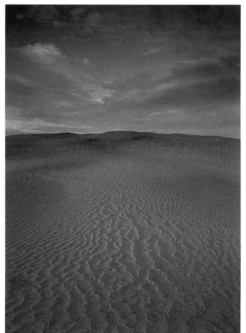

Sunrise, Great Sand Hills.

Pentax 645, 45mm lens, Singh-Ray two-stop soft-edge graduated filter, Singh-Ray Colour Intensifying filter, Fuji Velvia film.

©*Daryl Benson*

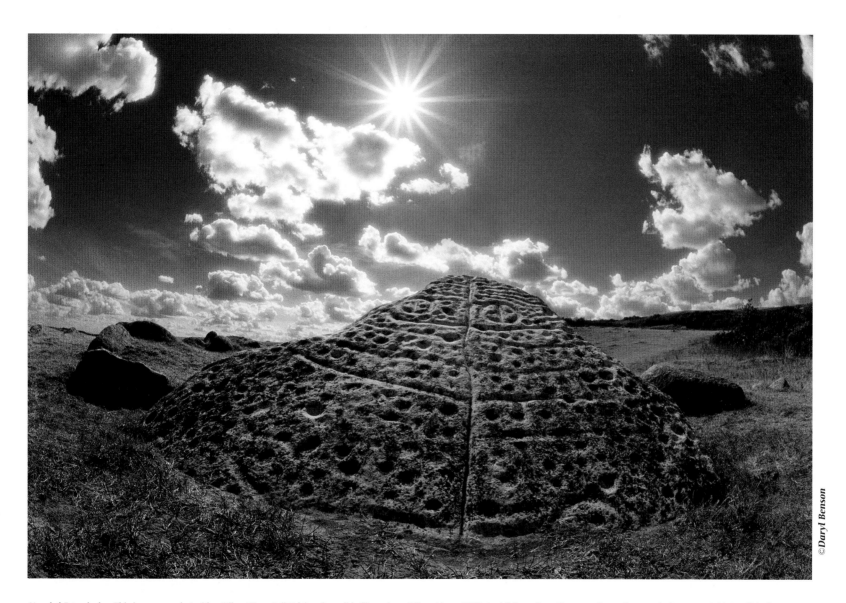

©Daryl Benson

Herschel Petroglyph – This image was shot with a Nikon F5 on Fuji Velvia colour slide film using a Nikon 16mm (180° view) fish-eye lens. The monochromatic warm look was created later, digitally.

Grasslands National Park

Despite its name, Grasslands National Park is not just land covered in grass. Although it does preserve a representative sample of native prairie grasses and wildlife, it also contains dramatic geological formations (coulees, buttes and badlands) and native Indian archeological sites (tepee rings, vision quest sites and medicine wheels).

The park is divided into two sections: West Block, centred on the Frenchman River Valley, and East Block, which is dominated by the Killdeer Badland formations.

Stop in at the Grasslands Visitor Information Centre in Val Marie (West Block) to pick up the "Frenchman River Valley Ecotour" brochure and the maps for both blocks. The Ecotour is a self-guided 28-kilometre (round trip) auto tour through the West Block, mostly on an ungraveled, dry-weather road— if it rains, get out or you'll get stuck! The first stop reveals the most dramatic landscape, with large buttes and coulees. Spend some time hiking around this area for striking elevated views in all directions and for shots of tepee rings, circles of rocks that once held down the outer skirts of tepees.

There are no facilities in the park—no marked trails and no drinking water (get it in Val Marie; you'll need at least two litres per person per day).

The highest point in the park is 70 Mile Butte in the northwest corner of West Block, rising 100 metres from the valley floor. It's a moderate hike from the access road on the west side of the park. The butte provides a panoramic view of the surrounding landscape, great for both sunrise and sunset shooting.

The landscape is even more dramatic in East Block, but many of the best badland formations are on private property and you'll need permission to hike to them. The names and phone numbers of the landowners concerned are available at the Visitor Information Centre in Val Marie. I suggest that you pick up a 1/50,000 scale Energy, Mines and Resources topo-graphical map, 72G/2; it will prove invaluable in locating access roads and the most interesting formations. The southeast corner of the proposed park boundary in East Block has some of the best badland formations and views.

Strong wind is an almost constant companion in Grasslands National Park, but you'll find the wind preferable to the mosquitoes that rise from the ground like demon seed when it's calm. Be careful, wind gusts are strong enough to blow over an unattended camera and tripod.

–DB

Saskatchewan

Grasslands National Park

East Block – Much of this National Park is still privately owned land, and grazing cattle are a common sight in many areas.

Pentax 645, 120mm lens, Cokin Sunsoft warm diffusion filter, Fuji Velvia film.

©*Daryl Benson*

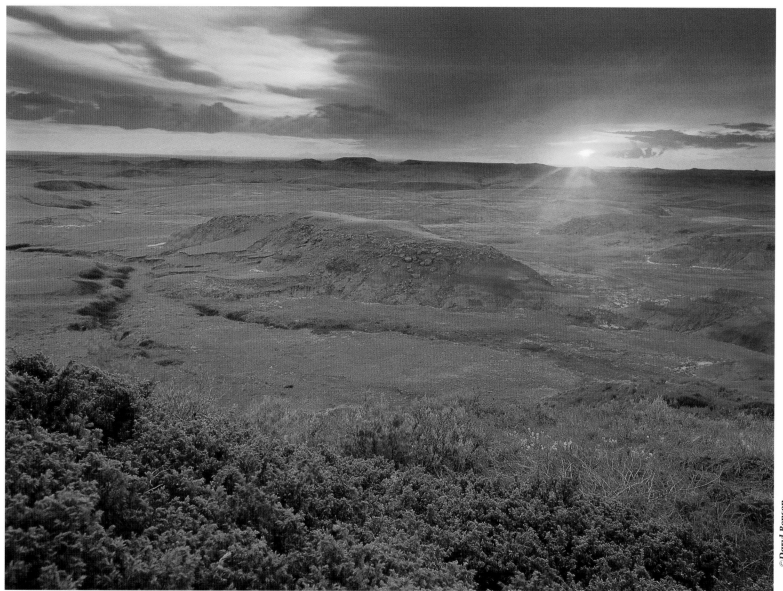

©*Daryl Benson*

Sunset, Killdeer Badlands, East Block – I used to really hate lens flare in a photograph, but I've noticed that my taste has slowly changed over the years and I now often like the look a bit of flare gives to an image.

Pentax 645, 45mm lens, Howard Ross Colour Enhancing filter, Singh-Ray two-and-one-half-stop reverse graduated filter, Fuji Velvia film.

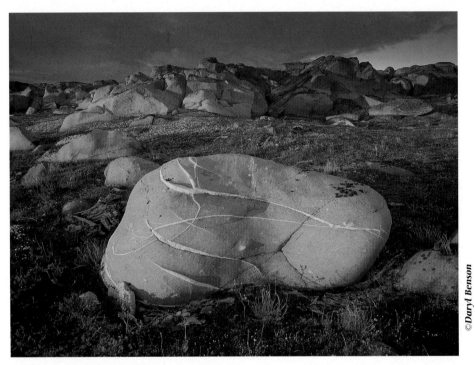

©*Daryl Benson*

Sunrise, Jackson Pollock Rock, Bird Cove, near Churchill.

OPPOSITE: *Canadian Shield sliding into Hudson Bay.*

© *Daryl Benson*

MANITOBA

Churchill

You can get to Churchill by plane, train or boat, but not by car. If you're not flying in, the best way is to drive to Thompson, Manitoba, and take the leisurely 12-hour train trip (Via Rail; 1-800-561-3949).

This open landscape is primarily tundra, dwarf shrubs and glacially polished Canadian Shield dotted with colourful lichens. For landscape photography, the beginning of July is probably the best time to visit: the wildflowers are at their peak and there should still be icebergs in the harbour.

The summer sun takes such a low arc in the sky this far north that the beautifully long shadowed light at sunrise and sunset lasts for hours: you can shoot sunset photos from 9 p.m. to midnight and sunrise shots from 3 a.m. to 6 a.m.

Bird Cove, just outside of Churchill, is a great spot to photograph the exposed Canadian Shield rock formations, at either sunrise or sunset. When the winds are blowing onshore in early July, the pack-ice drifts to the shoreline and lies stranded at low tide, giving an excellent opportunity to photograph and explore all the weird shapes and colours of icebergs. Although at an average height of 9 metres they're not as dramatic as those found off Newfoundland, they are just as unpredictable and dangerous while they melt. Approach and photograph them with caution: they can fall over or break into large chunks without warning.

Another interesting attraction at Bird Cove is the wreck of the Ithica, which lies semi-submerged at high tide and can be hiked to at low tide (be careful not to get stranded when the tide comes in).

Cape Merry, at the mouth of the Churchill river, is another good spot to photograph the exposed Canadian Shield. There are several locations nearby with colourful lichen (between the grain elevators and the turn-off for Cape Merry there is a large rock outcrop absolutely covered in orange lichen). Cape Merry is also a good place to see and photograph Arctic fox, Arctic hare and many bird varieties—ptarmigan, Arctic terns and, if you're lucky, Ross's gulls.

After the ice breaks up, three thousand beluga whales move into the mouth of the Churchill River to spend most of July and August there. Boat tours (complete with underwater acoustic gear, to listen to the belugas singing) are available and are a good way to see and photograph them.

Churchill is known as "The Polar Bear Capital of the World." From October to November, thousands of visitors arrive to see and photograph the bears that congregate there, waiting for Hudson Bay to freeze over. There are organized tours to Gordon Point and Cape Churchill using specially designed all-terrain buggies. This seasonal event is very popular, so book early (Tourism

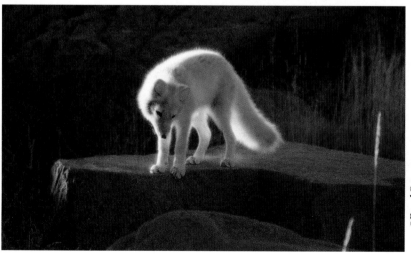

Arctic fox, late evening light, Cape Merry – Arctic fox, Arctic hare and ptarmigan are all commonly seen among the tan and orange rocks at Cape Merry. Spotting them is ridiculously easy in late autumn if there is still no snow and their coats have changed to a "here-I-am-two-miles-away" white!

Nikon F5, Tokina AF 80–400mm lens at 300mm, f/5.6, Cokin Sunsoft warm diffusion filter (see Filters section), Fuji Provia film pushed one stop from ISO 100 to 200 (photo cropped slightly from the original).

©*Daryl Benson*

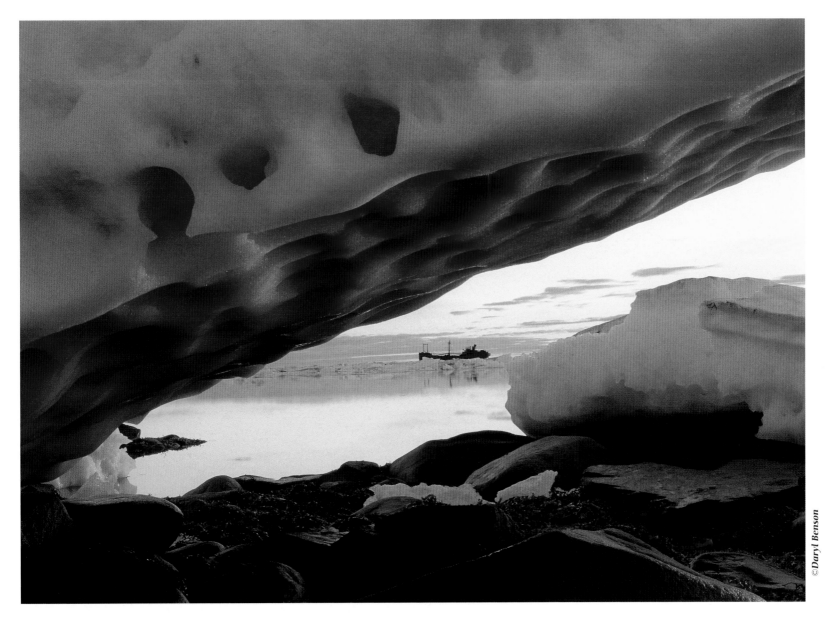

*Ithica at sunset, low tide, Bird Cove – The 1961 wreck of the Ithica lies stranded
in Bird Cove among the many lingering icebergs of early July.*

*Pentax 645, 45mm lens at f/22 (for maximum depth of field),
Cokin blue/yellow colour polarizer, Fuji Velvia film.*

Manitoba; page 150). You can also see bears at Ladoon's dog compound just a few kilometres outside of Churchill where, from the warmth of your own rented vehicle (I recommend a four-wheel-drive), you can watch several dominant polar bears rest, fight among themselves and—as incredible as it may seem—occasionally play with Brian Ladoon's chained Canadian Eskimo sled dogs!

Mosquitoes and black flies aren't a concern in polar-bear season, but in the summer you'll find these annoying little creatures unbearable. The best protection is loose-fitting clothing (they can bite right through tight jeans) that is snug around the ankles, wrists and neck. DEET, the active ingredient in most mosquito repellents, is my favourite defence against insects. Don't expect pretend-repellents such as Avon's Skin-So-Soft to work very well in the north: look for a true bug repellent with a high concentration of DEET. But be aware that DEET is toxic: don't use too much of it, especially on small children or adults with sensitive skin. It will also attack many plastics, so be careful handling your camera equipment right after you've applied repellent.

A bug jacket is a good $40 investment when mosquitoes and black flies are swarming, and I recommend one for all travel in northern Canada. Several styles are available: all are basically light-coloured, loose-fitting, long-sleeved pullover shirts with hoods. There are elastic bands around the waist and wrists. The front of the hood and the underarms have a fine mesh for vision and ventilation (it can be hot here on long summer days), a mesh fine enough to keep the smallest insects out yet still allow reasonable vision. It may be a little awkward composing through a viewfinder with the hood zipped up, but it sure beats mosquitoes in your ears, eyes, up your nose and down your throat.

—DB

Polar bear snuggled into its snow bed, Cape Churchill, Wapusk National Park.

Nikon F5, Tokina AF 80–400mm lens at 400mm, Singh-Ray two-stop soft-edge blue graduated filter, Fuji Provia pushed one stop from ISO 100 to 200 and overexposed one stop from the meter reading.

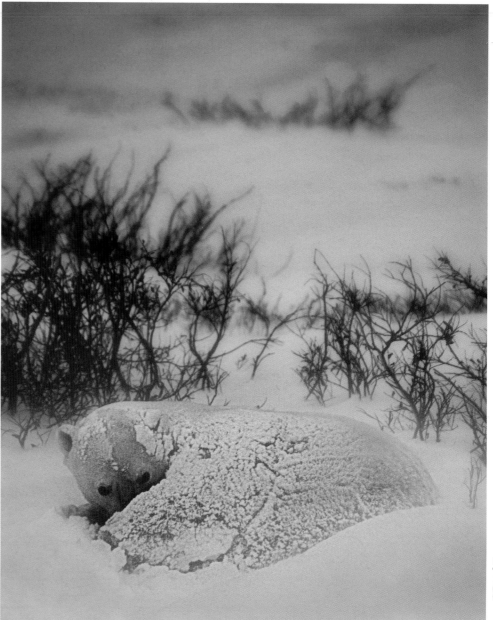

©*Daryl Benson*

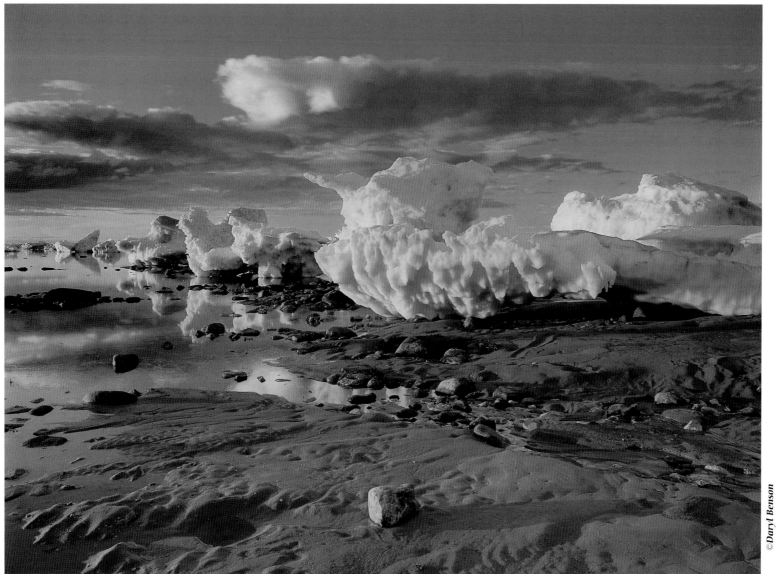

©*Daryl Benson*

Stranded icebergs at sunset, low tide, Hudson Bay, near Churchill – In mid-summer at latitudes as far north as Churchill, the "sweet" golden light of sunrise and sunset lasts for hours, as the sun traces a slow sloping arc along the horizon. Sunset light can last until midnight, with the glow of sunrise beginning a mere three hours later.

Pentax 645, 45mm lens, Cokin blue/yellow colour polarizer, Singh-Ray two-stop soft-edge graduated filter, Fuji Velvia film.

Whiteshell Provincial Park

Whiteshell Provincial Park lies just north of Highway 1 (the Trans-Canada) along the Manitoba-Ontario border. Highway 44, just north of the town of Falcon Lake, provides a good variety of photographic opportunities. To start with, the rugged shoreline on either side of the beach at Caddy Lake Resort is a beautiful spot for sunrise shots. And The Lily Ponds, right beside the road just up Highway 44 from Caddy Lake, support two varieties of flowering lilies: yellow pond lilies, which first appear in May, and the larger, beautiful white "Fallen Star" blossoms, which start to show up in June. Both species bloom in profusion at the edge of these ponds well into September.

McGillivray Falls Trail is probably the best short (4.6 kilometre) trail in the park. But in my opinion the exposed outcrops of Precambrian Shield that make this park so visually interesting are better seen and photographed all along Highway 44, from the town of West Hawk Lake west to the town of Rennie.

Highway 307 breaks north from Highway 44 just east of Rennie and continues through the park for 84 kilometres to the town of Seven Sisters Falls, passing several resort lakes and many outcroppings of exposed bedrock. One of the nicest locations here is Blueberry Hill, a spot well-known locally. It's an elevated outcrop of Precambrian Shield with many great rock formations that look out over Nutimik Lake and a small island. It's positioned well to catch both morning and evening light. Turn off Highway 307 at the Nutimik Lake General Store and follow the road for 0.7 kilometres, then turn left at the Nutimik Lake Block 2 sign and follow the road up the hill for 0.4 kilometres until it stops at a rock outcropping that doubles as a parking lot. A short (40 metre) trail just off to the left leads to Blueberry Hill. If you're in the mood, bring a lunch and a bathing suit: the area is used by the locals for picnics, swimming and diving. Enjoy!

By far the most impressive features of the park are the Bannock Point Petroforms, located south of Nutimik Lake just off Highway 307. Petroforms are archaeological features created by the placement of stones to form recognizable shapes, often outlines of animal figures. The stones and boulders at this site are arranged on the exposed bedrock in the shapes of turtles, snakes, humans, bear and wolf prints and various geometric forms. While archaeological features like these are difficult to date, some are believed to be as much as 1,500 years old.

Other photographic areas of interest nearby are the Alf Hole Goose Sanctuary near Rennie and Whitemouth Falls near the town of Seven Sisters Falls.

—DB

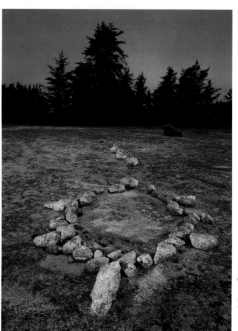

Turtle Petroform – While the complete significance of these prehistoric sites may never be known, they are believed to be places where spirits still teach anyone who is open to instruction. This location is still used today by the Anishinabe, so show your respect by not disturbing anything during your visit. There's a small Natural History Museum just up the road at Nutimik Lake where you can get more information or arrange a guided tour of the area. These petroforms were illuminated by a flashlight during a 15-minute exposure at dusk.

Pentax 645, 45mm lens at f/22, Fuji Velvia film.

©Daryl Benson

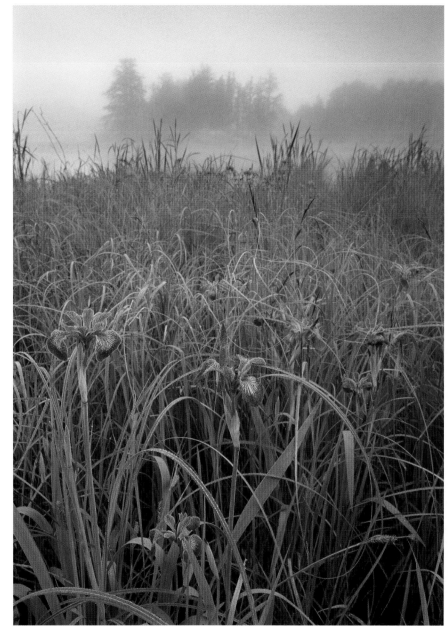

Blue Flag Irises, Beyak Lake – The Frances Lake canoe parking lot near Hanson's Creek and Beyak Lake (just west of The Lily Ponds on Highway 44) is a good spot to photograph Blue Flag Irises, which bloom in large numbers here around mid to late June.

Pentax 645, 45mm lens at f/22, Singh-Ray Colour Intensifying Polarizing filter and two-stop soft-edge graduated filter, Fuji Velvia film.

©*Daryl Benson*

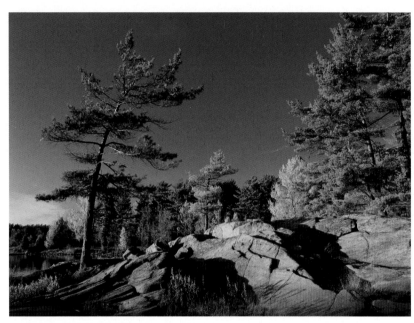

Sunset, Sturgeon Bay Provincial Park.

OPPOSITE: *Full Moon at Dusk,*
Manitoulin Island.

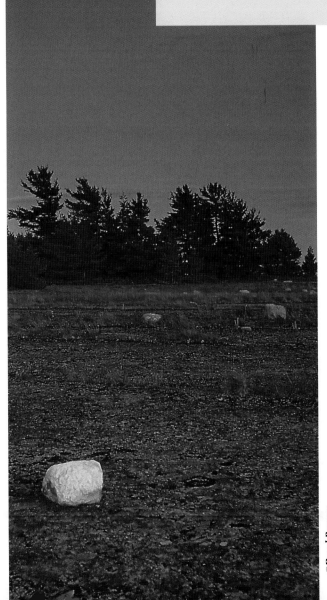

©*Daryl Benson*

ONTARIO

North Shore of Lake Superior

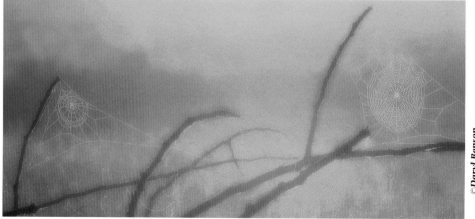

Lake Superior is the largest freshwater lake on the planet, and much of the 690 kilometre drive along its north shore, from Thunder Bay to Sault Ste. Marie, resembles a rugged ocean coastline. This stretch of Highway 17 passes one national park, several provincial parks and too many panoramic vistas to count. Here are some of the photographic highlights, from west to east.

The turnoff for Kakabeka Falls Provincial Park, where the Kaministiquia River plunges nearly 40 metres into a steep gorge, is 32 kilometres west of Thunder Bay on Highway 11/17. The falls, the "Niagara of the North," can easily be photographed from walkways and viewing platforms. When the dam is open (in spring, fall and on weekends) the falls throw up a lot of mist, so watch for rainbows and carry a towel to dry yourself and your gear.

The turnoff for Sleeping Giant Provincial Park is 42 kilometres east of Thunder Bay along Highway 11/17; take route 587 south. The most dramatic features are the 140-metre cliffs along the western edge. A rough road here leads to several beautiful overviews of Thunder Bay and Caribou Island (but it's not recommended for trailers or large campers); the location can be spectacular at sunset. Get a park map from the Visitor Centre at the Marie Louise Lake campground or at the Terry Fox Visitor Centre just east of Thunder Bay.

Ouimet Canyon Provincial Park (65 kilometres east of Thunder Bay) is a spectacular gorge 150 metres wide and 100 deep, with vertical rock walls. There's an easy loop trail from the parking lot to two strategically positioned viewing platforms. The canyon itself runs north and south and is not particularly well situated to catch morning or evening light, but the dramatic topography alone makes this a must-see spot. Be very careful if you wander off the marked trails; you're allowed only one fall from this height per lifetime!

Spider webs laden with morning dew – This photo was cropped from a backlit image shot just off Highway 11/17 near Dorion. I'm not aware of any regulation that says an image must always fit precisely within the confines of a camera's viewfinder. When you're preparing to frame or present an image feel free to crop, trim, montage, skew, flip or alter that image any way you want.

Pentax 645, 120mm lens, Cokin Sunsoft warm diffusion filter, overexposed one stop from the meter reading (see "Filters" section on page 136), Fuji Velvia film.

©*Daryl Benson*

Rainbow Falls Provincial Park (26 kilometres west of Terrace Bay) has a nice boardwalk and a footbridge trail along a photogenic cascading waterfall. The Falls Trail continues up the other side to two moderately scenic views of Lake Superior and the surrounding Rossport area (any "moderately scenic" location can be *spectacular* whenever nature decides to put on a show; the trick is to be there at showtime).

One of my favourite bits of land—one that typifies the rugged look of the north shore of Lake Superior—is Iconic Island, just a stone's throw from the side of Highway 17, 5 kilometres east of the Rossport turnoff (see page 57—the spot's easy to miss). Lakeshore Road is a few metres east of this spot; follow it for about a kilometre to find yet another small, accessible and photogenic island.

Aguasabon Gorge and Falls are just a kilometre west of Terrace Bay, too close and accessible to ignore. The falls can be best seen and photographed from the nature trails that skirt the gorge on either side of the observation platform. The entire area is best photographed in overcast, flat light.

Pukaskwa (pronounced "Puck-a-saw") National Park lies south of Highway 17, down secondary road 627. Stop first at the Interpretive Centre in Hattie Cove. The 1.6 kilometre Southern Headland Trail that starts here leads through small stands of mixed wood forest with numerous vantage points overlooking Canadian Shield bedrock. The trail descends to a rugged shoreline—great foregrounds for shooting at both sunrise and sunset—and ends at a sandy beach at Horseshoe Bay.

Pukaskwa covers 1,878 square kilometres, and if you're interested in exploring it more deeply ask about the 60-kilometre Coastal Hiking Trail. If you don't have the time or the inclination to explore the entire trail, catch a water taxi

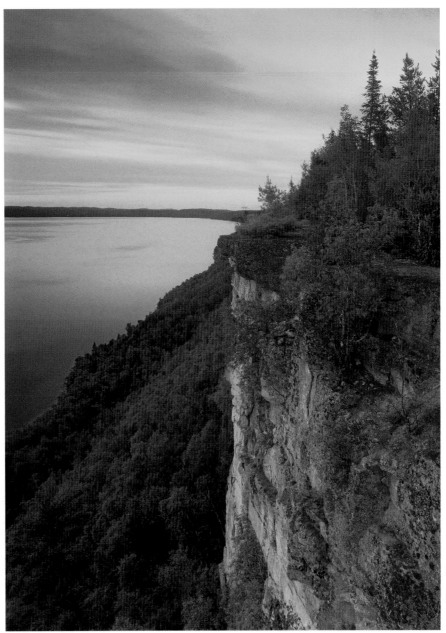

©*Daryl Benson*

Sleeping Giant Provincial Park – Sunset overlooking Thunder Bay from the cliffs on the western edge of the park.

Pentax 645, 45mm lens, Cokin blue/yellow colour polarizer, Singh-Ray three-stop continuous graduated filter, Fuji Velvia film.

in Heron Bay: you can be dropped off and picked up anywhere along the trail, weather and water permitting. Superior is like a sea: you can expect the wind and waves to be too rough for travel on the water at least one day in four.

Lake Superior Provincial Park covers 1,556 square kilometres, with a southern boundary along Highway 17, 124 kilometres north of Sault Ste. Marie. Its highlight is the Agawa Rock Indian Pictograph site at the southern end, accessible by an easy hike from the parking lot. The striking red-ochre pictographs are on a cliff face right at the water's edge, and you can hike around to see them all only when the lake is calm.

While the 690-kilometre stretch of Highway 17 provides many dramatic views of Lake Superior, my three favourites, from west to east, are: first, along the short stretch of road 26 kilometres east of Nipigon; second, a spot beside the highway just 3 kilometres west of the Neys Park turnoff (a view similar to that at Lookout Trail in Neys Provincial Park, but a bit higher and better); and third, a gorgeous view of Agawa Bay and Montreal Island from approximately 8 kilometres south of the southern boundary of Lake Superior Park.

—DB

Pic River Bridge, Hwy. 627, leading into Pukaskwa National Park – As with the image on page 54 this shot was cropped from its original format.

Pentax 645, 45mm lens, Cokin blue/yellow colour polarizer, Fuji Velvia film.

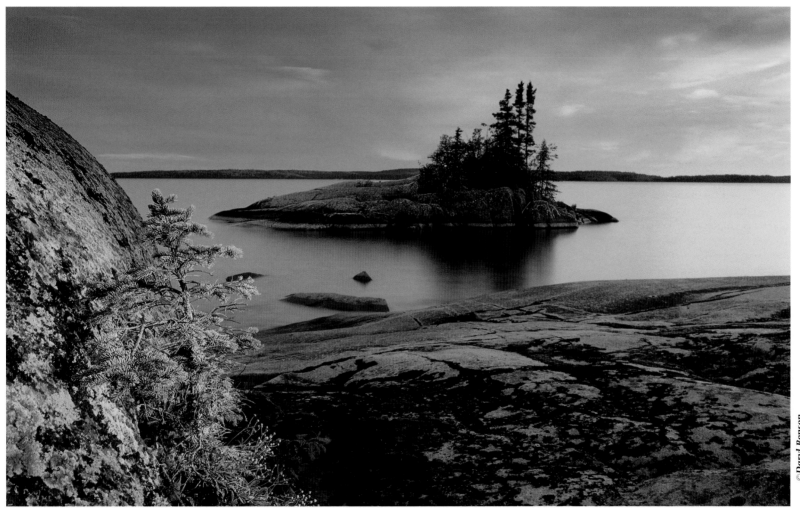

©Daryl Benson

Iconic Island, Near Rossport – This beautiful little island is conveniently located right beside the highway. A million-candle power flashlight was used to illuminate the small foreground tree during this 30-second evening exposure (see "Artificial Light" on page 130).

Pentax 645, 45mm lens, Cokin blue/yellow colour polarizer, Fuji Velvia film.

Killarney Provincial Park

My two favourite locations in Killarney Park are on short, moderate-difficulty hikes; the Granite Ridge Trail and the Chikanishing Trail (if you have a hard time pronouncing this, it's also known locally as the "chicken shitting trail").

The Granite Ridge Trail starts right across Highway 637 from the park office. Its a 2-kilometre loop trail with some steep sections. It's well-marked, with outlooks on exposed pink granite ridge-tops that provide excellent panoramic views of Killarney, with red and white pine in the foreground. There are good views available at sunrise, but this trail is best shot at sunset. It should be dynamite during the prime fall-colour season.

The Chikanishing Trail starts at the end of Chikanishing road, which is 2 kilometres west of the park office, and follows the Chikanishing river (I bet you've never seen the word Chikanishing so many times in one sentence before). It's a 3-kilometre loop that ends at a beautiful outlook onto Georgian Bay. This trail doesn't have the elevated vistas of the Granite Ridge Trail but it has more exposed pink granite and some very nice views that include the Chikanishing River.

At the far west end of Highway 637 is the town of Killarney. In the township, turn east off Highway 637 onto Ontario Street. You will find a narrow, rough gravel road on your right about 0.8 kilometres along the road; take it to its end (0.7 kilometres). You will now be at Georgian Bay, Red Rock Point and Killarney's East Lighthouse. The 7-kilometre Tarvat (or "Tar Vat") Hiking Trail starts here. My favourite part is right around the lighthouse and trail-head. Hike around this area and search out views of dramatic pines growing from the exposed granite and looking out over Georgian Bay, with lilypad-covered ponds in the foreground. Autumn is the best season to find morning fog over the water and to catch those classic white-pine-in-the-mist, Georgian Bay kinda images.

Get out of bed, you bum! Regardless of what latitude in Canada you live at or visit during the late spring, summer and early autumn months, pre-dawn light can begin at very early hours. While it might be difficult to escape the gravitational pull of a nice warm bed at 4:00 a.m., if you're serious about getting those beautiful fog-shrouded, dew-laden scenes on film, set the alarm and get out of bed! You can sleep-in in January.

—DB

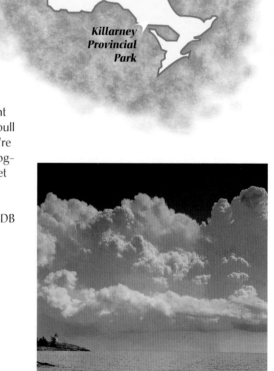

Passing Storm, Red Rock Point, East Lighthouse, Georgian Bay – This location offers many great landscapes that are representative of the Georgian Bay area.

Pentax 645, 45mm lens, circular polarizing filter, three-stop continuous graduated filter (to help balance the exposure between the sky and foreground), Fuji Velvia film.

©Daryl Benson

Ticks & Trips

Ticks are a common problem in many areas of Canada, especially in the spring (May and June). The best defence is clothing that doesn't let them get to your skin. Gaiters, pants tucked inside your socks, snug wristbands, waistbands and collars are a good start. DEET, the active ingredient in most insect repellents, isn't effective. Ticks don't like large areas of bare skin and are most commonly found along your hairline, the nape of your neck, underarms and groin area. You'll probably instinctively recognize a tick when you see one on your body, but briefly they are small (4 to 5 mm in length) with eight little legs on their watermelon-seed-shaped reddish brown bodies. You and your spouse or significant other can make an all-body tick-search part of your evening recreational activities.

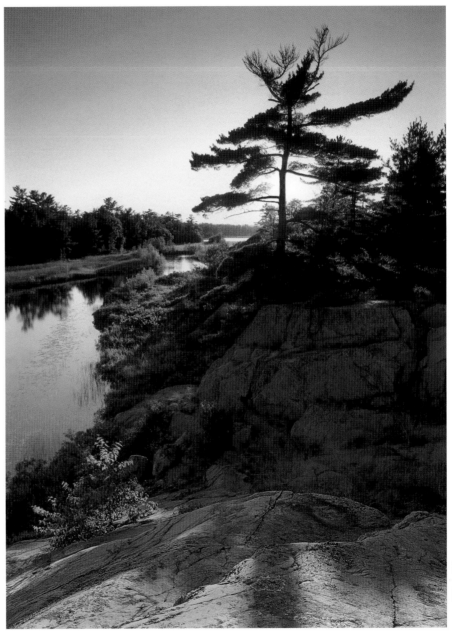

©*Daryl Benson*

Sunset, white pine, Chikanishing Trail – A circular polarizing filter, 81B warming filter and a three-stop continuous graduated filter were all used to help create this image (a bit of lens flare and reflection around the silhouetted tree trunk was removed digitally).

Pentax 645, 45mm lens, filters as mentioned, Fuji Velvia film.

Bruce Peninsula

The Visitor Centres for Bruce Peninsula National Park and Fathom Five National Marine Park are both in Little Tub Harbour in Tobermory. Stop there for maps.

You can get to one of the best landscape locations on the Peninsula from the Cyprus Lake campground in the Bruce Peninsula Park. There's a parking lot with five trail heads at the very end of the Cyprus Lake Road, east of Tobermory off Highway 6. Take the Georgian Bay Trail (an easy 30 minutes, well marked) until it hooks up with the Bruce Trail, then turn left to Halfway Rock Point. This little stretch of the Trail contains some of the most scenic overlooks and vistas of its entire 736 kilometre length.

There is a great cave and grotto formation just west of Halfway Rock Point, and cliffs to explore all along this section of the trail. Photography is best here in early morning light.

Another great sunrise location in the park is the bouldered Georgian Bay shoreline at Halfway Log Dump. Find Emmett Lake Road, 3 kilometres southeast of the Cyprus Lake Road. It's an easy 10-minute hike to Georgian Bay and Halfway Log Dump from the parking lot at the very end of this gravel road.

The two large rock formations on Flowerpot Island in Fathom Five National Marine Park have come to symbolize the Bruce Peninsula. Take a glass-bottomed tour boat from Little Tub Harbour to the island so you can see some of the 21 shipwrecks that lie below the surface in the cold, gin-clear waters. If you're serious about shooting the Flowerpot formations you should camp on the island to take advantage of the best light of early morning. There are 4.3 kilometres of hiking trails, lots of shoreline, caves high on cliff faces (on the north side of the island)—but no drinking water and only six campsites, so plan ahead.

There were once three Flowerpots, but one fell over in 1903. The other two have been reinforced against further erosion with concrete caps and a little masonry work at their bases, but the additions are subtle and shouldn't interfere with your photography.

Just to the north of Red Bay on the west side of the peninsula is Petrel Point Nature Preserve. A photogenic boardwalk system there carries you beautifully through a small fen (a boggy lowland partially covered in water), with numerous orchids and insectivorous plants (the pitcher plant and the sundew). If botany is one of your passions, the Bruce Peninsula should be a mecca (over 40 species of orchids and 20 of ferns). Check in with the National Park Visitor Centre in Tobermory for specific information and locations.

If you're approaching the Bruce Peninsula from the west and would like to shave about 500 kilometres off your trip, consider taking the 1-3/4 hour ferry crossing from South Baymouth on beautiful Manitoulin Island to Tobermory on the Bruce Peninsula.

–DB

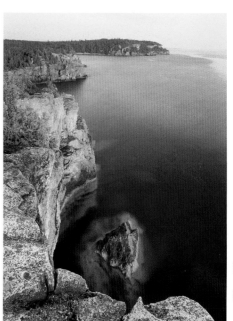

Sunrise, Halfway Rock Point, Georgian Bay – Shot just off the Bruce Trail in Bruce Peninsula National Park, looking west toward Fathom Five National Marine Park.

Pentax 645, 45mm lens at f/22, Cokin blue/yellow colour polarizing filter, two-stop Tiffen soft-edge graduated filter, Fuji Velvia film.

©*Daryl Benson*

Full fathom five thy father lies;
Of his bones are corals made;
Those are pearls that were his eyes:
Nothing of him that doth fade,
But doth suffer a sea-change
Into something rich and strange.

The Tempest, William Shakespeare

Sunrise, Georgian Bay, Halfway Log Dump.

Pentax 645, 45mm lens, Cokin blue/yellow colour polarizer and mauve two-stop graduated filters, Fuji Velvia film.

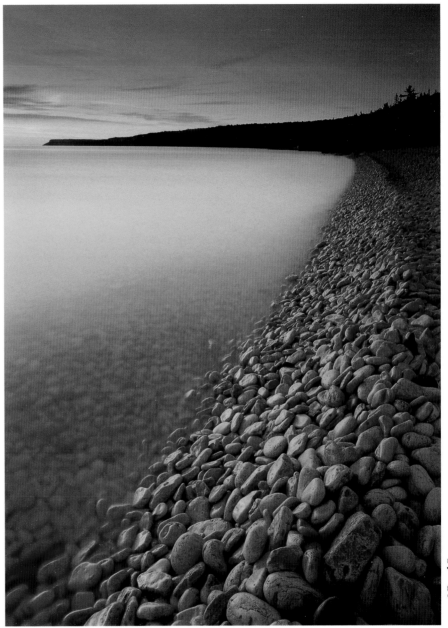

©*Daryl Benson*

Niagara Falls

This location is unlike any other we've discussed. In contrast with most of the quiet spots we describe elsewhere, Niagara Falls is visited by over 5 million tourists every year, and they concentrate their activities around one area—the falls! So know this going in: wherever you go and whatever you do, there will be lineups! Accept this fact and you will find your visit much more enjoyable.

My three favourite photographic things to do at Niagara Falls are the "Maid of the Mist" boat ride, the "Journey Behind the Falls" tour and the "Cave of the Winds" tour.

The Maid of the Mist excursion goes right into the basin of the Horseshoe Falls, and the lineup for it can be anywhere from 30 minutes to an hour. Expect to get wet (recyclable thin blue raincoats are provided). Try to be near the head of the line when they load the boat: the most desirable spots are on the top deck at the very front (offer to wait for the next excursion so you can be at the head of the line, to get one of these spots). You will have the best, clearest and wettest view from here. Gorgeous rainbows can be seen in the mist starting around mid afternoon (remember that the centre of a rainbow is always 180° from the sun's position). Try to use a wide-angle lens (28mm or wider) and bring along a good water-resistant camera bag and several towels to wipe off your equipment as you shoot. If you're concerned about getting your camera wet don't even get it out—it *will* get wet! Unfortunately those little waterproof disposable cameras don't have lenses wide enough to capture the entire rainbow, but they are an option.

The lineup for the Journey Behind the Falls can be up to two hours, but it's worth it. The tour is open year-round; check out the ice in winter! Again you will get wet; just how wet will depend on the wind that day. Bring towels and a water-resistant camera bag; recyclable yellow raincoats are provided. Rainbows are best seen and photographed in the mist in the mid-afternoon.

The Cave of the Winds tour on the American side (on Goat Island) is another wet adventure. Lineups here are likely to be the shortest—about half an hour—and they supply real raincoats (but you have to give them back). You must remove your own footwear and wear the dorky looking leather moccasins they provide, which are surprisingly comfortable. Since everyone's wearing them, it's okay: you all look dorky together. On this adventure you go down to the base of Bridal Veil Falls and walk along a railed boardwalk through the fall's considerable mist. The advice given for the other locations about keeping dry and catching rainbows (mid to late afternoon) applies here as well. Ironically, the American side of the falls is much less commercialized and far less crowded than the Canadian areas are. My favourite photo spots there are Prospect Point and anywhere at all on Goat Island!

—DB

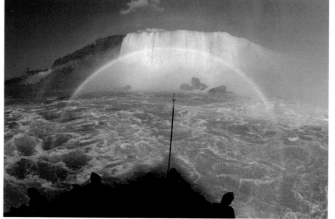

"Maid of the Mist" boat ride – Rainbows are best seen and photographed from the front of the upper deck, and are visible in the plentiful spray around the Horseshoe Falls from mid to late afternoon on sunny days.

Nikon F5 (because of its ability to resist a fair amount of water), Nikon 16mm (180° view) fish-eye lens, Fuji Velvia film.

©*Daryl Benson*

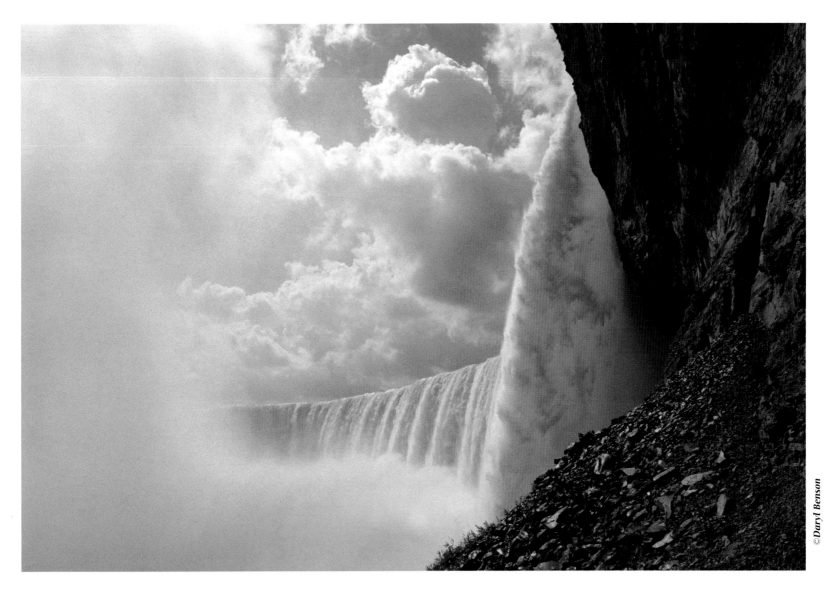

©*Daryl Benson*

Horseshoe Falls, Journey Behind the Falls Observation Platform – One of my favourite views of the falls is from this platform, and you can probably sneak off a few shots from the upper deck without getting wet. This whole location falls into shadow early in the afternoon, so if you want sunlight to bring out the bright yellow raincoats everyone wears, get there in the morning (the lineup will be shorter then, too).

Pentax 645, 45mm lens, Cokin blue/yellow colour polarizer, Fuji Velvia film.

Algonquin Provincial Park

Ontario

Algonquin Provincial Park

There are parks, and there are parks. And then there is Algonquin Provincial Park—all 7,700 square kilometres of it.

A result of the bump-and-grind of plate tectonics and the scrubbing and scouring of four glaciers over the last million years, Algonquin epitomizes the Canadian Shield. The most recent glacier retreated from its icy pilgrimage a mere 11,000 years ago, leaving behind more than 1000 lakes within the boundaries of the Park. It is little wonder the canoe was for so long the primary mode of transportation of both indigenous peoples and European settlers. Modern explorers can paddle their way on 1,600 kilometres of established canoe routes and hike along 170 kilometres of backpacking trails.

I encourage first-time Park visitors to spend several hours at the Visitor Information Centre to learn of both the human and the natural histories of the area. The dioramas are nothing short of art—you're sure to enjoy the black bear sow rolling a log in search of ants. The inquisitive expression of one of her twin cubs will bring a smile to even the most sullen visitor.

Most visitors concentrate their attention on the 56-kilometre length of the Highway 60 corridor. Points along it are referenced starting at the western gate, with all attractions, trails and by-roads identified by their eastward distance from there. The Visitor Information Centre is at kilometre 43, the Logging Museum at kilometre 54.6, and so on.

Autumn is the best time to visit: there are fewer people, no insects, spectacular autumn colours and active wildlife, including rutting moose. The last week of September is a good bet. If autumn foliage is your quarry you should do well anywhere west of the Lake of Two Rivers Campground at kilometre 32. Although there's a mixture of deciduous trees there, sugar maples dominate so during the peak colour period the hillsides are awash in hues of red. Be sure to explore the gravel road at kilometre 20 that meanders to Source Lake. Every turn and twist offers a photo opportunity, especially on overcast, damp days.

Far and away my favourite spot along the Highway 60 corridor is Costello Creek, which you can reach by taking the Opeongo Lake Road at kilometre 46.

Costello Creek – As the sweet early morning light gives way to the harsher reality of mid-day we need only aim our cameras to the sky. Adapt to the light you are presented with; use it to your benefit.

Nikon F90, 80–200mm f/2.8D lens, f/11 at 1/125 s, Fuji Velvia film.

©*Dale Wilson*

As you drive north most photo opportunities will be to the east, on your right, making the route perfect for sunrise shots. Immediately across the road from the Costello Lake picnic area is a small inlet where the haphazard disarray of fallen trees–perhaps the bounty of long-forgotten loggers–provides a beautiful low-angle foreground for wide-angle shots. Don't be surprised if a moose wanders out to browse on the mist-laden point of land directly opposite you.

Not much is to be found farther down the Opeongo Lake Road until its hard surface becomes loose gravel. Then Costello Creek becomes very obvious, with marsh grasses that turn to golden hues in autumn. There should be heavy frost hanging from the grasses and shrubbery before sunrise in autumn, and this situation provides a wonderful setting for experiments with equipment or technique. I favour an 80B (blue) filter and a half-stop of over-exposure to add a very subtle aura to these scenes. You shouldn't have any difficulty finding a blue heron, and be on the watch again for moose.

Although Algonquin Park is only a three-hour drive northeast of Toronto and about the same distance from Ottawa, it is a place where one can easily forget urban complications. It is little wonder that one of Canada's pre-eminent artists, Tom Thomson, found much of his inspiration here.

–DW

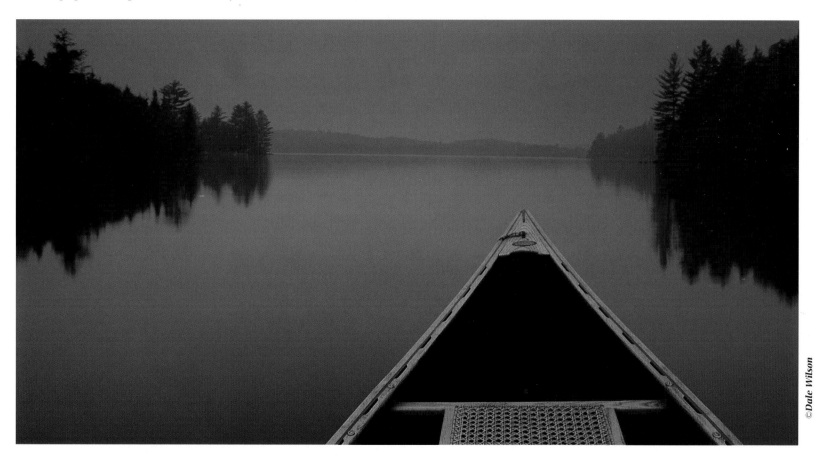

©Dale Wilson

Canoe Lake – An 80A filter and one stop of additional exposure will help convey a sense of serenity on a cool, damp day. *Nikon F90, 28mm lens, f/22 at 1/8 s, 80A (blue) filter, Fuji Velvia film.*

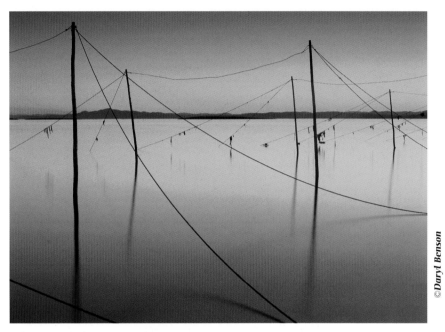

©*Daryl Benson*

Fishing weir at dusk, St. Lawrence River.

OPPOSITE: Baie Comeau.

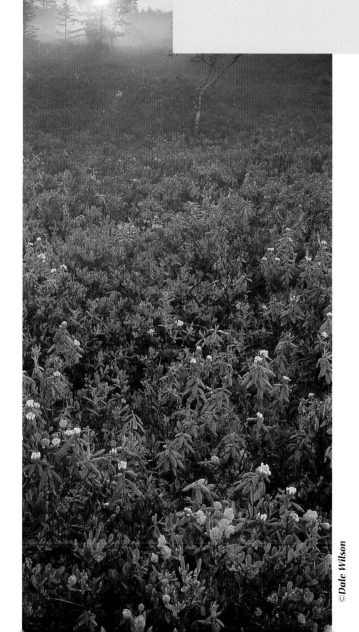

©*Dale Wilson*

QUEBEC

Eastern Townships

About 80 kilometres east of Montreal and 100 kilometres south of Quebec City, bordered on the south by Maine, New Hampshire and Vermont, the Eastern Townships offer a mosaic of intertwined architecture, landscape and culture that make this region of Quebec a great place to just chill-out.

Here English- and French-speaking residents thrive together, a fact especially evident in one of the funkiest little towns I have come across in a long time: Frelighsburg. Located on Highway 237, Frelighsburg has quaint antique shops, inviting eateries and warm country inns where one might expect Dick Lowdon (from Bob Newhart's TV sitcom) to welcome you—such is the presence of American Colonial architecture.

I have spent time here in both summer and autumn, and prefer the latter for the extraordinary colour in the surrounding countryside. Spring should also be lots of fun, particularly among the apple orchards along route 213 from Dunham to the U.S. border crossing at Richford, Vermont. Be aware, though, that most orchards have high wire fences to keep the plentiful whitetail deer at bay.

In this most western region of the Townships be sure to schedule a shoot at the Richford border crossing. From Frelighsburg drive south on route 237 for 12.5 kilometres to the guardhouse. Immediately to your left is a gravel road, la

Chute de la Frontière; drive up it for 400 metres to the crest of the hill. At a cement marker to your right you will find a clear view of the longest unprotected border in the world. You will be facing south, of course, so both dusk and dawn are good times of day.

–DW

Parc du Mont-Megantic; the view from Sanctuaire du Saint Joseph – The unimaginable heat and extreme humidity would normally give an image with an unpleasant blue hue. I decided to capitalize on this effect rather than try to eliminate it, and used an 80A filter, thereby making the scene really blue. As photographers we must learn to play with the hand we are dealt; nature is not always accommodating.

Nikon F90, 80–200mm f/2.8D lens with 1.6x converter, 80A (blue) filter, f/5.6 at 1/60 s, Fuji Velvia film.

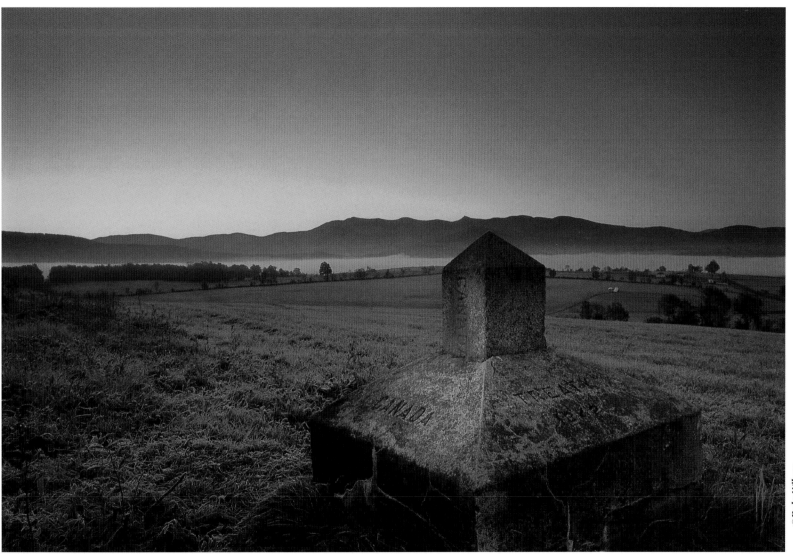

©*Dale Wilson*

Near Frelighsburg – A pre-dawn light reading of about 30 seconds at f/8 allowed me to light-paint this border marker near Richford, Vermont. A two-stop mauve graduated filter provided the colour balance I wanted in the sky.

Nikon F90, 28mm lens, f/11 at 30 s, Fuji Velvia film; the border marker light-painted with a one-million candlepower spotlight for two seconds.

Forillon National Park

I have a lot of "must see's" on my list, and I must confess that Forillon National Park was not among them. But the nearly extinct Harlequin Duck *is*—or was—on the list, and I had heard that nearly a hundred of these beautifully coloured birds frequent the shores of Forillon to mate and nest.

Once I arrived at Forillon via Highway 132, at the easternmost point of the Gaspé Peninsula, it was immediately apparent that this National Park offers more than the much-sought-after Harlequin. In fact, a proliferation of wildlife typical of boreal forests makes it an ideal destination for nature photographers. Black bear in particular are abundant and often seen.

Don't miss driving to Cap-Bon-Ami for a sunrise shot of Cap-Gaspé. This is the northeastern tip of the Appalachian Mountain Range that is much better known at its southern end around Great Smoky Mountain National Park in Tennessee and North Carolina. A small observatory near the parking lot offers a great view of the distant cliffs. The serrated rock ledges that you can get to from the beach beg to be included as the foreground element in your picture: catch them with a 28mm lens. This is a spot where your graduated filters will really earn their keep: about two stops of top-to-bottom balancing is needed to deal with the distant cliffs, which are lit up with beautiful morning light, and the foreground, still in shadow.

Keep your longest lens within easy reach while browsing around the rocks and beaches of Cap-Bon-Ami: it was here that I flushed several ducks that I believed to be Harlequins. While I was sitting on the rocks cursing myself for not being more attuned to my reasons for being there in the first place, the ducks flew back and landed in the water about 20 metres from my perch. Their number had grown to 11, including four incredibly coloured males.

In the south sector it is very easy to capture striking postcard-style images at Anse-Blanchette: scenes that grace many calendars. There's a farmhouse very near the shoreline under the cover of a large hill to the east, so you don't need to be at this location until about two hours after sunrise.

Just outside the park's north area gate is the village of Cap-des-Rosiers and a lighthouse that begs to be photographed. I've done best by parking in the small parking lot at the bottom of the knoll just below the light and walking along the beach and the rocky cliff area toward the light itself. Here you will be facing to the north and northeast, and morning will throw more sunlight on the cliffs, should that be the light you want. I have found that about one stop of graduated filter works well. As with all lighthouses, wait for the beacon to glow to add that little extra panache.

The prime difficulty with photography in the Forillon area is the hour of sunrise: around 4:00 a.m., if you're there near the summer solstice. This means you will have to set your alarm clock for slightly after 3:00 a.m.–Yawn!

–DW

Maison Blanchette – Shooting in a westerly direction from the shoulder of the road yields a scene to be found on countless calendars and postcards.

Nikon F90, 50mm lens, f/11 at 1/125 s, two-stop blue graduated filter, Fuji Velvia film.

©Dale Wilson

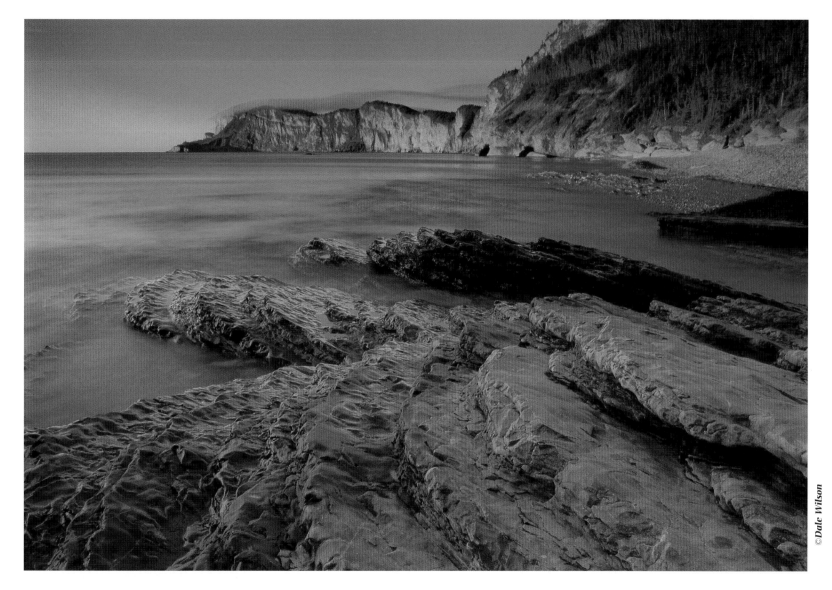

©Dale Wilson

Cap-Bon-Ami – Intricate and interesting rock formations along the shoreline provide perfect foreground elements for intimate panoramic seascapes. Photographers who can pull themselves out of bed at such an early hour will be rewarded with breathtaking sunrises.

Nikon F90, 28mm lens, Cokin blue/yellow colour polarizer, two-stop mauve graduated and Howard Ross Colour Enhancing filters, f/22, exposure unrecorded, Fuji Velvia film.

Percé
(Bonaventure Island)

Most tourists, if not all, make the trip on Highway 132 to the end of the Gaspé Peninsula to view the anomaly known as Percé Rock. Of course, photographers also want to get their shots of Percé, but a day of fun awaits the nature photographer just a short boat ride away at Parc de l'Île-Bonaventure-et-du-Rocher-Percé.

Check the tour-boat schedules on rue du Quai, your departure point. Be forewarned that the tour operators didn't consult photographers about the best times of day to make pictures: the earliest departure is about 8:00 a.m. and the latest possible pick-up on Bonaventure Island is about 5:00 p.m. The tour boat will take you on a 45-minute excursion around the island that is the summer home to 250,000 birds, including a colony of 70,000 northern gannets—your principal objective. I'll put it as delicately as I can: don't look up with your mouth agape, and it's not a bad idea to wear a chapeau (hat)!

Once on the island, the quickest route to the gannet colony is by way of Les Colony trail, which is 2.8 kilometres long and will take 45 minutes to hike. If the view from the boat impressed you, wait until you get so close you feel you could reach out and touch one of these beautifully sleek birds. But don't. The mature gannets are unbelievably tolerant because of the almost continuous human presence, and in all probability the birds are nesting.

As you leave the trail from the coniferous forest you will immediately see a picnic/rest area in front of you (personally, I enjoyed my lunch much more after I hiked back into the woods for about 500 metres, away from the unappetizing stench of bird dung). From this covered shelter take note of the walkway leading to your left, and an observation deck just beyond the few trees. I preferred this vantage as it allowed me to lower the camera upside-down to ground level while holding the tripod legs. I shot several rolls of film using a cable release and guessing at the composition, and got this one

image (opposite) which, I think, shows what Bonaventure is all about.

Because of the awkward boat schedules, you will essentially be making your pictures at the worst times of day. Select your film carefully: you want low-contrast. I had relatively good luck using Fujichrome Provia rated at ISO 64 and having the lab pull-process it (this lowers film contrast). The birds aren't going anywhere soon, so you might want to try such creative techniques as panning during exposure. Be prepared to shoot at least five rolls of film during this excursion, for one of the most exciting days of image-making possible.

Incidentally, one of the better locations to photograph Percé Rock is the Park's Interpretation Area on Bonaventure Island. My experience suggests that it is best to make these pictures as soon as you arrive on the island; later in the day an atmospheric haze (probably a light fog) starts to build as warm air meets colder sea water.

—DW

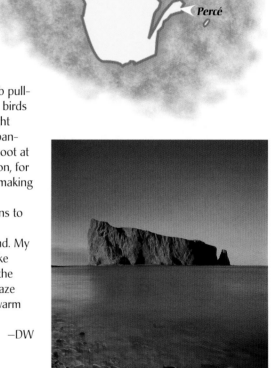

Rocher Percé de la Gaspésie – From the wharf you can walk along the pebble beach at low tide, taking photos as you saunter. Dusk is best and you'll have to use graduated filters to record detail in the deeply shadowed foreground.

Nikon F90, 28mm lens, Cokin blue/yellow colour polarizer, two-stop grey graduated and Howard Ross Colour Enhancing filters, f/22, exposure unrecorded (around one minute), Fuji Velvia film.

©Dale Wilson

©Dale Wilson

Parc de l'île Bonaventure – The old-boys' mantra of "it must be sharp throughout" is hogwash in some situations. Why would we want to freeze-frame a creature as sleek, beautiful and graceful as the northern gannet? To do so, in my humble opinion, would be to sterilize one of creation's most impressive aerial shows (on land, however, few birds are more awkward!) I purposefully exposed several rolls of film in shutter-priority mode with a speed of 1/30 of a second for this very reason.

Nikon F90, 28mm lens, Cokin blue/yellow colour polarizer, shutter priority at 1/30 s, aperture unrecorded, Fuji Provia film (EI 64).

Mingan

Every now and then a photographer will stumble upon a location purely by accident. The Mingan Archipelago National Park Reserve was one of those locations for me—well, sort of.

I first visited the Mingan for all the wrong reasons: literature suggested that the colourful Atlantic Puffin is the icon of the Park. For this reason I drove the 10 hours from Quebec City, and you can imagine my disappointment when I learned upon arriving that there are only several hundred puffins here. These are so skittish it's almost impossible to get close enough to them for successful pictures. I decided to resort to plan "B" and make photographs of the monoliths.

Nothing can prepare you for what awaits. Should you have several weeks or, better yet, months of summer vacation on the books and are looking for a suitable destination, hook up your trailer and make the trek to Havre-Saint-Pierre or Longue-Pointe-de-Mingan.

The 900 or so islands and islets that make up the Mingan Archipelago form a distinctive habitat that has produced a remarkable collection of 130 different plant communities with nearly 500 species of vascular plants, 150 of mosses and 190 of lichens. Some forty of these plants are considered rare. Contact the Park Superintendent (418-949-2126) for pertinent flora information and, because of the very fragile environment that supports this flora, what restrictions apply.

To photograph the monoliths you will need transportation from one of several private operators at the government wharf in Havre-Saint-Pierre. My suggestion is to secure passage to Île Quarry, where there are excellent opportunities to capture shots of the monoliths—both on the seacoast and in the forest—by way of day-trips. The adventuresome can make arrangements to camp at the southwest corner of La Grande Île at a spot known as Les Châteaux. Unfortunately I had to contend with inclement weather, but I can see how this one location could easily provide two days of shooting. Take triple the amount of film you would normally expect to expose.

If there is one location in eastern Canada that has most excited me visually, the Mingan Archipelago National Park Reserve is it. The best testimonial I can give is that I will be back, but next time I'll fly to Sept-Îles and be fully prepared to camp on the islands.

—DW

Les Châteaux de la Grande Île – Travel arrangements sometimes leave us scrambling for an image that does justice to the location. Use every trick and technique you can muster when inclement weather prevails. Including the sun in your photo to increase contrast will sometimes work when skies are grey and woeful.

Nikon F90, 80–200mm f/2.8D lens, Cokin blue/yellow colour polarizer, two-stop blue and two-stop mauve graduated filters, Exposure unrecorded, Fuji Velvia film.

© *Dale Wilson*

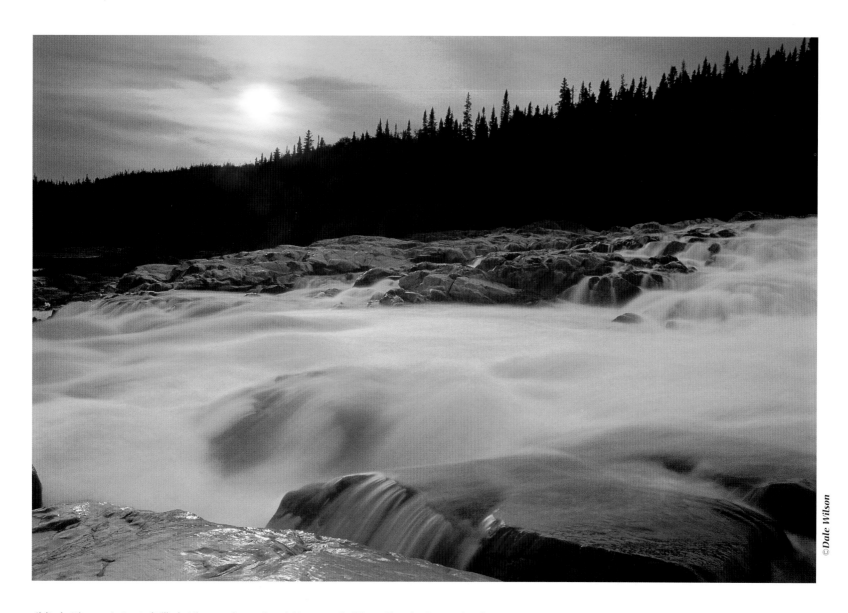

Chûte du Mingan – Just east of Ville du Mingan and past a large bridge across the Mingan River, there's a gravel road to the left (look for a small hand-painted sign saying "Chûte du Mingan") that leads you for about 5 kilometres to a picnic area and the waterfall. In late June you will be rewarded with Atlantic salmon leaping their way upstream. This is the private land of the local Montagnais Band of First Nation peoples; please treat the area with respect.

Nikon F90, 28mm lens, Cokin blue/yellow polarizer, two-stop and one-stop grey graduated filters, f/16 at 4 s, Fuji Velvia film.

Magdalen Islands

Situated right in the middle of the Gulf of St. Lawrence and scarcely 80 kilometres long, the Magdalen Islands—or les Îles-de-la-Madeleine—prove time and again to be one of eastern Canada's most difficult places to photograph. The challenge is not in finding suitable subject matter but in dredging up the self-discipline to haul yourself away from the serenity and seclusion of the seemingly endless beaches.

Reservations are strongly recommended for the five-hour ferry crossing from Souris, Prince Edward Island (call C.T.M.A. Traversier at 418-986-3278). Your first stop on arrival should be the tourist bureau at the end of the wharf where you disembark in Cap-aux-Meules. Get a road map titled—aptly—Îles-de-la-Madeleine.

Your immediate reaction to "the Maggies" will be that the geological make-up is much like that of Prince Edward Island. The observation is very accurate, to the extent that the Magdalen Islands have what P.E.I. so recently lost: an Elephant Rock. The whimsical formation stands guard just off Le Gros-Cap, south of Cap-aux-Meules. Getting there is easy: from the tourist bureau drive west on Highway 199 for 3.8 kilometres to Chemin de Gros-Cap; turn left, then drive another 1.8 kilometres and turn right onto Chemin Camping. About half a kilometre farther you'll see the gate-house for a derelict campground. Find a suitable parking spot along the road and follow the ill-repaired fence to your left. About a five minute walk will get you to the cliff-top overlooking the anse (cove) the elephant guards. This is not an easy place to catch good light, as you will be facing south and the elephant is enclosed in cliffs that cut off early morning and late evening light. I have found that about two hours before sunset is the best time.

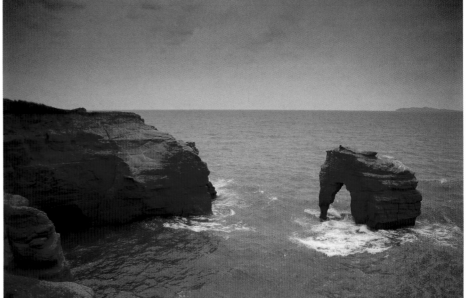

Le Gros-Cap – The Elephant—a rather large sandstone formation in the shape of a pachyderm—stands guard just off Le Gros-Cap. Be extremely careful as you walk along the cliff-tops as there are often overhangs that break away easily. A local rule of thumb is to stay about 5 metres from the edge of the cliff.

Nikon F90, 80–200mm f/2.8D lens, Cokin blue/yellow polarizer, one-stop blue and one-stop mauve graduated filters, exposure unrecorded, Fuji Velvia film.

©Dale Wilson

Some really great sandstone formations can be found at Pointe-Hérissée via Chemin du Phare, and the best location I've found for sunset is a little to the northeast along a small gravel road that follows Anse-des-Baleiniers, which is accessed from Chemin P.-Thorne. Both places are on Île-du-Cap-Aux-Meules.

There is a vibrant and exciting artistic community with intriguing rustic architecture in Havre-Aubert, on Île-du-Havre-Aubert. From the village, drive west on Highway 199 and exit left on Chemin du Sable, which eventually becomes a gravel road that leads you to Dune du Bout du Bane, as it is called locally (but be warned that it may be called "Dune Sandy Hook" on your map). This, in my humble opinion, is the best beach on the islands and a great place to sit back and write a letter to the publisher of this book explaining why you think Wilson should receive a raise in pay.

–DW

Two things happen on Île du Cap aux Meules about 30 minutes before sunset: first, residents and tourists alike all leave whatever they are doing, and second, they congregate at either the Cap du Phare lighthouse or the Municipal Park at Chemin de la Belle Anse to watch the gorgeous sunsets. There is a small stairway just to the south of the parking lot at Belle Anse that overlooks a small creek, seen here. You can have a lot of fun photographing details of the creek, broken shells and sandstone formations while waiting for those few romantic minutes as the sun tips over the horizon.

Nikon F90, 28mm lens, Cokin blue/yellow polarizer, exposure unrecorded, Fuji Velvia film.

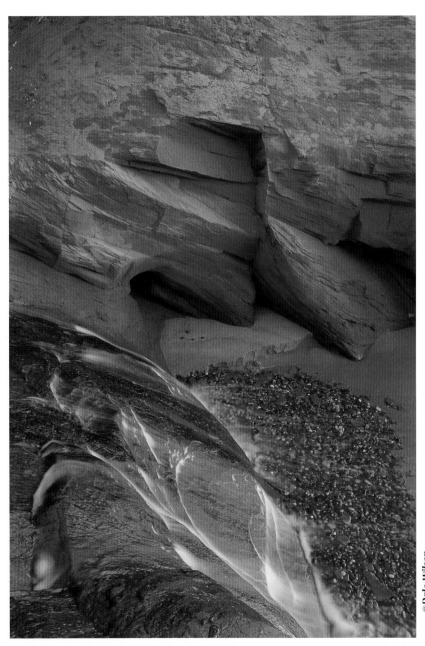

©*Dale Wilson*

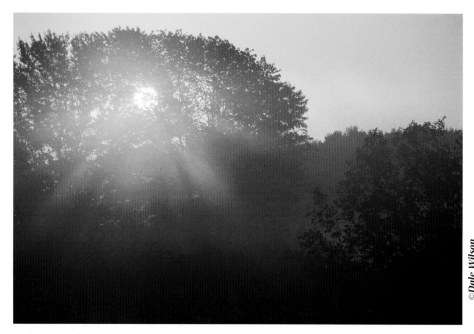

©*Dale Wilson*

Apohaqui, near Sussex.

OPPOSITE: *Bathurst Lake, Mount Carleton Provincial Park.*

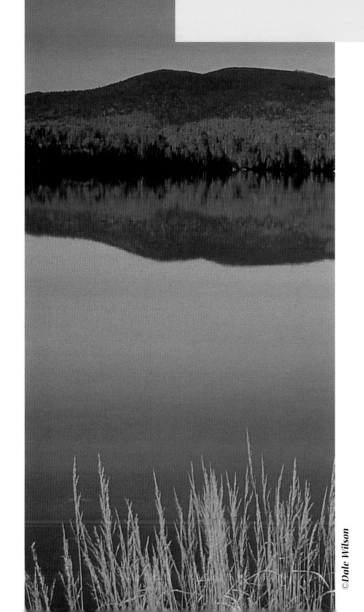

NEW BRUNSWICK

© Dale Wilson

Mount Carleton Provincial Park

Mount Carleton Provincial Park was the last place I visited before our book designer's deadline fell, and it's about the only location described in the book that I have visited only once. Shame on me! One short visit earns this Park my nomination as the second best photographers' park in Atlantic Canada, just behind Newfoundland's Gros Morne National Park.

The Park lies atop the Appalachian Mountain Range in the north-central region of New Brunswick, and it's accessed by way of either Highway 385, which originates in Plaster Rock; or Highway 180, which connects the townships of Bathurst and Saint-Quentin. Both these roads use a hardtop material known locally as chip-seal—not quite pavement, but next best. Inside the Park all roads are gravel, in quite good repair.

One location I found to be excellent in both sunrise and sunset situations is the boat launch on Nictau Lake. Since all roads in the park either come to a dead-end or lead you back to the lone entry gate, let's call the gatehouse kilometre zero and measure distances from it. To get to the boat launch, drive 1.3 kilometres from the gate house to a fork in the road where you turn left, heading to Armstrong Brook Campground. Then drive 1.4 kilometres to a small boat-launch sign directing you to the right; then another 200 metres down the single-lane pathway to another fork. Right leads you to the canoe/portage entry point; left to the boat launch and a small dock area. From here you can shoot till your heart's content, with Mount Sagamook providing beautiful reflections in the lake.

I also had fun at Caribou Brook, known locally as Caribou Pond—it was once a beaver pond. Follow the directions for the boat launch on Nictau Lake, bypassing the boat-launch exit, and continue 12.1 kilometres from the gate house, where the pond appears as a small marsh on your left. Walking a few hundred metres up the marsh will allow you to place reflections from rugged Mt. Jumeau in the brook. Caribou Pond is also one of the best locations in Mount Carleton to see moose,

and I was even lucky enough to spot a running black bear on the road nearby.

Although at 820 metres Mount Carleton itself is the highest point in the Atlantic Provinces, the panoramic vistas from Mount Sagamook are more spectacular, making it my recommendation for hiking. Atop Sagamook you will face north, with a clear view to both the east and west. Little Nictau and Nictau Lake to the west provide the best views, so you will have to decide whether morning or evening is the best time of day, depending on your interest in shooting—or in avoiding—back-lit scenes.

Allow at least four days to explore this park properly, and try to be completely self-sufficient. The campgrounds are extremely well kept, but they lack such services as electricity, so you won't be able to charge your NiCad batteries. On the positive side, the hooting owls, calling loons and barking coyotes don't have to compete with the noise pollution of radio, television and express-ways. What a way to fall asleep after a day exploring the best inland park in Atlantic Canada!

—DW

© Dale Wilson

Near Franquelin Campground – Driving along the south side of Nictau Lake early on a frosty morning provides ample opportunities to make pictures of backlit deciduous trees. In this example I experimented with an 80B (blue) filter to accentuate the chill in the air.

Nikon F90, 80–200mm f/2.8D lens, 80B (blue) filter, exposure unrecorded, Fuji Velvia film.

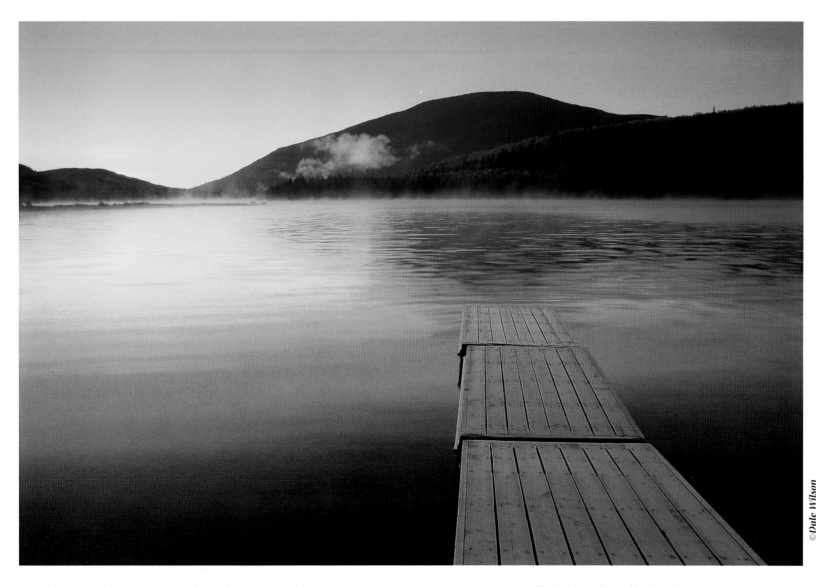

©*Dale Wilson*

Nictau Lake – You'll find several foreground elements in the area around the boat launch to include in your sunrise photos. Mount Sagamook provides a pleasing backdrop and you should get vapour coming off the water most mornings in September.

Nikon F90, 50mm lens, Cokin blue/yellow colour polarizer, two-stop and one-stop grey graduated filters, exposure unrecorded, Fuji Velvia film.

Grand Manan Island

On page 94 I recommend Nova Scotia's Brier Island as the best three-day holiday destination in that province, so it should come as no surprise when I suggest Grand Manan Island as the best five-day destination in New Brunswick. They are, after all, islands from the same archipelago that offer the photographer very similar opportunities, only Grand Manan Island is much (dare I say it?) *grandeur.*

Drive south from Saint John on the Trans-Canada Highway to St. George, and take the exit for Blacks Harbour and the car ferry to Grand Manan. Although ferry reservations are not required, at least phone ahead for sailing times: the trip takes about an hour and 45 minutes and you don't want to miss a crossing. There are many inns, motels, B&B's and cabins on the island, but make a reservation—Grand Manan is a popular destination for nature tourists.

The ferry lands at North Head, a great place to establish your base. Most amenities are available there, including whale-watching tours. The Swallowtail lighthouse at North Head provides great photo opportunities: you can drive to a small parking lot on a bluff overlooking the lighthouse or you can follow one of several foot paths down to the light itself and find compositions as unique and compelling as your creativity allows. Don't miss shots of the herring-fishery weirs along the shoreline. If you're really adventurous, talk to the local fishermen on the wharf to see if you can accompany them as they *dry-up* their weirs.

You will want to spend a day searching for the rare and endangered whales that frequent the Fundy waters surrounding Grand Manan. Only about 250 North Atlantic right whales remain in the world and most of them can be found in the Bay of Fundy. The endangered humpback is also often seen, as are minke and finback whales. Numerous operators offer charter-boat tours from North Head—just follow the signs along the wharf.

You should also make reservations with Peter Wilcox of "Sea Watch Tours" in Seal Cove to visit Machias Seal Island, one of the best places in the world to photograph the Atlantic puffin. You won't necessarily need long glass to catch these small birds, but a 300 to 400mm lens will be handy. It's also a good idea to wear a hat and to carry your tripod over you like an umbrella, to ward off dive-bombing terns.

Dark Harbour is a great place for pictures of dulse harvesting, and Seal Cove is renowned for its herring smoke houses. And there are hiking trails, waterfowl observation points and other opportunities galore. My best advice: this is an island—try to get lost on it!

—DW

Seal Cove – Most often photographers create their own luck by being prepared and working hard at their craft—this image is an exception. I had no idea the fish-plant worker would stroll onto the stage for a look-around. As quickly as he appeared, he disappeared. When working in fog try overexposing your image by one f-stop for a more natural appearance—just as you would do in snow.

Pentax 67, 300mm lens, exposure unrecorded, Fuji Velvia film.

©Dale Wilson

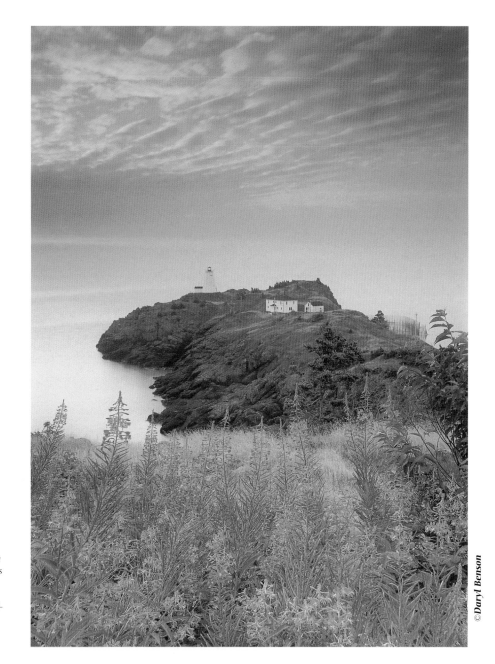

Dawn, Swallowtail Light and fireweed, North Head – A low, close approach on a strong foreground with a wide-angle lens helps exaggerate scale and depth.

Pentax 645, 45mm lens at f/22 (for maximum depth of field), Cokin blue/yellow colour polarizer, Cokin two-stop mauve graduated filter, Fuji Velvia film.

©*Daryl Benson*

Hopewell Cape

Harry Thurston writes in his highly acclaimed book *Tidal Life*, "The dramatic shoreline of the Bay of Fundy bears the fluid moulding of the tireless onslaught of the tides. Over time, the tides have created the perfect 'bathtub' for their own propagation and have sculpted the coastline into whimsical shapes such as the 'flowerpots' at Hopewell Rocks. In time, the tides will be their own undoing." Travelling at about 13 km/h (7 knots), the tides scrub the sandstone formations four times a day, taking about 6 hours and 15 minutes to flood and as long to ebb.

Hopewell Cape lies south of Moncton along Highway 114. The easiest way to avoid the downtown core of the Moncton/Dieppe area is by taking the circumferential Highway 15 and following the directions to Fundy National Park. After the Petitcodiac River bridge leading from Moncton to Riverview, Highway 15 becomes Highway 114, and away you go for a 30- to 45-minute drive to Hopewell Cape.

Sunrise is the best time to photograph this area, as you are essentially prevented from facing west. Most of the classic touristy postcard shots are taken from the bottom of a stairwell leading to the beach itself, but I prefer to avoid the trite: I let my imagination wander and look for shapes, outlines or perhaps even whimsical caricatures such as the "Face in the Wall," opposite. Because of the inherent challenges of shooting into the sun and my inability to use split-graduated filters because of the topography, I opted instead to combine two filters for this surreal blue look: a Cokin blue/yellow polarizer and a circular polarizer. This combination gives either a solid blue or yellow hue to your image, depending on how you rotate either of the two filters. Simply look through the viewfinder—WYSIWYG (What You See Is What You Get).

You must be mindful of the tide: check newspapers or other local sources to determine when low tide coincides with sunrise. And consider wearing rubber boots, as the sea bed is a type of mud that is a nightmare to clean from clothing and the carpet of your car.

A great side visit that can easily fill several days lies just down the road: Fundy National Park. There are numerous amenities outside the park at Alma, and accommodations and dining are seldom difficult in the park itself. There are trails of various lengths and attractions: consult the Visitor Information Centre to learn what is available to pique your interest.

—DW

Flowerpot Rocks – By walking along the beach and isolating details from the eroded cliffs you can create your own whimsical figurines. You never know, you might find a Brian Mulroney look-alike!

Mamiya 7, 43mm f/4.5 lens, Cokin blue/yellow colour polarizer and circular polarizer, exposure unrecorded, Fuji Velvia film.

©Dale Wilson

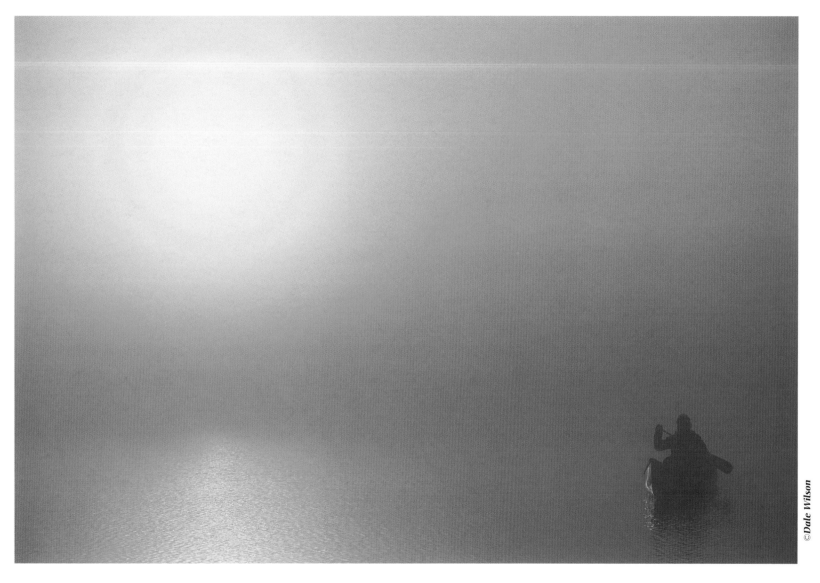

©Dale Wilson

Wolfe Lake, Fundy National Park – Not all photographs merely happen; some are arrived at through perception and work. Previous scouting revealed this location that would catch the sunrise so I could include the sun in the image. My friend, Len Clifford, received hurried instruction on canoeing and set forth. Previous conversations with "The Big Guy" provided the heavy vapour rising off the lake and we were able to shoot for about an hour before the aura waned.

Nikon F90, 80–200mm f/2.8D lens, Cokin blue/yellow polarizer, exposure unrecorded, Fuji Velvia film.

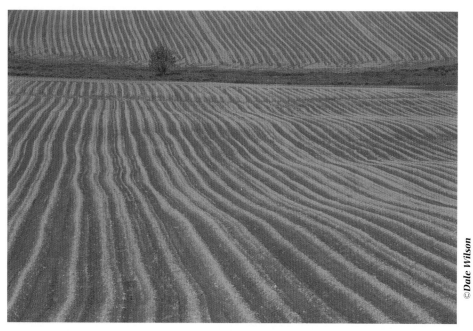

©*Dale Wilson*

Near Hunter River.

OPPOSITE: *Confederation Bridge,*
Borden-Carleton.

©Dale Wilson

PRINCE EDWARD ISLAND

Queens County

Known as the Land of Anne by some, Spud Island by others and Abegweit by First Nation peoples, the Island has been a favourite travel destination since it was first settled. In July and August this peaceful red isle is transformed by a sea of multicultured invaders pouring in, with a particularly effective stampede on the Cavendish area—a land made famous by the girl with red pigtails: Anne of Green Gables.

So my preferred time to make pictures here is any time but these two chaotic months, but I particularly enjoy June and September. During this shoulder season most amenities in the province are open and I don't have to fight for hotel or restaurant reservations. June tends to be better photographically simply because of the lush greens of the many agricultural areas. The best photographic locations on the Island are in Queens County, in particular in the area surrounding Cavendish and Prince Edward Island National Park.

The New Glasgow area is a great place for a base, as it is central and only a few minutes from Highway 2—the main route running the length of the island. The rolling hills and dales provide many panoramic vistas of sweeping farmlands; simply pick a high elevation and breathe in the stunning beauty. As an added bonus, the New Glasgow Lobster Suppers are always nearby: select any hill in New Glasgow and journey down to the River Clyde and a feast. In addition, New Glasgow is only a seven-minute drive from the hustle-n-bustle of Cavendish.

Photographically, there are several areas that stand above the rest. The beaches of Prince Edward Island National Park offer unlimited opportunities to shoot miles of clean sand and dunes. The eastern end of the park, around Tracadie Bay, features solitude, with large dunes. You must, however, respect the fragile nature of the dunes and heed the signs to protect the mirram grass—the lifeblood of the dunes. Without the roots of the grass to hold the sand in place this fragile topography

Long Creek, near Strathgartney Provincial Park – Agriculture looms everywhere on "The Island." A general three-year crop rotation of hay, potatoes and grain provides new opportunities from the same location each successive year: this year it was grain in this field.

Nikon F90, 80–200mm f/2.8D lens, Cokin blue/yellow colour polarizer, one-stop blue graduated and Singh-Ray Colour Intensifying filters, f/16 at 1/4 s, Fuji Velvia film.

©Dale Wilson

would simply blow away. You can make great shots anywhere along the countless miles with a wide-angle lens: by including an intricate sand pattern as a foreground element and using the dune peaks as a background there is no real need to scamper among the dunes at all.

I particularly enjoy shooting sunsets at a spot just a few minutes' drive from the National Park Cavendish Visitor Centre. Drive north through the east gatehouse and immediately turn right at the junction, following the sign to North Rustico. Another 700 metres brings you to a small unmarked pull-off and parking space to your left. Once you're on the beach road, slightly to your right there's a small outcropping with beautifully sculpted patterns along its edges. This is one of the best locations in the park for sunsets: use a graduated filter to hold back the sky portion of your image.

Not far from Cavendish is the scene that is synonymous with P.E.I.: the Springbrook farm. Drive west on route 6 from Cavendish, past Stanley Bridge toward the village of New London; then make a right turn onto route 20 and follow the signs to French River. The often-photographed farm is on your right, 16.4 kilometres from the Visitors Information Centre in Cavendish. Use a long lens to compress this vista. Although I have had my best luck here at mid-afternoon, that's not the best time of day for images of French River—another P.E.I. classic—just 2 kilometres past Springbrook.

As you top the hill just before French River you will recognize the scene: perhaps the most photographed hamlet on the island, best shot in midmorning light. The parkade at the crest of the hill on your right is somewhat distant from the village itself, so you'll need a 200mm lens, whose coverage seems to fit a vertical image particularly well.

Springbrook, New London Bay – This location is becoming an icon of sorts, and little wonder why. You can shoot right from the shoulder of the road; just use long lenses to compress the scene. I prefer mid-afternoon to early evening because of the orientation of the sun, which allows a polarizing filter to be used to its maximum colour-popping, contrast-raising intensity.

Nikon F90, 80–200mm f/2.8D lens, Cokin blue/yellow colour polarizer, two-stop blue graduated and Howard Ross Colour Enhancing filters, exposure unrecorded, Fuji Velvia film.

©Dale Wilson

©*Dale Wilson*

Long Creek, near Strathgartney Provincial Park – This image was taken from the same spot as that on page 88; I don't even recall moving the tripod. No filters were used–surprisingly–but does it matter? This is one of those rare and precious mornings where the light simply "works." Enjoy it when it does.

Nikon F90, 80–200mm f/2.8D lens, exposure unrecorded, Fuji Velvia film.

No photo excursion to P.E.I. would be complete without a picture of the Confederation Bridge. Assuming you are driving from New Brunswick to P.E.I., turn left at the first set of street lights as you come off the bridge. The road appears to lead nowhere, but drive 50 metres and take another left onto a gravel pathway that parallels the bridge. Another 1.4 kilometres will bring you to a dead end, and you will have to walk along the shoreline to get a good vantage point. Dusk is best, and just after sunset a good balance of ambient and artificial light from the structure itself will reward you with great material. Be careful: the bridge abutment rocks are huge and sharp edged; they're particularly dangerous after dark.

Not surprisingly there are many other locations around the island that deserve your attention. The island is small—you can easily drive from one end to the other in five hours—just follow your nose.

−DW

Cavendish area, Prince Edward Island National Park − It can be difficult to capture images without people in many tourist locations in Canada, and such is the case at Cavendish. The easiest way to deal with this problem—if it even is a problem—is to avoid such locations. It is probably one kilometre to the beach where thousands of sun-worshipers gather every day to bask and as many romantics congregate at night to marvel at the sunset. I prefer the seclusion and its rewards. Sunsets can become trite after a while; why not experiment to create something unique and different? I have found that tungsten film or an 80A filter gives a blue hue to the scene yet allows the reds of the setting sun to shine through. Try it, I think you'll like it.

Nikon F90, 28mm lens, f/22 at 15 seconds, two-stop blue graduated and 80A (blue) filters, Fuji Velvia film.

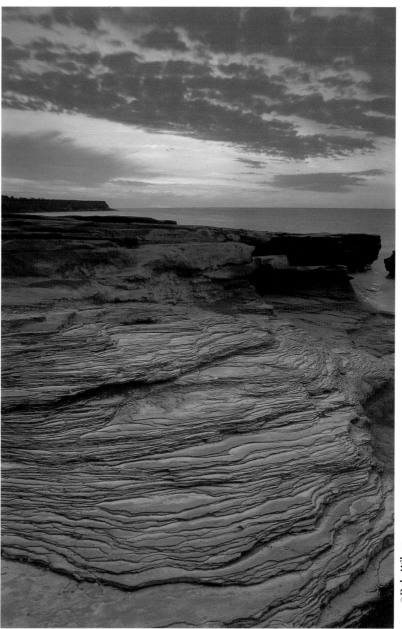

©*Dale Wilson*

Sumac, Lynne Mountain, Cobequid Range.

OPPOSITE: *Peggy's Cove.*

© *Dale Wilson*

NOVA SCOTIA

Brier Island

Long Island and Brier Island, along with several smaller uninhabited islands, lie right at the tip of Digby Neck, on the south coast of the Bay of Fundy. With a population of only 321, Westport, Brier Island's only village, cannot help but be relaxing, and I recommend it as the best three-day summer holiday destination in Nova Scotia. There is only one way to get there: drive west on Highway 217 from Digby for about an hour.

There are countless photo opportunities, including rare flora, numerous shore and seabird species (Brier Island is located on the Atlantic Flyway, and autumn is the best season for bird-watching) and spectacular seascape opportunities wherever you choose to set up your tripod. Brier Island juts into the lower Bay of Fundy, and the waters surrounding it are the summer home of the nearly extinct North Atlantic right whale. Endangered humpback whales are also regularly seen in these waters, as are finback and minke whales and the Atlantic white sided dolphin.

My preferred location on Brier Island is a stretch of basalt columnar formations along the east and south-east shorelines—perfect for beautiful sunrise photographs. Simply park your car at the lot at the end of the road and walk south toward a small monument that profiles the heroics of Joshua Slocum, the first sailor to circumnavigate the world solo. Really good hiking boots are essential as you will be scampering along a fairly rugged shoreline. Be careful of the slippery seaweed and of the tide: you will have great difficulty out-running the rising water if you're caught where you shouldn't be.

One of the quirkiest sights in all of Nova Scotia is the "Balancing Rock." Near the village of Tiverton on Long Island, this precariously perched piece of basalt stands nearly seven metres high and looks like a good wind would blow it over. Not so. It's easy to find; just look for a sign several kilometres west of Tiverton or ask any local resident.

I first discovered the Balancing Rock in 1991 when working on an editorial assignment and I immediately saw its photographic potential. Getting close to it was extremely awkward then, but I am pleased to note that a boardwalk now makes getting across the bogs much easier and a really convenient stairway with an observation deck has replaced the knotted hawser thrown over the cliff. It's about a 30-minute hike from Highway 217 and is most definitely a sunrise location, unless you want to light-paint the rock, as I did for the photo on the opposite page.

Takes lots of slide film with you and make reservations well in advance at Brier Island's only motel or at one of several B&B's.

—DW

Sunset, Western Light.

Pentax 645, 45mm lens, Cokin blue/yellow colour polarizer, Singh-Ray two-stop hard-edge graduated filter, Fuji Velvia film.

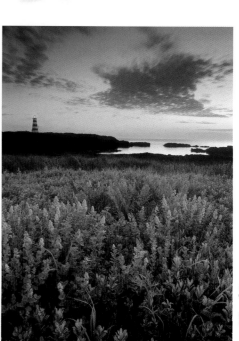

©*Daryl Benson*

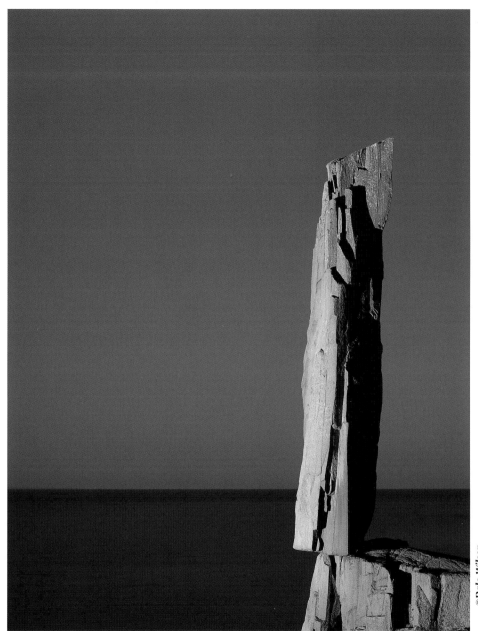

©Dale Wilson

Balancing Rock, Tiverton – Although many adjectives could be used to describe the culprits, fishermen in lobster boats once lassoed this anomaly of nature and tried to pull it over–or so goes local legend. Obviously they were unsuccessful. This is one big rock that is firmly planted and begs to be light-painted after sunset, otherwise it's a sunrise shot. To learn more about light painting, see page 131 in the "Techniques" chapter.

Pentax 67, 105mm lens, f/11, f/8, f/5.6 and f/4 at 20 minutes, Fuji Velvia film. The rock was light-painted for two minutes during the exposure. A hand-held incident light-meter suggested a correct exposure starting at f/11, but as it got progressively darker the "correct" exposure time got longer. It's best to establish a base time–say 20 minutes in this case–and adjust the lens aperture as the light fades, while leaving the shutter open.

Peggy's Cove

No spot in Canada's Ocean Playground is more quintessentially Nova Scotian than Peggy's Cove. It's all there: a lighthouse, pounding surf on large granite outcroppings and a tranquil fishing community. And it's only 50 kilometres from Halifax, the largest city in Atlantic Canada.

The only reasonable route to Peggy's Cove is Highway 333, which joins Highway 103 at Upper Tantallon to the west and reaches the Halifax area of Armdale to the east. If Halifax is your base, try to cover the entire loop of Highway 333, as there are several other scenic maritime villages in the area, including West Dover just to the east of Peggy's Cove and Indian Harbour immediately to the west. You'll have no difficulty finding Peggy's Cove itself: it's one of the top tourist destinations in all of Canada, so road signs are abundant.

Photographers who want images of the lighthouse without people around it will have their patience taxed to the limit. The task is almost impossible in the peak tourist season of July and August, and extremely difficult at any other time except the dead of winter. April's the time I recommend; the snow has usually melted but it is still cold enough to discourage most visitors.

The best approach to the village and the lighthouse is to arrive in mid-afternoon and play tourist, taking pictures around the harbour. Be sure to set aside enough time late in the day to find the perfect location to get the classic lighthouse-against-sunset photograph. If you stake out a vantage point on the south side of the lighthouse there is a better chance you'll be able to eliminate people from the image, as I managed to do in the photo on the opposite page. From this low elevation the camera's line of sight will be just over the heads of the tourists who sit on the rocks to enjoy the sunset. The other classic view is from the water's edge just to the north of the little cove in front of the lighthouse itself, immediately below the restaurant. But from there you can be almost guaranteed there'll be people in your picture.

You must exercise extreme caution when walking on the rocks at Peggy's Cove: rogue waves are common and have called numerous visitors to the depths to dwell with King Neptune. Please be careful, the Atlantic Ocean is huge and deserves your utmost respect.

–DW

Peggy's Cove – This is the scene that greets you as you drive into the village. A classic shot that you'll have to take a number for in summer–it's not that bad, but just about.

Nikon F90, 80–200mm f/2.8D lens, f/22 at 1/2s, Cokin blue/yellow colour polarizer and one-stop grey graduated filter, Fuji Velvia film.

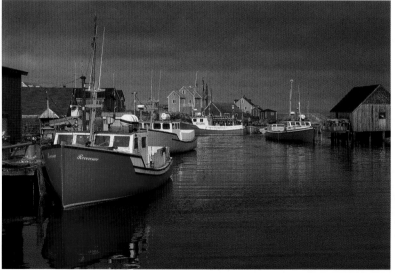

©Dale Wilson

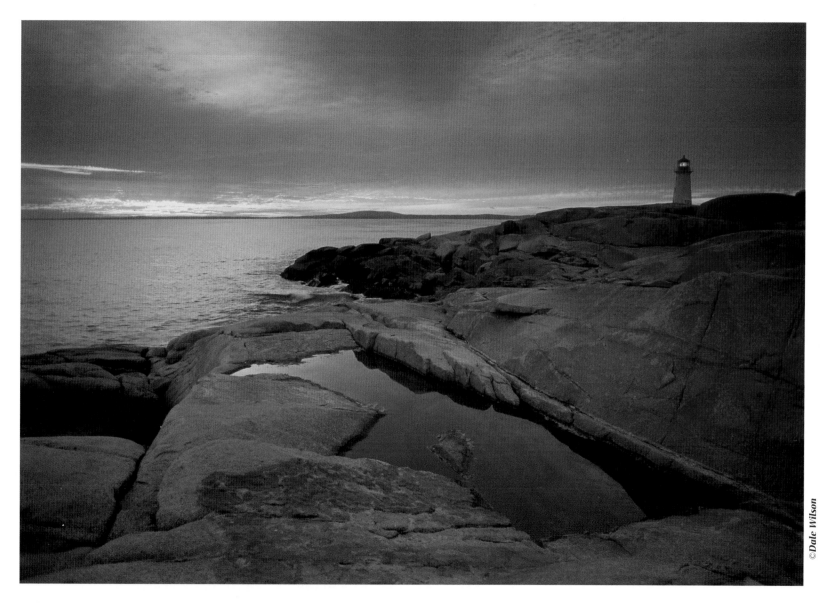

Dusk, Peggy's Cove Light – Scamper around the rocks and look for a unique angle or view. Odds are it has already been done, since this is arguably the most photographed lighthouse in the world, but it's fun to try.

Nikon F90, 28mm lens, f/22 at 15 s, Cokin blue/yellow colour polarizer and two-stop grey graduated filter, Fuji Velvia film.

Cape Breton Highlands

The autumn foliage of Cape Breton Highlands National Park offers a more exciting colour palette than anywhere else in Canada, and quite possibly in North America.

The best time to visit is immediately after Thanksgiving weekend in October. The holiday weekend itself can be nightmarish, with hordes of people and endless lines of tour buses. Restaurants are filled to capacity and accommodations are hard to find unless you have made reservations well in advance. On the Monday following the holiday weekend, however, you will pretty much have the entire Highlands region and the National Park to yourself.

The park is enclosed by the northern section of the famed Cabot Trail, a loop of highway that starts and ends officially at Baddeck, but that can be joined at several points, depending on where you're coming from and which way around the island you want to travel. I prefer to enter at the park's west end, near the Acadian village of Cheticamp, and tour the park's section of the Cabot Trail clockwise.

One cannot leave Cape Breton without the classic Cabot Trail photo, and the opportunity comes early in the trip. Park your car at the Cap Rouge pull-off and look southwest toward the village of Cheticamp—you will instantly recognize the view. This is an afternoon shot, unless you are looking for a photographic challenge. A sunset photo from this location can be breathtaking, but it's difficult to pull off. The sun will be setting slightly to your right, and you'll need to use about

three stops of graduated filter to hold back what would otherwise be a greatly overexposed sky. And you'll have to place the filters at just the right angle so they don't mask the distant landscape. I have found that the transition in exposure is not as evident in the final photo if I use several graduated filters with their edges feathered—

©Dale Wilson

North Mountain – Mountain ash growing in a roadside ditch is just one example of the abundance of colour in this national park. The colour polarizer was oriented to add just a hint of blue to the tops of the damp leaves.

Nikon F90, 80–200mm f/2.8D lens, f/22 at 2 s, Cokin blue/yellow colour polarizer, Fuji Velvia film.

overlapped slightly rather than lined up exactly. Use your depth-of-field preview control to position the filters precisely, and you'll be well on the way to making a beautiful, natural-appearing photo.

Two particular locations in the park call me back each year: Mary Ann Falls and Beulach Ban Falls. Beulach Ban Falls is at the eastern base of North Mountain, near the most northerly point on the Trail. It is reached by way of a gravel lane that passes the warden's cabin, on the opposite side of the road from the Big Intervale campground. About 2 kilometres on this road will get you to a small picnic park, and to the falls themselves. You will hear the falls before you see them; they're only about 100 metres from the parking lot. Beulach Ban Falls is an ideal location to place crimson leaves selectively along the banks of the flowing stream, and then make your shot looking upstream, with the falls as a background—or maybe not; it's up to you. The falls are high enough—my guess is about 30 metres—that you'll have no difficulty finding details to concentrate on, as I did in the photo on page 101.

On the Park's east coast, drive about five kilometres west from Ingonish until you come upon a gravel road to your left that leads to the Marrach Group campground. Continue along it for about 7 kilometres until you find a parking lot alongside a small wooden bridge. Mary Ann Falls are then to your immediate right. Effective photographs can be taken from a number of vantage points, but the weather will often limit your choice. Overcast days are common here in autumn, and you'll want to eliminate the resulting drab skies from your pictures. Try shooting from the trail that leads to the base of the falls—a 50mm lens will give you just about the ideal field of view. Note the little pool at the base of the falls where fallen leaves are trapped, travelling in inescapable circles. A low camera angle will give your shot an intriguing foreground, especially if you keep the shutter open for several seconds.

Near Beulach Ban Falls – As bizarre as it might seem, I prefer light rain when working in the Highlands. Yes, I placed the leaves—but the person who photographed this scene after me didn't!

Nikon F90, 28mm lens, f/22 at 1/4 s, Cokin blue/yellow polarizer, Fuji Velvia film.

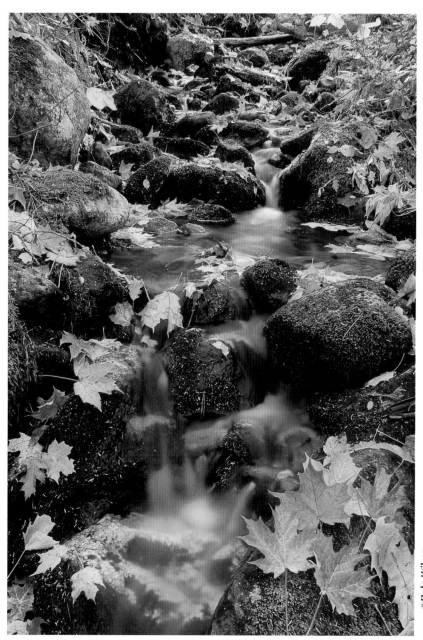

©*Dale Wilson*

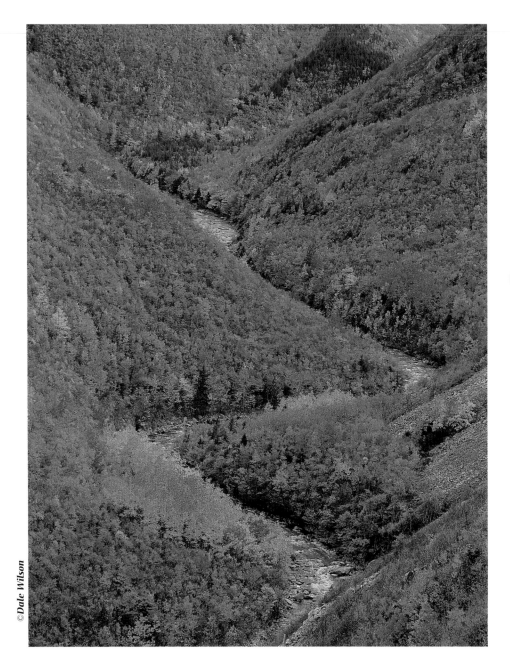

©*Dale Wilson*

There are many other locations in Cape Breton Highlands National Park that deserve your attention: there's a fantastic panoramic image looking up the MacKenzie River from atop MacKenzie Mountain, and the MacIntosh Brook Trail offers some of the best forest-floor shooting in all of Nova Scotia, as does the Lone Shieling Trail. As an alternative to fall-colour photography the Park offers excellent seascape opportunities at Presqu'Ile, Black Brook Cove (see the photo on page 5) and Green Point. Don't neglect locations outside the park, especially the Margaree Valley area and the Uisge Ban Falls Trail near Baddeck (take Exit 9 from Highway 105 and follow the signs).

The Highlands of Cape Breton in autumn is a world-class destination. Plan to spend at least four days there to appreciate its splendour.

–DW

Travel Tip

To save accurate caption data for each frame of film you expose, take verbal notes as you shoot with a mini-cassette tape recorder. The first roll of film on a trip is Roll No. 1; mark it on the film canister (and ask your lab to transcribe it to the processed film) and record the necessary information on tape, counting each frame out loud. Continue with Roll No. 2, and so on. When you get home you can caption your slides accurately and confidently, no matter how many rolls you exposed.

MacKenzie River – Surprisingly, Cape Breton Highlands National Park doesn't provide many opportunities to make successful big-vista pictures. Cap Rouge is one and MacKenzie Mountain Lookoff, as seen here, is another.

Pentax 67, 300mm lens, f/16 at 1/8 s, Fuji Velvia film.

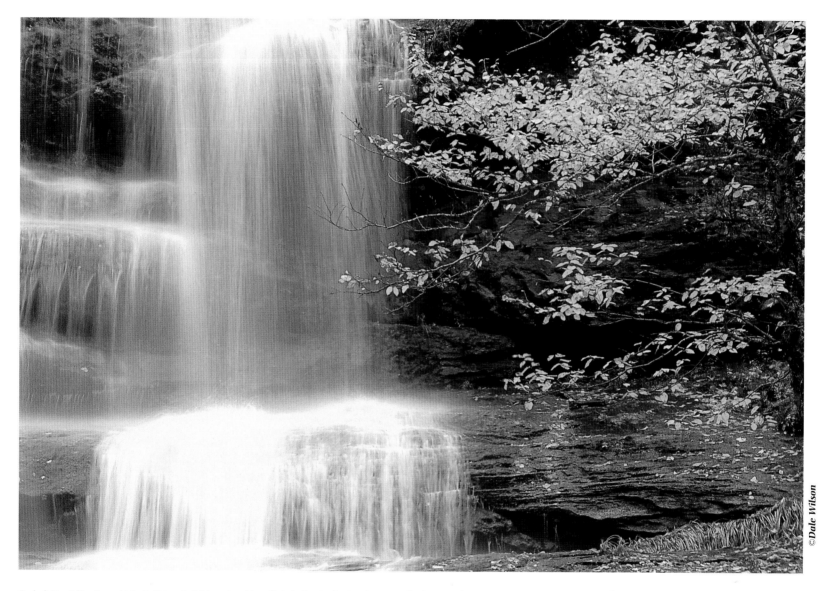

©Dale Wilson

Beulach Ban Falls - Several trips to this waterfall have taught me that starting to shoot at the stream flowing away from the base of the falls and progressively working my way toward the cascading water yields the best results. Perhaps it's because only when I rid myself of the inclination to "show it all" can I concentrate on the more interesting details.

Nikon F90, 80–200mm f/2.8D lens, f/16 at 1 s, Cokin blue/yellow colour polarizer, Fuji Velvia film.

©Dale Wilson

Big Falls, Sir Richard Squires Provincial Park.

OPPOSITE: **Burnt Islands, South Coast.**

NEWFOUNDLAND AND LABRADOR

Icebergs

No where on planet Earth are icebergs more accessible than along the northern shores of Newfoundland and Labrador. This region of the North Atlantic is not called "Iceberg Alley" without reason; just ask any mariner.

An iceberg starts its journey approximately 4000 kilometres to the northeast when it is calved from the Jakobshavn Glacier in western Greenland. Following the West Greenland Current, the berg is eventually deposited in the waters of the Labrador Sea, where it migrates southward toward the northern coast of Newfoundland. Some icebergs traverse the eastern coast of the province and may eventually make contact with the Gulf Stream, a component of the North Atlantic gyre, which will move the much-melted berg toward Ireland.

But we are interested in the icebergs off Newfoundland, and the sheer euphoria of seeing and photographing them. I have had my greatest success by driving to a few randomly selected spots at the tip of the Northern Peninsula, in particular the region around St. Anthony. Mid-May through June is a great time of the year, but it is too early then for tour-boat operators, so you must resort to charm and personality: a hundred dollars should get you a couple of hours out in a speedboat (an inshore fishing boat, in Newfoundland). If you are prone to seasickness, concede defeat, as I'll guarantee you will be hanging over the gunwale while riding the waves trying to look through a viewfinder!

A peculiarity of iceberg photography is the advantage there is in shooting them at high noon, preferably from the shadow side. Mid-day casts very effective rim light along the top of the massive bergs and throws long shadows down the sides, creating interesting textural detail. Think of that detail as you drive along the coastline scouting for bergs: pick those

Witless Bay – By phoning ahead to a tour operator in Bay Bulls, near St. John's, I learned this 100-metre-high iceberg was just outside the harbour. The image was made from a regularly scheduled charter tour boat.

Pentax 67, 105mm lens, f/5.6 at 1/250 s, Fuji Velvia film.

with rough, serrated edges and avoid those with flat, glassy sides.

The use of polarizing filters is a personal choice, but there really isn't any need. What the polarizer will do, however, is increase contrast significantly should you aim your camera upward. Be careful: the sky will transform to a cobalt blue or black (unless that's what you're looking for, of course!).

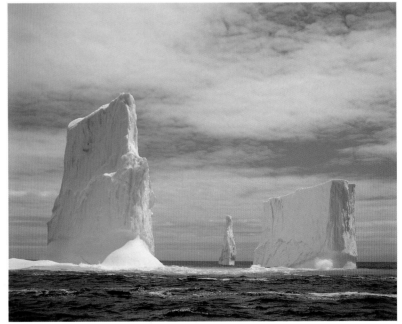

©Dale Wilson

Unfortunately Newfoundland does not have an iceberg watch for the benefit of tourists. Rather than taking your chances with such an expensive outing, consult Environment Canada before setting out. Twillingate, north of Gander, and the area surrounding St. John's are also easily accessible and should be considered. Some years are better than others and the undertaking can be costly, so you will want to take all the measures you can to maximize your chance of success.

–DW

Travel Tip

Life is full of mysteries. Many people enjoy camping while on photo excursions, but some—like me—spend more time cleaning cooking utensils than exposing film. A bit of my father-in-law's Newfoundland wisdom: sprinkle a little table salt in the frying pan before adding oil or butter, and heat it until it rolls easily on the bottom of the pan. Then cook as you normally would without fear of having to use dynamite to clean up. It works! Go figure?

Griquet, near St. Anthony – One of the challenges when hiring someone to provide a service in an unfamiliar area is how to compensate fairly. I consider "gas money" to be $50 per hour, and this seems to be fair in these northern coastal communities. A framed print at Christmas will keep you remembered and help to cement a relationship you'll enjoy again should you ever decide to return, which I'm sure you will.

Nikon F90, 28mm lens, f/8 at 1/125 s, Fuji Velvia film.

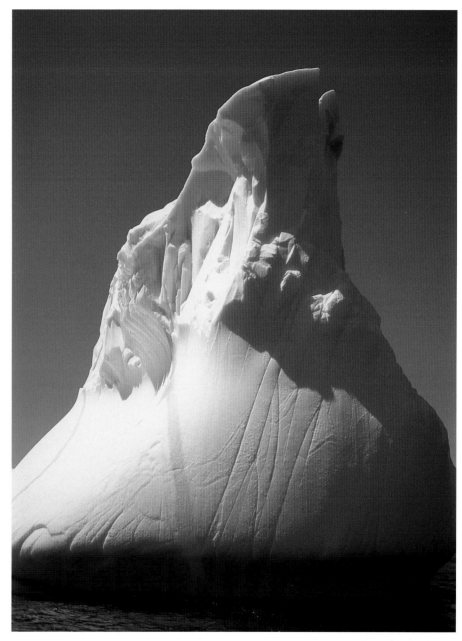

©*Dale Wilson*

Gros Morne

Gros Morne National Park is to Atlantic Canada what Banff is to Alberta: a treasure trove of photographic opportunities. One major difference between the two National Parks, however, is that Gros Morne receives only about 120,000 visitors per year, while Banff gets four million.

Designated a UNESCO World Heritage Site, Gros Morne is best photographed by concentrating on a given topic, be it wildlife, flora, seascapes or landscapes. Each geographical region in the park offers its own rewards and anyone planning to explore and photograph Eastern Canada's premium photo destination should schedule a minimum of four days.

While each month offers its own special attractions and challenges, I prefer to photograph Gros Morne in September when the air is usually *clean* and there are few tourists. Late in September the animals—moose in particular—become more active as they enter the rutting season. July is prone to a lot of atmospheric haze and August is the warmest month, averaging about 14°C.

Even during the summer months, snow can be found at higher elevations and the evenings can be quite cool. In addition to foul-weather gear, warm clothing and wind breakers are a must for personal comfort. If you can accept strange looks from the unknowing, finger-less gloves are invaluable during the early mornings of late August when metal tripod legs can be quite cold on unprotected hands.

Access is gained by driving along route 430 (the Viking Trail) from Deer Lake to the park's epicentre at Rocky Harbour, about 71 kilometres. Or turn off route 430 onto route 431 at Wiltondale to get to the south side of the park, where you'll drive past the Tablelands mountains and eventually arrive at the fishing hamlet of Trout River.

Often overlooked, the Tablelands mountain range is one of the most unusual geological formations in the world. The yellowish-brown rock known as peridotite was thrown heavenward by the continental bump-and-grind of plate tectonics. Exposed from the earth's mantle, this rock is devoid of plant-supporting nutrients, and consequently the Tablelands Range hosts only a few varieties of flora, with most to be found along Winterhouse Brook.

Photographically, the area is a challenge that demands the photographer's full attention to make creative images. One of the best ways to photograph the Tablelands is to leave the parking lot at the trail head and follow the marked trail until you reach the brook that flows from the bowl on your right, a leisurely 20-minute hike from the parking lot. The stream will probably find its way into most of your pictures as it is the dominant feature, save for a few wildflowers that grow sparsely along the stream banks. Any time of day is good as you will most likely be facing south for most of your picture making, but if you must make a choice, opt for evening.

One of the most exciting areas to photograph seascapes is the north side of Bonne Bay, just a few kilometres past Lobster Cove Head lighthouse. Green Point, on the Gulf of St. Lawrence,

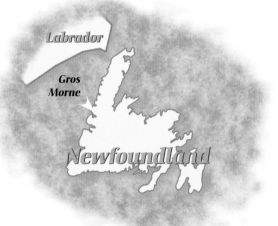

The Tablelands – A panoramic view of Bonne Bay, the Long Range Mountains and Gros Morne Mountain follow a three-hour hike along Winterhouse Brook in the Tablelands range.

Pentax 67, 105mm lens, Cokin blue/yellow colour polarizer and one-stop mauve graduated filter, exposure unrecorded, Fuji Velvia film.

©Dale Wilson

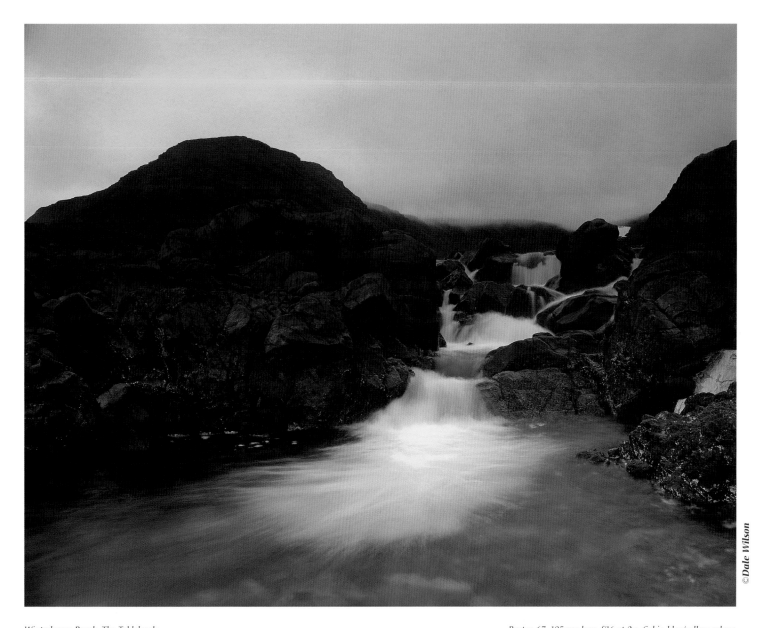

©Dale Wilson

Winterhouse Brook, The Tablelands.

Pentax 67, 105mm lens, f/16 at 2 s, Cokin blue/yellow colour polarizer and two-stop mauve graduated filter, Fuji Velvia film.

provides an ideal vantage point as the large rocks turn a lovely orange colour in the sweet light of sunrise and sunset, and you can photograph both here. The best location is on your left about 500 metres beyond the Green Point Campground. You will know the spot when you find fishermen's seasonal cabins along the shoreline. As this is a working area for the fisherfolk, it is courteous to park at the top of the bank and walk over the hill to the shoreline. There are no tips as to how best to photograph this location, simply walk among the shoreline boulders and keep changing lenses, from wide-angle to telephoto. You are guaranteed good images here, but be mindful of the flood tide—even though the water in summer is pleasantly warm!

Other attractions not to be missed are Western Brook Pond and the boat tour of the land-locked fiord. Secure your reservations at least a day in advance from the front desk at the Harold Hotel in Rocky Harbour. Your best bet is to time a trip that will have you in the Pond about four hours before sunset; that will give you light striking the north face. As awe-inspiring as this world-class landscape is, it is very tough to photograph well. Conveying a sense of scale in your photographs is tremendously challenging, as the fiord is long with walls that rise straight up.

Don't neglect spending an hour or so at the Information Centre, where you'll find displays of wonderful photography in both static and video presentations. There is also a bookstore with additional reading material about the park—look particularly for material by resident writer Michael Burzynski.

—DW

Green Point – All too often we are guilty of merely extending our tripod legs to their maximum height and then standing on tiptoe to look through the viewfinder. But by raising or lowering the camera height we can put a totally different perspective on what we see. In this case I set the camera about a metre high, to allow the rocks to be the dominant subject. Of course the beautiful light from the setting sun and passing storm clouds didn't hurt the cause any.

Nikon F90, 80–200mm f/2.8D lens, f/11 at 2 seconds, Cokin blue/yellow colour polarizer and two-stop grey graduated filters, Fuji Velvia film.

South East Brook Falls.

Pentax 67, 55mm lens, f/22 at 1 s, Cokin blue/yellow colour polarizer, Fuji Velvia film.

©*Dale Wilson*

Spillars Cove

Spillars Cove lies at the tip of Cape Bonavista, with Bonavista Bay behind you and Trinity Bay ahead as you face east awaiting sunrise. For most of my many visits there the weather has been unbelievable: hurricane-force winds, driving rain and sleet—and did I mention wind? Only once was I blessed with a calm day, with bright sunny skies and temperatures hovering around 20 degrees; you know, the kind of day that's great for mosquitoes. I'll take the wind, thank you.

In fact, the stronger the wind the better. This mean and rugged coastline lies generally northwest to southeast—perfect for photographs of the sunrise—and strong winds only add to the beauty. Use from two to four stops of graduated filter of various colours to add even more drama to the sky. The incredible shoreline is far enough away to permit lens apertures of f/5.6, to give shutter speeds high enough to keep the crashing waves from blurring while maintaining an acceptable depth of field.

There are several access roads leaving the Trans-Canada Highway between Clarenville and Port Blandford that meander toward Cape Bonavista, and if time is not of concern you should explore them all. The quickest way is to take Highway 230 at Clarenville and just follow the signs. Once you reach the village of Bonavista be prepared to get lost, as planned urban development and ease of transport were unheard of in the 17th century—streets simply followed the coastline and houses were built… wherever. But this is part of the charm of rural Newfoundland. If you follow your nose and a few scattered signs you should easily find the lighthouse. A few hundred metres before the ocean sentinel there's a gravel road to your right that leads to "The Dungeon," a provincial natural attraction. Take this road and you will immediately see the coastline as it appears on the opposite page.

Should the wind be blowing hard—and it often is—keep your tripod as close to the ground as you can, to minimize camera movement. Once you've composed the image in your viewfinder you can use your body as a wind-shield during the exposure. For this photo, I drove my vehicle right to the edge of the cliff and took my pictures from the lee side. Before trying that, though, make sure the marsh is dry enough to hold the weight of your vehicle and check the cliff edge for overhangs. You don't want to break through!

–DW

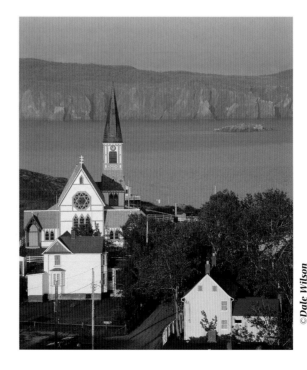

© Dale Wilson

Trinity – About an hour's drive from Bonavista is the historic town of Trinity. Get there two hours before sunset and climb Magistrate's Hill for this classic postcard view.

Pentax 67, 300mm lens, f/8 at 1/250 s, Fuji Velvia film.

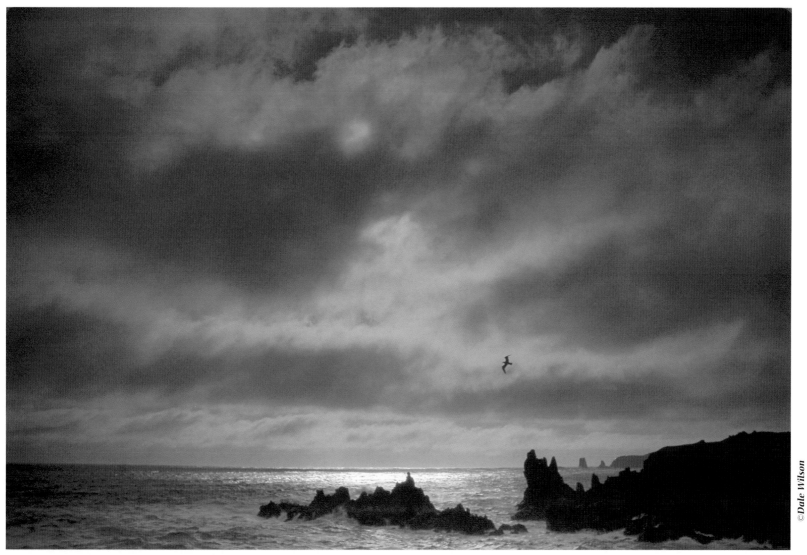

©*Dale Wilson*

Dawn, Spillars Cove - This image is a result of only having one kick at the can, so to speak: I had other commitments so I couldn't stay and wait for better weather. In these cases, reach deep into that "Tickle-Trunk" and pull out all the stops.

Nikon F90, 80–200mm f/2.8D lens, 80A (blue), two-stop blue and two-stop mauve graduated filters, exposure unrecorded, Fuji Velvia film.

Cape St. Mary's

Cape St. Mary's Ecological Reserve is about a one-hour drive south on Highway 100 from the Marine Atlantic ferry terminus at Argentia. The drive to the reserve itself is fascinating and provides many opportunities for images of the rugged maritime coastline, particularly around Ship Cove and Gooseberry Cove.

Once at the reserve your best vantage point will be mere metres from the large precipitous pinnacle known as Bird Rock, which is a 30-minute walk from the Interpretation Centre. You will be welcomed there by the third largest nesting colony of gannets in North America, along with a large rookery of Atlantic murres (known as turres in Newfoundland), black-legged kittiwakes and northern razorbills. Also, be particularly attentive for the resident red fox, which you might find scampering along the cliff face as he hunts for eggs in early summer and for unattended chicks in mid-summer.

Photos can be made here even during the harsh light of high noon—photos like the image on the opposite page. Lying at the cliff's edge, I extended my tripod to its maximum length of three metres and then held it at arm's length over the edge of the cliff, with the camera lens pointed straight down. The predetermined exposure was made with a cable release. I took several shots to get at least one with the composition I was looking for. In hindsight I would not recommend this practice, but it resulted in my favourite photo from the reserve.

Most of your photography will be done while facing south, with an unobstructed field of view to both the east and west. Pre-dawn is my preferred time, which means leaving the Interpretation Centre about an hour before sunrise (times are available from the Centre or from "The Evening Telegram" newspaper).

Extreme caution must be exercised as this is a natural area with no retaining or safety fences to keep an errant foot from getting too close to the edge. An inattentive moment could result in a fall that would surely be fatal, as the drop to the ocean is about 125 metres.

–DW

Cape Pine – Nearby at Trepassey is the 7000-strong herd of woodland caribou. I've had my best success in early to mid-June along the Cape Pine lighthouse road, a gravel trail that turns off the St. Shott road.

Pentax 67, 300mm lens, f/4 at 1/1000 s (hand-held from the car window), Fuji RDP film.

©Dale Wilson

©*Dale Wilson*

Bird Rock – All too often we endeavour to fill our viewfinder with an individual portrait of an animal. For the complete picture we should also attempt to include its environment, as in this photo of Bird Rock.

Pentax 67, 55mm lens, exposure unrecorded, Fuji Velvia film.

Cape Spear

Cape Spear is the most easterly point of land in North America, so you can have the distinction of photographing sunrise here before anyone else on the continent.

Tourists usually take the 15 minute drive along Highway 11 from downtown St. John's to the Cape Spear National Historic Site to see Newfoundland's oldest lighthouse, constructed in 1835, and of course to view the sunrise. But even at such early hours, photographers wishing to make images of a natural seascape without the presence of "humanoids" will face challenges.

Non-photographers have every bit as much right to be here as photographers, so the easiest solution is to side-step the challenge. As you top the hill and for the first time see the two lighthouses, you'll notice a small parking lot to your immediate left that overlooks a small cove. Although you could go the extra distance of about 200 metres to the literal easternmost point of land, you might do better to stay here and make wonderful pictures of crashing surf without unwanted people interrupting the picture-making process.

I have found that an ebb tide nearing its lowest point, along with relatively high winds, are ideal conditions. As the waves crash against the reefs we need only use an 80-200mm zoom lens to compose striking images. June may offer the added bonus of icebergs, if the weather's right, and September usually brings stronger winds, which means even bigger waves.

Study your viewfinder image carefully, as there is a small outbuilding with a power line at the extreme north tip of land that has the uncanny ability to find its way into your picture.

With careful in-camera cropping this horrendous eyesore can be eliminated.

I know you'll enjoy one of my favourite locations in eastern Canada; but before you leave, walk out to the lighthouses. After all, you'll want to say that you were to the easternmost point of land in North America—even if it was at high noon.

—DW

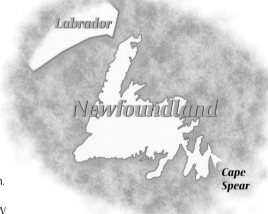

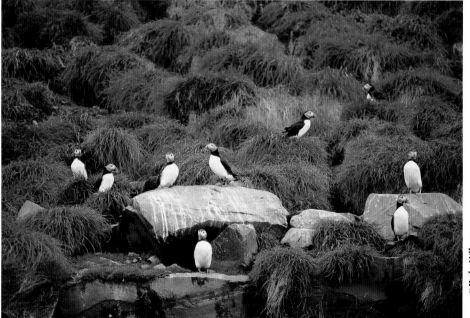

Bay Bulls – Around a cove, a couple of bays, and maybe a few icebergs later is Witless Bay Ecological Reserve. Thousands of common murres, razorbilled auks, various gulls and the colourful Atlantic puffin are within easy 300mm-lens range of the decks of the charter boats operating out of the area.

Nikon F90, 80–200mm f/2.8D lens with 1.6 teleconverter, exposure unrecorded, Fuji Provia film.

©Dale Wilson

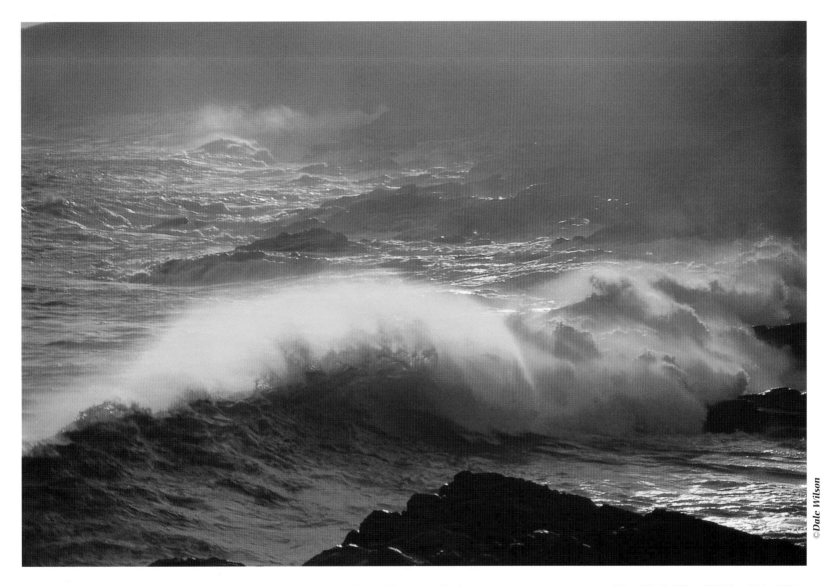

©Dale Wilson

Dawn, Cape Spear – You can rotate the Cokin blue/yellow colour polarizer to render an image with a warm yellow hue or a colder blue in backlit situations. Two other photographers I've shown this shot to prefer the blue version, but I prefer the yellow; no one likes the non-filtered version. Starting on page 136, you can see what filters can do for your image making.

Nikon F90, 80–200mm f/2.8D lens, f/5.6 at 1/125 s, Cokin blue/yellow colour polarizer, Fuji Velvia film.

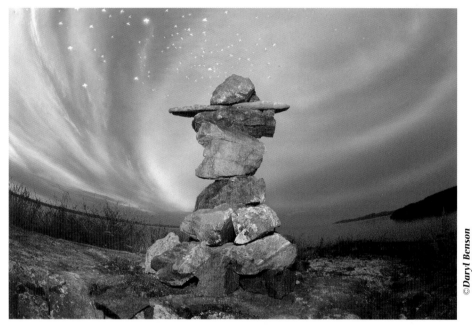

Mosquitoes over an Inukshuk, Eastern Arm of Great Slave Lake, Northwest Territories.

OPPOSITE: *Tombstone Valley, along
the Depster Highway, Yukon.*

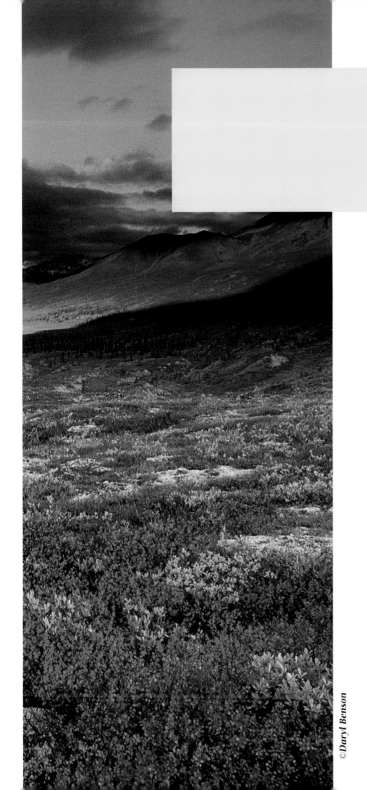

© *Daryl Benson*

THE NORTH

Yukon
(Dempster Highway)

Dempster Highway

Yukon

The gravel Dempster Highway runs 736 kilometres from just before Dawson City to the MacKenzie Delta in the Northwest Territories.

Autumn is prime photography time; here that means late August to early September. My favourite location is Tombstone Valley, between kilometre 70 and kilometre 75, where the valley frames Tombstone Mountain to the west. Willow, bearberry and blueberry bushes pour autumn hues down the mountain slopes onto the tundra like spilled cans of paint—colour-enhancing and intensifying filters were made for this! Be warned that hiking on the spongy tundra is like walking on piles of mattresses, and there are few references for scale, so everything's farther than it seems. Many areas are so thick with willow and alder that bushwhacking even short distances can take hours.

The Dempster is the only highway in Canada that crosses the Arctic Circle (at kilometre 405.5). Northern Lights are common, especially from mid-autumn to mid-spring, so keep an eye open before you tuck yourself in at night.

Other photographic highlights are the tundra-covered Ogilvie Mountains and a classic view looking back down the snaking highway from the Richardson Mountain Pass at kilometre 463.

There are only two spots for gas and repairs: the Eagle Plains Hotel, kilometre 369, and Fort McPherson, kilometre 550. Take a good spare tire, an extra gas can, and be prepared when you travel this road: it could be many, many long hours before you see another vehicle, or the long, lonely face of a weary grader operator.

If you're approaching the Yukon along the Alaska Highway, stop at Liard River Hot Springs just beyond Muncho Lake Provincial Park (in B.C.); it's one of the prettiest, most relaxing outdoor spas I've ever been in.

–DB

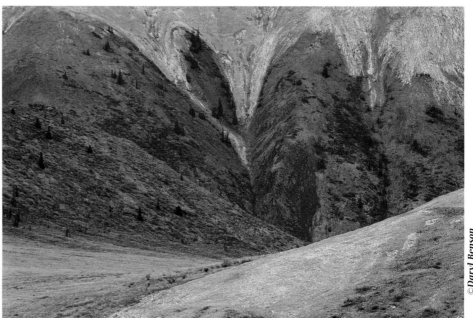

©Daryl Benson

Ogilvie Mountains – Autumn colours on the weathered slopes of the Ogilvie Mountains, as seen from the Dempster Highway.

Nikon FE, 80–200mm f/2.8D lens at 200mm, Howard Ross Colour Enhancing filter, Fujichrome 100.

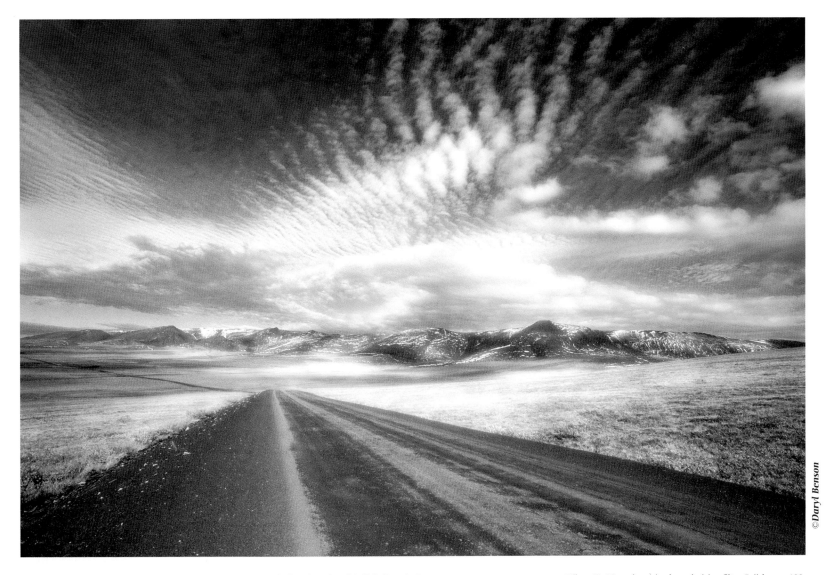

©*Daryl Benson*

The Dempster Highway – I took this image originally on colour slide film, then altered it digitally to look like a black-and-white infrared shot—the creative process needn't end when the shutter is released.

Nikon FE, 20mm lens, circular polarizing filter, Fujichrome 100.

Northwest Territories and Nunavut

One of the few roads that nibbles at the fringes of the vast Northwest Territories is Highway 1, "the Waterfalls Route," which heads north at the border with Alberta. It parallels the scenic Hay River for several kilometres and passes right beside Twin Falls Gorge Territorial Park, where the Hay River cuts a deep gorge through the limestone bedrock and boreal forest to form two gorgeous waterfalls. Alexandra Falls is the larger and more scenic; Louise Falls lies 2 kilometres north. Both are easily accessible and are well worth the stop (see photograph opposite).

Wood Buffalo National Park, Canada's largest park at 44,807 square kilometres, straddles the Alberta/N.W.T border near Fort Smith. A must-see landscape location in this park is the Salt Plains: remnants of the ocean that once covered the area. There is a spectacular–almost aerial–overlook from a constructed platform just off Highway 5, and a short (500 metre) switchback trail that leads down the escarpment to the salt plains.

The Grosbeak Lake salt flats are my favourite spot in the park. They're 24 kilometres south of Fort Smith off the Pine Lake Road and are part of the Salt River Loop Trail. Continue 2.5 kilometres south, past the Salt River Loop Trailhead and parking lot on Pine Lake Road. Enter a small parking spot

on your right and go to the trail that starts just across the road to the east. This easy-to-follow trail goes through the woods for about 1.5 kilometres and then opens onto a large salt flat dotted with "erratics"– large rocks deposited by glacier action.

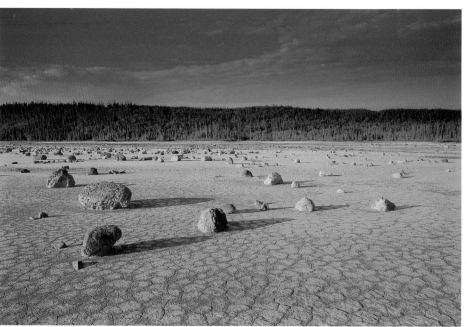

Wood Buffalo National Park – Glacial erratics cast long shadows at sunrise on the Grosbeak Lake Salt Flats.

Pentax 645, 45mm lens, Cokin blue/yellow colour polarizer, Singh-Ray two-stop hard-edge blue graduated filter, Fuji Velvia film.

Wood Buffalo National Park

©*Daryl Benson*

If your travels in the Northwest Territories take you to Yellowknife, its capital, don't miss a drive down the road that goes nowhere: The Ingraham Trail. Construction of this road, which was to go several hundreds of kilometres north to the seaport at Coppermine, started when John Diefenbaker was Prime Minister, but when the road reached the 69.1 kilometre mark Mr. Diefenbaker lost a federal election, the road lost its political support, and now there it sits. It's a photographic bonanza, though, as it provides prime access to the Canadian Shield landscape of exposed bedrock, shallow lakes, ponds and stunted pine forests. Two good shooting spots are the Cameron Falls Trail (1.5 kilometres long) and in the Cameron River Bridge area.

–DB

Nunavut

Unfortunately I was foiled twice in my efforts to travel around and to photograph this newly named region of Canada, the eastern part of the former Northwest Territories. Researching the area, however, taught me that one's travel plans here must be flexible to the extreme (make this your mantra). I also determined that because of the diversity of the land and the cultures that call it home, the success of any trek undertaken is directly related to the skill of the guide and the outfitter selected. And have your feet planted firmly on the ground when considering the budget: lodging, meals and guide services will cost about $500 per day; travel costs will be additional.

–DW

Twin Falls Gorge Territorial Park – Here the peat-coloured Hay River plunges over Alexandra Falls. While I wouldn't recommend this spot for actual camping, it made for an interesting photograph. The inside of the tent was illuminated with a Coleman lantern (see "Artificial Light", page 131).

Pentax 645, 45mm lens, Cokin blue/yellow coloured polarizer, Fuji Velvia film.

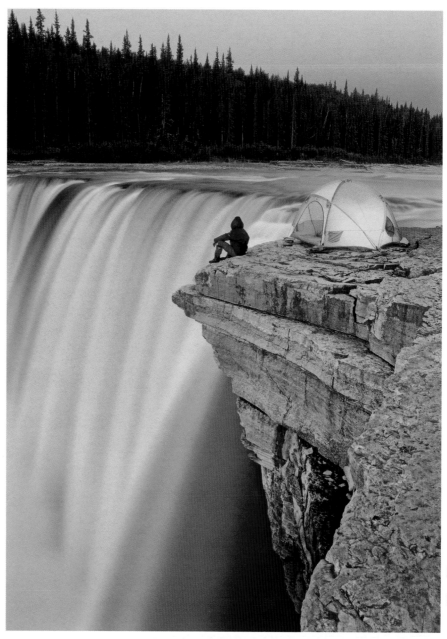

©*Daryl Benson*

Light painted pine cones.

OPPOSITE: *Beach Gravel,*
Brier Island, Nova Scotia.

© Daryl Benson

TECHNIQUES

Light

Light is to photography what gravity is to skydiving, what a sharp rasp is to an obese Pinocchio, what gophers are to gravel roads in Saskatchewan.

Regardless of your personal style, choice of camera, lens, composition or subject, light is the element with which you create. How well you understand this, and how well you understand the way film sees light, will ultimately determine the control you have over your photography. The moment you truly understand that you are not photographing a subject but are capturing light is the moment you will begin to have control over this medium. Photography will then become a matter of skill and craft rather than mere chance. Light is everything to photography!

Let's divide the huge topic of light into two categories: natural light sources and artificial light sources.

Natural Light

The biggest, brightest and most diverse natural light source you're going to be inspired by is, of course, that big bad boy in the sky, 150 million kilometres away: the sun.

As I travel the breadth of Canada I hear many people talk about the unique "quality of light" in their own particular town, county or province. They all claim one of the reasons they enjoy living where they do is that the quality of light, and the beauty it illuminates in their part of Canada, is like nowhere else they've seen. And all of them are right.

While it's obvious that the same sun illuminates the whole country, each region is absolutely unique. There are so many separate elements that combine in different ways to effect the

Dawn, foxtails, asters and western dock, near Sherwood Park, Alberta – The sweet natural light at sunrise and sunset has always been my favourite–and most inspired–time to photograph.

Pentax 645, 45mm lens, Howard Ross Colour Enhancing filter, Singh-Ray two-and-one-half-stop reverse-graduated filter, Fuji Velvia film.

©Daryl Benson

quality of light that I would not have room in several books to explain them all (and, to be honest, I'm not sure I really understand them all).

The unique quality of light can be affected by latitude. How far south or north do you live? Does the sun take a slow sloping arc across the horizon when it sets, as it does in the far north? Or does it drop from the sky at sunset like the trillion tonne sphere that it is? The physical geography that surrounds you also has a huge effect. For example, a sunrise in the mountains is very different from one on the wide-open prairies, a sunrise on the prairies is very different from a sun rising over the Atlantic Ocean or near the Great Lakes, which is different from a sunrise in the northern boreal forest, which is different form a sunrise in downtown Vancouver, and so on, and so on. The unique geography and topography in each corner of the country affects the way light reflects, penetrates and illuminates the landscape.

Time of year and its relationship to a particular region also effects the quality of light. For example, a calm, clear autumn sunset on the prairies is often like being gently draped in a thin, soft, orange blanket. The chaff and other tiny particles floating in the atmosphere from the harvesting activities at that time of year give rise to a light like I've seen nowhere else. Similarly, a chilly winter sunrise over Halifax harbour with the billowing columns of sea smoke rising off the Atlantic creates a scene like nowhere else. The thick morning fog generated by the Great Lakes in fall, the combined automobile and manufacturing exhausts of a large city during a hot summer inversion, or the crystal clarity of a –40° cold-sun blue-sky winter day in the mountains—all are like nowhere else.

The sun will be the most dramatic, diverse and inspiring source of illumination you'll photograph under, and the quality of light right outside your back door is as distinctive as anywhere in the country.

Chasing Rainbows

Storms can have a dramatic effect on the quality of light. Fresh fluffy winter snows or early spring rain showers are enjoyable and interesting to photograph, but my favourite atmospheric show by far is the God-Beam-making, Lightning-

shaking, Rainbow-creating summer Thunderstorm!

Summer thunderstorms can set the stage for dramatic light and overwhelming displays of nature that completely dwarf anything on a human scale. Unfortunately (photographically speaking), the more intense the display, the briefer its existence. Because of this, success in capturing these displays of nature on film requires a photographer to exercise three skills: 1) preparedness; 2) mobility; and 3) persistence.

While very dramatic storms may be rare at any one location over the course of a summer, in an area the size of a province such storms could be occurring several times a day. Success is directly related to opportunity: the more opportunities you go after, the more success you'll have. To photograph summer storms you've got to put yourself in the path of as many of these travelling tempests as possible. In other words, you've got to go *chasing rainbows*.

Only rarely does a single word encapsulate the essence of a technique, but when it comes to chasing rainbows, *mobility* should be your mantra. Many of the more dramatic storms are small "cells," each only a few kilometres in diameter, that travel across the landscape at anywhere from 40 to 100 kilometres per hour. Knowing this makes it possible to follow and photograph these storms. Be prepared with your camera equipment ready: plenty of film, spare batteries, large plastic bags, tripods (yes, more than one!), lens-cleaning tissues and dry hand towels (to keep you, your equipment and especially the front of your lenses dry), a full tank of gas, Environment Canada phone numbers (listed later), and a good, complete set of road maps (not so much to figure out where you're going but to find your way back home after you've finished chasing and shooting the storm and are now possibly several hundred kilometres from home, in unfamiliar territory, in the dark).

Keep a couple of phone numbers handy to help get you, your camera and your chase vehicle in position to photograph these dramatic displays of nature. Environment Canada's nationwide phone number is 1-900-565-5555. You can speak directly to a meteorologist and ask very specific up-to-the-minute questions about weather conditions or storms in your area. There is a small charge for the service ($1.95 per minute with a two-minute minimum, charged on your phone

bill), but in my opinion it's definitely worth the expense to get accurate information that will help you to make good decisions on whether or not to chase a particular storm. If you want to pay for this service using Visa or MasterCard, or if you're calling from a cell phone, dial 1-888-377-7770.

In my experience, shooting from the periphery of a storm is best. If you're too close all you're going to see are windshield wipers fighting the rain. The most dramatic shafts of breaking light, rainbows or colourfully lit clouds and landscapes are usually found close to sunset along the western edge of the storm.

Let's imagine you left home some three hours ago, chasing those storm clouds. You have travelled hundreds of kilometres trying to keep up with the storm; okay, so now what? Well, stretched before you could be the most dramatic, spiritual, eyepopping, heartstopping, glowing, surreal landscape you've ever seen. Or it could be gray, wet and dismal, leaving you cursing the day you ever took this book seriously. There are almost no guarantees; in fact failure is more common than success. "Almost" no guarantees? I can guarantee that if you are persistent you will eventually be successful. Once you've experienced the adrenaline rush of seeing and shooting the dramatic light of a storm you'll be addicted—and persistence in the face of bad odds will be a price you'll be more than willing to pay.

Two of the godsends that punctuate summer storms and make them so exciting to chase and rewarding to photograph are rainbows and lightning. Here are some facts and tips about these two natural phenomena that should help you better understand and photograph them.

Rainbows
- Rainbows are always centred 180° from the sun, and are best seen and photographed at the tail end of a passing storm, as the sky clears behind it.
- The lower the sun, the larger the arc of the rainbow that will be visible. If the sun is higher than 42° above the horizon, a rainbow can't be seen from ground level.
- If you're shooting a rainbow against a huge dark sky, underexpose. This will keep the background dark and will intensify the colour and contrast of the rainbow against it.

©Daryl Benson

- Use a polarizing filter to increase contrast and thus heighten the appearance of a rainbow on film.
- Rainbows can also be seen and photographed in fog, mist, spray from waterfalls and sometimes from airplane windows. If you have the opportunity to photograph from an airplane (I always try to get the window seat when I travel), try using a polarizing filter as you shoot through the plane's window. Quite often the stress lines in the plastic window (which are visible through a polarizing filter) will create beautiful ribbons of colour through the scene below. Bows covering a full 360° can sometimes be seen encircling the shadow cast by a plane on nearby clouds, a phenomenon called "Glory."

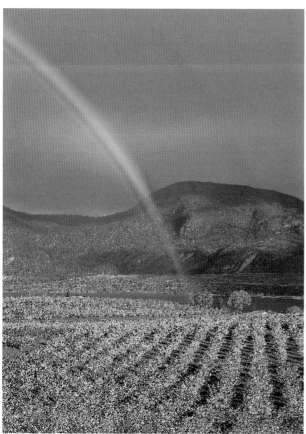

Apple orchard in bloom, Okanagan Valley, near Osoyoos, B.C. – Rainbows are one of the photographic rewards for persistent storm chasers. A polarizing filter can enhance the contrast in a scene and thus increase the "presence" of a rainbow on film. In these examples I used one of my favourite filters, a Cokin blue/yellow colour polarizer, rotated to maximum blue (left image) and then to maximum yellow (artistic license was taken with the layout here, the image on the left shows the correct orientation of the scene).

Pentax 645, 45mm lens, Cokin blue/yellow colour polarizer, Fuji Velvia film.

©Daryl Benson

Lightning

- A bolt of lightning can be 50 kilometres long and less than 3 centimetres thick.
- There are approximately 100 lightning strikes per second, worldwide.
- A bolt of lightning can be hotter than the surface of the sun.
- In North America 100 to 200 people are killed every year by lightning.
- Tripods make great lightning rods!
- Needless to say, use caution and common sense when photographing lightning.
- Lightning is easier to photograph at twilight or at night when you can lock the shutter open for long exposures with a lens set to a moderate aperture (f/5.6 to f/8 with ISO 50 film). Use larger apertures if the lightning bolts are thin and spiderlike.
- The ideal position for photographing lightning is in front of an oncoming storm. It is drier there, plus you'll have a better view of the lightning pattern.
- Lightning pattern? While each storm is unique, there is usually a pattern—which is quasi-predictable—to where and when the next bolts will strike. By watching the lightning strikes, you will notice their movement, pattern and frequency.
- Try to position your vehicle with a window or door leeward from the wind and rain, so you can shoot while keeping dry (this is where those vans with sliding cargo doors on both sides come in real handy). Turn the engine off and try to keep still during exposures.
- If possible, set up two or more cameras. This will allow you to choose several different lens focal lengths and compositions and will better your odds of getting a good strike on film.
- A shot of a lightning bolt has more impact if you can combine it with an interesting foreground. But if you're shooting for "stock," a clean and uncluttered straight shot of a strong bolt of lightning is preferable. The more powerful and generic the image the broader its appeal and the more saleable it will be.

I have been chasing and photographing storms ever since I first took up photography as a hobby (a hobby that's now a passion) and I have encountered many strange and unusual phenomena during my travels. One thing that still puzzles me, though, is why don't sheep shrink in the rain?

The Night Sky

Night unveils its own set of unique possibilities. Your only main source of natural light is the moon (moonlight, of course, is actually sunlight reflecting off the surface of the moon). A full moon casts 1/40,000 the amount of light the sun does, so exposures are going to be very, very long. Photographing under moonlight is far from an exact science: there are many variables that can cloud the subject (how clear is the sky, is there snow to reflect the moonlight, how full is the moon, how high in the sky is the moon, etc.). Here's a starting point: with the full moon as the light source, using ISO 50 film at f/8, your exposure time should be about 1 hour, but you should bracket (expose again, changing settings: for example, open your aperture to f/5.6 or use the same aperture [f/8] but expose for 2 hours, for a one-stop bracket "over"). Clear as mud?

Those settings were for using the full moon as an *illuminator*; if instead you want to photograph the full moon as a *subject* and have its face show up with all the craters and details, start with an exposure of 1/60 to 1/30 of a second at f/8 on ISO 50 film.

While we're talking about nighttime exposure formulas, I'll throw one more out for you: to photograph stars as points of light in the sky use an exposure time no greater than the focal length of your lens divided into 600. For example, if you're using a 20mm lens, 20 into 600 is 30, and your exposure time should be no more than 30 seconds (if you had a 100mm lens your exposure time would be 6 seconds; I'm keeping the math examples easy for my benefit). The aperture of the lens doesn't enter into this calculation, which simply determines the longest exposure possible before star images turn into little streaks of light, but the larger the aperture the more stars will show up in the final shot, so shoot with as large an opening as you can. If you are interested in capturing star trails (where the stars trace smooth, concentric, partial circles in the night sky, giving it that domed cathedral appearance) try these settings: ISO 50 film, as large an aperture as you can and an exposure time of 1 to 1 1/2 hours (with no moon in the sky and as far away from city lights as possible). Bracket, of course. The stars will appear to move (of course it's the earth that's moving) counterclockwise around the North Star.

To find the North Star (Polaris), first find the Big Dipper, then using the two stars at its pouring end (they are called the pointer stars) draw a line from lower to upper, continue 3 1/2 times their separation and you'll come to a medium bright star (it's easily the brightest star in that region of the sky). That's Polaris (you can now also see the Little Dipper; Polaris is the last star in its handle).

All of these recommendations are only starting points. If you're interested in this type of photography give them a try, but as with any new technique don't always expect to get great results overnight (I couldn't help myself).

Northern Lights
Aurora Borealis (oh-ROR-a bor-ee-AL-is)

Next to drops of water in a hot frying pan, nothing evaporates quicker than a good auroral display, especially once you get your camera out and set up. Fortunately Canada is one of the best places on the planet to see and photograph the northern lights. A donut-shaped auroral zone of high activity encompasses much of northern Canada, including such locations as Yellowknife, N.W.T., Goose Bay, Labrador and Churchill, Manitoba. In this zone of high auroral activity the northern lights can be seen almost every cloudless night, especially from autumn to spring when the nights are long and dark.

Auroras dance above the earth at heights ranging from 100 to 1000 kilometres. Powered by particles thrown from the surface of the sun, they are shaped into the dancing curtains we see by the earth's magnetic field. Gases in the upper atmosphere (the ionosphere) are electrically excited by these incoming solar particles to create the colours of the aurora. Oxygen produces green light and nitrogen glows blue-violet and pink.

Here are a few tips for seeing and photographing northern lights.
- If there's a strong auroral display one night, chances are good there will be another the following night.
- Strong auroral displays are more common around the spring and fall equinoxes.
- Strong displays tend to recur at 27-day intervals (because that's the time it takes the sun to make one rotation,

returning any storms on its surface to face the earth for another good auroral display).

- If you live outside the always-active, donut-shaped auroral zone previously described (which most of us do), the intensity and frequency of displays will ebb and flow over an 11-year period (the 11-year cycle of sunspot activity). The next peak is expected in the year 2001 (get ready!).
- Forecasting aurora is not 100% reliable, but if you want to increase your odds of seeing and photographing a good display, phone the Space Environment Center in Boulder, Colorado at (303) 497-3235 for a recorded message on solar and auroral activity (it's updated daily). Or call (303) 497-3171 to reach the forecast desk and talk with a real live person. Also check out their web site at *http://www.sec.noaa.gov/* and click on "latest space weather" and then "auroral activity estimates." Solar activity is rated by the Center on a 1 to 10 "K" scale going from K1 (very quiet) to K10 (rock-and-roll, severe storm, get the camera out and shield those electrical transformers).
- A strong auroral display will race from horizon to horizon, so use the widest angle lens you have (28mm or wider).
- Use your largest aperture. Most lenses are not at their sharpest wide open, but with northern lights absolute sharpness is not the critical thing. You want an exposure short enough to capture the dancing curtains and shafts of light; if it's too long all you'll end up with is a sky full of green mush.

- Use fast film, up to 200 ISO for slides and up to 400 ISO for prints. High-speed slide film tends to be very grainy and you may not be happy with the results if you go faster than 200 ISO, but high-speed print films have finer grain. If you use print film, take it to a professional lab to be processed and printed; one-hour labs sometimes have difficulty with dark and contrasty images.
- It's difficult to suggest an accurate exposure time: it will depend on the maximum aperture of your lens, the film speed, and, most important, how strong, bright and fast the display is! As a starting point for a strong display, with an aperture of f/2.8 and 200 ISO film try exposing for 30 seconds to 1 minute and then bracket (both shorter and longer exposures) from there.

Good luck!

—DB

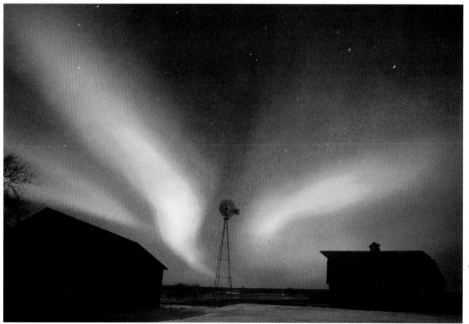

Northern lights near Edmonton, Alberta – This old barn and windmill are less than a ten-minute drive from my back door. When I noticed this strong auroral display I was able to get to the location quickly and set up before the show faded into memory. Know your own back yard (see page 34).

Nikon FE, 20mm lens at f/2.8, exposure approximately 30 seconds, Fujichrome 100 film. (A few distant yard and vehicle lights were removed from this image digitally.)

©*Daryl Benson*

Q.

How many photographers does it take to change a light bulb?

A.

*Fifty.
One to change the light bulb, and 49 to say, "Awww, I could have done that."*

©Daryl Benson

Blurry bovine – A flash was used here on full power during a one-second exposure at dawn. It froze the initial image of this curious cow ("Pop"), and then during the remaining second of exposure time the animal's movements created the darker ghosted image ("Drag"). This technique of using a flash to illuminate moving subjects during longer exposures is called "Pop and Drag."

Nikon F90x, Nikon SB-26 flash, 20–35mm lens at 20mm, Fuji Velvia film.

Artificial Light

We have created many artificial sources of light in our age-old battle to cheat the dark of some of the time it spends with us. Any (and I do mean any) of these artificial sources of illumination can also be sources of inspiration, photographically.

Artificial light sources I've had experience shooting with include camping lanterns, vehicle lights, road flares, oilfield gas flares, signal flares, streetlights, floodlights, flashlights, penlights, yardlights, firelight, birthday sparklers, glow-sticks and, of course, flash.

Flash

This is the most common, most powerful (for its size) and most portable of all photographic light sources. There are literally dozens of flash styles, sizes, features and manufacturers to choose from. Be glad to have all these options, for in the beginning of flash photography (in the late 1800s) they used a little something called "Blitzlichtpulver" ("Flash Powder"): a mixture of highly flammable magnesium powder, potassium chlorate and antimony sulfide. This concoction was used in a (not always) controlled explosion of light to illuminate one's often-horrified subject. In those days, ISO 12 was considered fast film so a lot of Blitzlichtpulver was needed, and of course there are many interesting stories of exploding flashes, cameras and studios that add a little colour to those early days of black-and-white photography.

In those days, flash was intended to be used as the primary source of light in a photograph. This often resulted in a harsh, dominant light that was more memorable because of its unrealistic look than for any aesthetic appeal. In recent times photographers have used flash more creatively as a secondary or "fill" light, rather than just as the main source of light in a photograph. In this technique, flash is used in coordination with a primary light source (usually the sun) to enhance an image by brightening or filling in its shadows.

The concept is simple in theory, but because of some mental gymnastics you must jump through, it can be complex in practice. Fortunately most current flashes allow you to perform fill-flash automatically, by setting their power

output to provide anywhere from +3 to –3 stops of "fill light" in relation to the camera exposure (which is set to correspond to the level of the primary light source—again, probably the sun). Personally I prefer the fill light set to –1 to –1 1/3 stops. I find this to be the most pleasing and natural looking; however, as with any technique or recipe, season to taste.

There are many flash techniques and their explanations are sometimes lengthy; I recommend you begin by checking the "Resources and References" section on page 150 for several excellent books with detailed information on this topic. Just don't expect your little on-camera flash to illuminate Mick Jagger, on stage, from your seat in the 400th row of the auditorium!

Camping Lanterns

Small portable camping lights have been a favourite source of inspiration for me, photographically, for several years. The brightest I've been able to find (brighter is always better—you can dim a light that's too bright, but you can't brighten one that's too dim) is the Coleman 2000 "NorthStar," a gas-burning mantel model (gas lanterns burn brighter than propane units). This lantern is about equivalent to a 100-watt light bulb. While that's not extremely bright compared to a flash unit, the lantern's advantage is that it's a steady source of illumination, so its light is easy to judge—what you see is what you get. You can note exactly where the highlights and the shadows fall and you can easily move the lantern (or lanterns) around until you get exactly the effect you want (see the images on pages 121 and 146).

The colour of gas-burning lanterns is fairly warm, and the brighter and hotter the mantels burn, the closer to daylight colour they become. In general, gas lanterns deliver a slight orange-yellow hue on daylight films. In most applications I find this colour bias pleasing, but if you wish to correct this hue, try using an 82A blue filter.

One drawback to lanterns is that their light is not always strong enough to allow you to focus accurately on your subject, especially if the lantern is your only light source. A bright flashlight shone into the composition often helps with critical focusing. It also comes in handy for searching

through your camera bag, checking camera settings in the dark or to be used as an illuminator in that incredibly creative technique called "light painting."

Light Painting

Imagine this… it's June 1889. It's a warm starry night on the outskirts of Arles, a small town in the south of France. You are on an evening walk enjoying the calm and unusual stillness in the region's winds. Flickering and dodging in a distant field a small, unfamiliar light catches your attention. Curiously you move closer for a better look. The light begins to become recognizable as a small group of tiny flames atop someone's head! "Sacre bleu" you gasp, this person's hair is on fire! Quickly you dash out into the field, yelling as you run "Ne bouge pas! J'arrive" ("Don't move, I'm coming"— remember, you're in France). Running at full stride, you are almost there as your eyes begin to focus on what this mystery really is. Why it's a circle of small candles lit around the brim of a hat! What form of madness is this, you wonder?

Finally, out of breath, you are face-to-face with the wearer of the hat and a wave of immediate recognition and understanding calms your anxiety. Oh, you mutter to yourself in disgust, it's just that idiot Vincent Van Gogh. What's he up to now?

With the benefit of hindsight, we know Vincent was no idiot, but he did have problems (other than just a low local public opinion). Unlike many of his contemporaries, Vincent liked to paint not from memory, but on location with his subject before him. This often put him and his equipment in conflict with the surroundings—strong winds, heavy rains and dark nights. Vincent's solution to the last problem was to attach small candles to the brim of his hat in order to illuminate the canvas so that he could continue painting into the starry night.

That imaginative use of light to solve a creative problem embraces much of what photography is. By substituting light for an artist's brush and palette and film for a canvas, this analogy is not a difficult one ("photo" means light in Greek and "graph" means draw).

One current photographic technique that strongly resembles the creative process of applying paint to a canvas

is called, not surprisingly, "light painting."

There are a variety of photographic products commercially available to apply this technique in a studio setting where you have electric power. But, like Vincent, the idea here was to be able to work on location, wherever that may be. So I went looking for the brightest, most portable and powerful continuous light source I could find. A few types of scuba diving lights looked promising, but unfortunately their beam was so hot the flashlight casing had a tendency to melt when they were used out of water—a major drawback. I finally settled on two more appropriate devices: a 30,000 candlepower rechargeable Mag-Lite flashlight (available at most camping, recreation and large hardware stores) and, for more beefy projects, a 1,000,000 candlepower, rechargeable, Brinkmann Q-beam searchlight (available at Canadian Tire stores).

In practice the idea of light painting is to direct a beam of light over specific subjects or small areas in a scene during a long exposure. This selective illumination helps focus attention on the subject, while also giving a unique quality of light, contrast and drama to the resulting photograph. By adding coloured gels to the flashlight (or to the camera lens), by controlling the size and direction of the light beam and by varying the amount of time you leave the light on any one area during the exposure you can creatively paint a composition with light.

There are some physical limitations. For example, regardless of how bright your light is it can't compete with daylight for illumination. And the actual act of light-painting may take several minutes to execute, depending on how large the subject and how bright your flashlight. Because of these factors, the technique is best used in the calm twilight

Hay bales near Waterton Lakes National Park, Alberta – I used a 30,000 candlepower Mag-Lite flashlight to illuminate these hay bale ends during a 15-minute exposure at dusk.

Pentax 645, 45mm lens at f/22, Fuji Velvia film.

©*Daryl Benson*

or predawn hours when exposure times will be long enough to allow you to combine ambient and painted light to create the image you want.

If you're interested in this technique, I recommend you just grab a flashlight and head out into the dawn or twilight to give it a try. If you want a little more formal explanation for metering and exposure, however, use the following example as a guide.

Let's say one evening you want to photograph a small forested area and would like to light paint one of the trees in the scene to make it glow, to stand out from the rest of the image as if it were plugged into its own private power supply. You can fairly accurately determine the exposure time by shining your flashlight on the tree (making sure that the flashlight is the same distance from the tree that it will be when the light painting is actually done), and metering the illuminated area. If you have a hand-held or in-camera spot meter this is fairly easy: just point the meter at the illuminated area and see what it says. If you don't own one of these devices, no problem, just move your camera right up into the scene so the entire viewfinder is filled with the area illuminated by the flashlight (don't worry about focus—you're just interested in the meter reading). You may have to lay the flashlight down or prop it up as you move into the composition to get the reading.

Let's say the meter reading is two seconds at f/22 with ISO 50 film. You estimate that it will take about a minute to move the beam of light over the entire tree, illuminating each area for two seconds. Your exposure time will then have to be at least one minute.

Next read the ambient light level. For this example let's say the ambient light reading is four minutes at f/22. That's easily enough time to allow you to light-paint the tree (remember you're doing this at dusk or dawn when the ambient light is low).

Then take a good look at your watch to note when you start the exposure and use a cable release to lock open the camera shutter (set on B). Move into the scene (if necessary) and begin light painting, moving the flashlight slowly and smoothly over the tree, trying to illuminate each area with the beam for approximately two seconds, as per the earlier

meter reading. If you have to move into the composition to do the light painting be careful not to point the flashlight back at the camera, but don't worry about your own image showing up on the film. If the exposure is a minute or longer and if you keep moving, you won't be in one spot long enough to register on the film (wear dark clothes, if possible). After four minutes, close the shutter and, if time permits, try another shot.

As you paint, some areas of the scene will invariably get more light than others; that's actually good. As in traditional painting, this is where individual style and unrepeatable uniqueness contribute to the resulting image. It's usually impossible to predict what the final image will look like: I've been practicing this technique for years and am still surprised by the results (when you get the film developed it's kinda like Christmas: you just don't know what's waiting for you in there). Good luck.

Vehicle Lights

There's nothing in the middle of the road but yellow lines and dead porcupines and the odd (emphasis on "odd") photographer. Admittedly, standing in the middle of the road can be a dangerous and questionable thing to do, however, there's more to it than just satisfying a macabre curiosity over dead rodents.

As photographers, light is our medium. Any source of illumination, natural or man-made, can be the basis for both inspiration and creativity, so enter "Vehicle Lights."

Most roadworthy vehicles have three creative sources of light: headlights, taillights and flashing hazard lights (the last two are more often used as subjects than as illuminators). These three light sources, during long exposures at dusk or dawn, can cut colourful ribbons of light into a landscape or illuminate appealing subjects within their nocturnal reach.

Headlights are by far the brightest and most versatile of the three sources. As the night sky gets darker and your headlights begin to reach farther into the night, steer toward rural areas where there will be fewer distracting and competing forms of artificial light. Pull well over to the side of the road, letting your headlights shine into the ditches or across open fields. Turn your engine off and explore the

areas being illuminated to see what subjects the light reveals. A good car battery will handle the drain of headlights left on for quite a while (you'll notice the light fall-off long before the battery goes dead). The farther from the vehicle you look, the less the headlights will compete with whatever soft evening ambient light there is. Try checking with your high beams on, or for added impact try taping coloured gels to your headlights.

Headlights come in a variety of bulb types and illuminating power. Generally, they deliver a colour bias much the same as Coleman lanterns, so similar filtration will apply. But, hey, this is creative photography we're talking about here. If you're trying to document the exact colour of roadside daisies, don't light them with car headlights.

At dusk or dawn, with long exposures, taillights will trace the paths of passing vehicles by carving ribbons of red onto your film. Similarly, by driving into the scene with your headlights off and your flashing hazard lights on (in a controlled situation), you can expose the film with alternating streaks of yellow.

"A controlled situation"? Here's one of the problems you'll encounter when shooting vehicle lights. You can't always expect a vehicle to drive down the road exactly when and where you want it to, especially with just its flashing hazard lights on. For most of the vehicle shooting I've done, I've either set up the shot and then driven through the scene myself or I've had a companion drive through. Walkie-talkies are handy accessories for this technique, as they allow you to communicate with the driver while shooting.

Some compositions may require the photographer to actually stand right in the middle of the road. In such situations, I don't recommend just waiting for a vehicle to happen by, use caution and common sense.

Here are a few tips to get you started with this technique.

• Have the driver go through the composition as slowly as is reasonable: 20 to 40 kph is about right in most situations.
• If you're doing taillight shots, have the driver press the brake pedal very lightly while travelling through the scene. This will increase the brilliance of the taillights in the shot.

• Keep the vehicle lights clean and free of dust, mud or snow buildup, for both safer driving and to maximize the light for exposures.
• An aperture of f/5.6 or f/8 with ISO 50 film will deliver good exposures for taillights and flashing hazard lights.
• Vehicle headlights are much brighter than taillights: f/16 or smaller is best for streaking headlight-only shots.
• If you're using headlights to illuminate the foreground road, have the driver move the vehicle from side to side during the exposure so the beams rake over the objects they're illuminating, rather than just burning two bright beams of light into the scene.
• Make sure exposures are long enough to expose the unlit part of the landscape properly and to allow the vehicle(s) to drive all the way through the composition. The length of twilight or predawn light will determine how many shots you'll be able to try before it gets too dark or light.
• A properly exposed landscape isn't always essential. A moody or dramatic sky balanced with vehicle lights graphically carving their way through a black and mysterious foreground can be very striking.

I make my living mainly as a stock and concept photographer, and many of my best-selling images are road and vehicle light shots. In the advertising market, roads have strong symbolic connotations: travelling toward the future, a road less travelled, transportation, adventure, exploration, etc. But whether they sell or not, I'll continue to photograph streaking vehicle lights, for the same reason I photograph wildflowers and thunderstorms. It's the reason we all started taking pictures. It's fun.

–DB

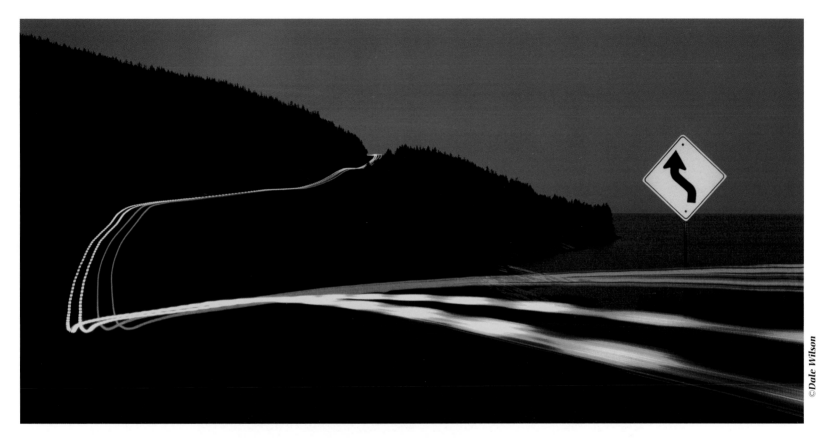

©Dale Wilson

Another tip is to try engaging your emergency brake to the first notch: depending on your vehicle model this might turn off the driving lamps, and you can then drive through the scene without danger of lens flare caused by the excessively bright headlights. In this image the camera was positioned on the shoulder of the road with the shutter set on bulb. I drove away from the camera at about 20 kph with my foot depressing the brake pedal lightly, and then drove back through the scene at the same speed with the hazard-warning lights on. The road shot is from the Gaspésie region of Quebec; the sign was photographed near Halifax and later "dropped-in" using Adobe Photoshop. The sign was lit by the headlights of my vehicle.

ROAD: *Pentax 67, 55mm lens, f/8 at 20 minutes, Fuji Velvia film. My meter read 15 minutes for a proper exposure and it took 12 minutes to drive through the scene and return; I gave it another five minutes to allow for waning light.*
SIGN: *Nikon F90, 80–200mm f/2.8D lens, f/8 at 2 minutes, Fuji Velvia film.*

Filters

Filters are to photography what adjectives are to writing. They add colour, flavour and an individual style to what is being communicated.

Filters for colour photography fall into several categories, depending on their intended use. Types include Neutral-Density and Colour Graduated Filters, Colour Compensating, Correcting and Enhancing Filters, Polarizing Filters and Soft-Focus Filters. Although all of these filters were designed for specific purposes and applications, they need not be limited to those circumstances—in fact, *au contraire!*

Graduated Filters

Beginning photographers are often disappointed when the images they get back from the photo lab don't match their memory of the scenes they had photographed. There are two main reasons for this. One has to do with the mind's tendency to embellish and exaggerate memories of an image over the period between shooting and processing. This embellishment is called optimism, an important characteristic we all have to varying degrees. The second reason many images don't successfully translate to film has to do with the way we perceive light. Our eyes can easily see all the detail in a scene with light-level differences in excess of ten f-stops. In comparison, film has, at best, an exposure tolerance of two to three stops from the brightest to darkest scene areas (that's for slide film; print film has a stop or two more latitude but still nowhere near what the human eye can see). That lack of exposure latitude in film is the second reason many photographs don't turn out the way we remember the scene.

When shooting around the "golden" hours of light at sunrise and sunset we're often faced with a range of light intensity of at least five stops from the brightest areas (the region of sky where the sun is), to the darkest areas (usually the foreground). We have three choices in this situation. We can overexpose the sky to preserve foreground detail, we can silhouette the foreground and expose the sky properly, or we can call in the cavalry: use a graduated filter to help get an exposure with detail in both foreground and sky.

Physically, all useful graduated filters are rectangular with a clear bottom half and, starting near their horizontal middle, a gradual application of neutral or coloured material that increases in density up to the top (see illustration opposite). The neutral or coloured material absorbs one, two, three or more stops of light, according to its specification. By using a graduated filter over your lens and positioning the edge of the neutral density portion on the

Sunrise at Moraine Lake, Banff National Park, is as beautiful as any location in Canada. Unfortunately film cannot capture the image your eyes and mind have already recorded, the exposure latitude is just too great, unless...

©Dale Wilson

horizon you can hold back light from the sky while allowing foreground light to reach the film unhindered. This reduces the range of light between sky and foreground to something the film can handle.

Example: let's say you're photographing a beautiful field of wildflowers at sunset. You're facing west and the sunset sky is, of course, much brighter than the wildflowers in the foreground. You meter the sky and the foreground separately (your in-camera meter will do this perfectly well: just point it twice, first including only the sunset sky and then only the foreground wildflowers). Let's say the difference between the two readings is four stops: the sky reads 1/60 of a second at f/32 and the foreground reads 1/60 at f/8. We'll expose for the foreground and use a graduated filter to hold back some of the light from the sky. A four-stop graduated filter would bring the two areas into perfect balance, but experience shows that this usually looks too contrived and artificial. A sky that is about one stop brighter than the foreground will look more realistic and natural (if that's your intent). In this example, an exposure of 1/60 of a second at f/8 using a three-stop neutral graduated filter would produce a very pleasing photograph.

Quite often it's difficult to tell exactly where the graduated portion of the filter begins when you look through the camera. To help, use your depth-of-field preview button and stop your lens down to the aperture you're shooting at.

The graduated filter's effects are most noticeable with small apertures and wide-angle lenses. And when you purchase a graduated filter look for one that's deeper than it is wide to allow you freedom in positioning—in selecting how much or how

little of the overall scene you want to filter, without having the top or bottom edge of the filter creep into the shot.

There's quite an array of graduated filter styles, colours and manufacturers (see "Resources and References" on page 150)—Cokin alone offered 24 varieties at last count. Some have a very smooth gradation from clear to neutral density, others are hard-edged, and some graduate slowly and continuously throughout their depth (see the illustration on page 139).

A particularly difficult situation occurs right at sunrise or sunset, with the sun and the brightest portion of the sky exactly on the horizon. It's difficult to use traditional graduated filters in these circumstances if you want to shoot directly into the sun: the density of the filter is too low right where the graduation begins. To solve this problem a custom filter can be made that, like the others, is clear at the bottom, but starts very abruptly at its middle with neutral density material and then smoothly graduates to very nearly clear again at the top. This twist on the regular graduated filter works quite well in those tough lighting situations right at sunrise and sunset (see images on pages 34 and 35).

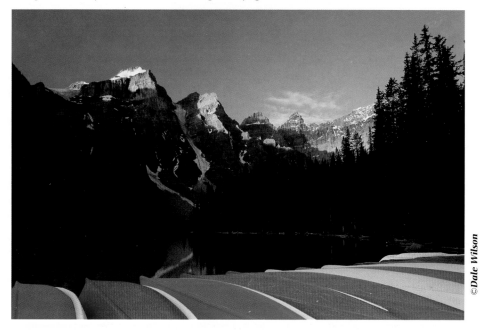

©*Dale Wilson*

...*a graduated filter is used. Here a Cokin G2 (two-stop grey) was used with the filter holder rotated to a slight angle to allow the feathered edge to follow the edge of light cascading across the distant mountain peaks. The Cokin G2 also infuses a slight magenta cast—a bonus!*

Nikon F90, 28mm lens, Cokin two-stop grey graduated filter, f/16 at 2 seconds, Fuji Velvia film.

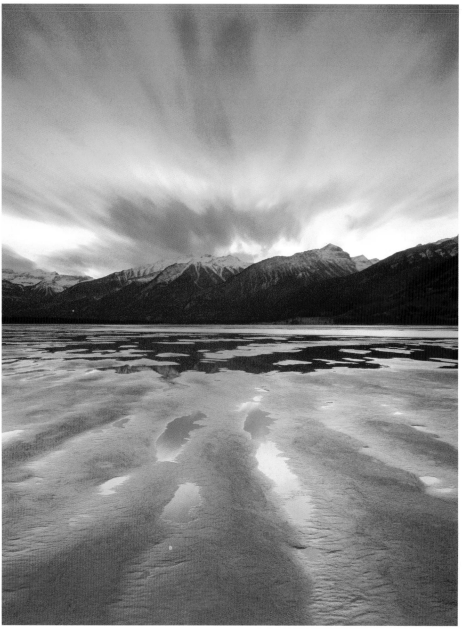

©*Daryl Benson*

Graduated filters should be one of the landscape photographer's first filter purchases. We suggest you start with the Cokin "P" series filter holder. Most filter manufacturers have adopted it as a standard of sorts and they offer filters to fit it. If you use a medium or large-format camera, however, you might consider the larger Cokin "X-Pro" or "LEE" holders and systems (see "Resources and References," page 150).

Colour Compensating and Correcting Filters

There's a whole hockey sock full of specialty filters that will correct, alter, or compensate for various different light sources or printing situations. However, in the world of creative photography we're more interested in using such filters to inject mood or to exercise creative license.

Kodak produces the widest variety of filters and while other manufacturers have their own versions they all cross-reference back to the Kodak filters and their numbers. So to maintain sanity (our own) we'll use the Kodak names and numbers when talking about specific filters.

Blue/Cooling Filters

There are two main categories of blue filters: the 80 series, which are colour-conversion filters to be used when shooting daylight film with tungsten light sources, and the 82 series, also used to balance the colour temperatures of warmer light sources. We've never used them for that.

Sunset, Jasper Lake Flats, Jasper National Park – By using heavy filtration I was able to turn what would have been a 15-second sunset exposure into a 15-minute exposure, creating this fiery sweep of colour from the streaking underlit evening clouds.

Pentax 645, 45mm lens at f/22, Singh-Ray five-stop neutral-density filter (see text on page 142), Cokin blue/yellow colour polarizer and Tiffen two-stop soft-edge graduated filter, Fuji Velvia film. Because of the near-opacity created by combining so many filters, I composed the image first, and then attached the three filters.

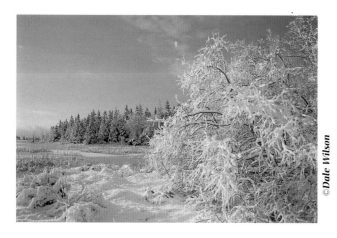

©Dale Wilson

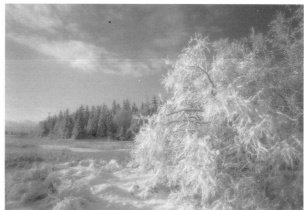

©Dale Wilson

West Lawrencetown, Nova Scotia (near Dartmouth) – Fresh snow usually takes on a blue hue on daylight-balanced slide film, as seen in the left image. Rather than use correcting yellow filters to achieve a pure white colour in the snow, I opted instead for an 80A blue, as seen in the right-hand frame. To give the final image a special touch, I shot through a diffusion filter fashioned from a GEPE slide mount. The 6x7 GEPE glass mount fits neatly into the Cokin "P" filter holder; make sure you use the back component, which is pebbled to eliminate the interference pattern known as Newton's rings.

RIGHT: Nikon F90, 28mm lens, 80A filter, GEPE 6x7 anti-Newton glass mount, exposure unrecorded (over-exposed approximately two stops from the TTL meter reading), Fuji Velvia film.

Our favourite 80-series filter is the 80A, dark blue filter. Whether you realize it or not, you've seen the results of this filter: it has long been used to create what is known as "Hollywood Midnight." The 80A is great at mimicking the blue hues typical of night scenes and when the shot is underexposed by about one stop the effect is very much as if it had been made by the light of a midnight full moon. The next time you see Lorne Greene ride over the horizon on a tranquil night, you'll know the scene was probably filmed at high noon.

Another situation that can make one instinctively reach for the 80A is a scene full of pristine fluffy white snow. Although warming filters are often recommended to counter the blue bias prevalent with snow, if the scene wants to be blue, make it blue! Try a diffusion filter as well, and overexpose up to two full stops. You'll have so much success with this combination in winter that you're likely to find your unfiltered shots boring.

Another aspect of colour filters is the psychological effect they have on our emotions. Filters can be used to reinforce and enhance moods in a photograph; for example, blue can evoke strong feelings of serenity or coolness.

Warming Filters
Most warming filters are intended to correct the excess blue of a heavily overcast sky or open shade, or to allow the use of tungsten-balanced film in daylight. Although we each have several different warming filters, we have yet to use them for any of those purposes: they are better used to create or enhance drama and mood in a photograph.

The 81 series of light-balancing filters are all, to varying degrees, light yellow. The 81B is the model to start with: it is strong enough to create a sense of warmth, but it doesn't completely overpower the cooler colours that may be in the scene.

The 85 series filters are a strong amber or orange and are designed to convert tungsten-balanced film for use in daylight. Again we seldom use them for that purpose, but we do use the strong orange 85 to dramatically enhance those warm hues at sunrise and sunset.

Most filter companies offer some variety of "sepia" filter, a darkish brown unit often used to mimic the look of old, time-weathered, antique images. This is a great filter to use if you want to give a subject that nostalgic air, be it an old homestead, antique memorabilia or a re-photograph of an old portrait. Try it as well in combination with a diffusion filter and overexpose by about one stop to create a soft, ethereal, antique look.

Another set of filters that must be mentioned are the fluorescent-correcting FLW, FLD and FLB models. They all have a pinkish/magenta hue and are designed to eliminate the greenish colour that fluorescent tubes and mercury-vapor street lights cast on daylight film. Because these filters are magenta

A continuous graduated filter – This type of filter was used in making images on pages 45, 55, 58, and 59.

in colour they are great for use at dusk or dawn to exaggerate and enhance similar hues in a sky, a landscape or in the northern lights.

Even though we have the tools to inject a wide spectrum of densities and colours into a scene, it's only with an understanding of how filters work that you can truly use them to accent your photography. For example, you cannot make 12 noon in down-town Toronto look like a warm, coffee-sipping, prairie sunset by simply slapping an orange filter over the lens. Filters work best at intensifying or enhancing moods and colours that to some extent already exist in the scene.

Colour Enhancing and Intensifying Filters

Several styles of this filter are available to enhance or intensify almost all of the colours in your photographs— all at once. Each manufacturer has a different version with a slightly different effect on film. Howard Ross's Enhancing Filter (the original) has the strongest effect, and because of this it's one of our favourites. It enhances almost all colours: reds, oranges, greens, blues and violets; the only colour it doesn't help out is yellow. Because of its strong enhancing effect it leaves a noticeable magenta colour bias in the more neutral hues or tones (the whites and greys). Singh-Ray produces a Colour Intensifying filter that does not leave as heavy a footprint on the image: it's subtler to the colours it enhances and is kinder to the neutral hues and tones. Tiffen, Lee and Cokin (see "Resources and References") also make colour-enhancing filters whose effect is most noticeable in the warmer hues, the reds, oranges and browns.

The effect of these filters is not always predictable, and you can't always trust that what you see through the lens will be what the film sees. As with anything new, don't set off on an important trip with one of these filters (or with any new piece of equipment) until you've had a chance to experiment and see some results. One of us once photographed some fair-skinned models using only a colour-enhancing filter. Everything looked great during the shoot, but when the images came back the models looked as if they had spent all summer tanning themselves on the beaches at Chernobyl!

Polarizing Filters

Regardless of the type of shooting you do, a polarizer is the most useful and versatile filter you can own. It's a

I believe the photos on this page and the page opposite are the last two made for this book. With an editor screaming for captions and a designer demanding images, I walked two minutes to "My Backyard" to get these shots to illustrate what a judicious combination of filters can do for your work. The image on this page was made without filtration, and it looks pretty bland. By comparison…

Nikon F90, 28mm lens, f/11 at 1/4 s, no filtration, Fuji Velvia film.

©Dale Wilson

very visual filter to work with: as you rotate it in its mount the effects are immediately noticeable. A polarizing filter can deepen the colour and contrast in a sky (the most intense effects are always 90° from the light source), eliminate glare from wet or reflective surfaces and cut through atmospheric haze to increase clarity and contrast in a scene.

On dreary, overcast days a polarizing filter will help eliminate the glare and dull reflections from foliage or wet surfaces to allow the more intense, true colours to show through. The intensity and appearance of a rainbow can be increased by using a polarizing filter (and if for some unknown reason a rainbow is ruining your composition, you can eliminate it with a polarizer). A polarizing filter will increase exposure times about two to two-and-a-half stops, and so it can be used as a moderate-strength neutral-density filter (a subject we'll get to shortly). Such a filter is useful when you want to show motion blur or the passage of time. A long exposure of a silky cascading waterfall is a classic example.

Polarizers come in two varieties, "linear" and "circular." Each has the same effect visually; the difference is just in the way they polarize the light passing through. If you own an auto-focusing or auto-exposure camera (basically any modern camera), use a circular polarizer, which won't interfere with its automatic functions.

Most polarizers have a tendency to be cool in hue, leaving a slight bluish footprint in the image. You can counter this by adding a warming filter (an 81B, for example) to the polarizer. Several filter manufacturers help out by marketing "Warm Polarizers," which are essentially polarizers that incorporate 81B filters.

Cokin has an amazing series of colour polarizers that selectively add colour to a scene, rather than just reducing glare as a standard polarizer does. The colour combinations these filters come in are blue/yellow, red/blue, purple/orange, and red/green. We've tried them all, and in our opinion the star of the series is definitely the model 173 blue/yellow. Like all polarizers, the effect depends on its orientation and on the polarization of light in the scene, but this filter adds colour (blue or

yellow) to the polarized areas and overlays the rest of the scene with the complementary colour. The effect is easily visible and you can rotate the polarizer for an effect ranging from very subtle to very intense. This one piece of glass is our most frequently used filter by far. If you have any doubt as to how useful it is, check the captions for the images in this book to see how many of them employ this filter.

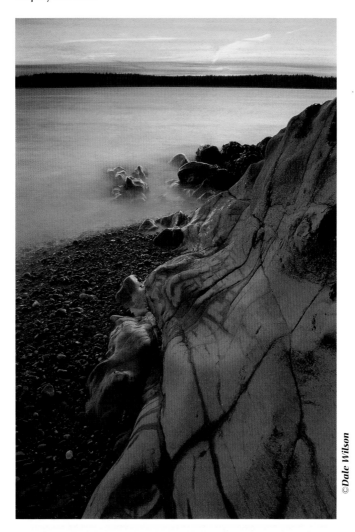

©*Dale Wilson*

...this photo includes pretty much the same detail in the foreground, but the sunset sky really shows its stuff. Rarely will a situation arise in landscape photography where just a polarizing filter–even my pet blue/yellow polarizer–gives you everything you want. Here I stacked three filters in the Cokin "P" holder, with no discernable image degradation. Remember this combination: it's deadly effective and can pull you out of many a pickle.

Nikon F90, 28mm lens, f/11 at 30 s, Cokin blue/yellow colour polarizer, Howard Ross Colour Enhancing filter and two-stop grey graduated filter, Fuji Velvia film.

Soft Focus Filters

It seems ironic that as film and camera manufacturers produce sharper and crisper products, photographers are leaning toward softer, more diffused looks in their images. Romantic, painterly, pastel, moody, soft, muted, dreamlike, foggy, atmospheric, ethereal and glowing; these are all terms commonly used to describe the look of diffused images. But there are more varieties of soft focus filters than there are adjectives describing them.

In the early days of cinematography, one way to achieve a fog effect was to take the cellophane wrapper from a cigarette package, fill it with smoke and hold it in front of the lens. Smoke could be let out or added until the desired effect was achieved. Wild, eh? Anything, and we do mean anything, you (intentionally) put in front of your lens can be called a filter. While there are numerous filters commercially available to create soft-focus effects, any number of common household items can also be used: Saran Wrap, textured glass, nylon stockings, vegetable grease, Crisco, hair spray or Vaseline smeared onto a clear filter. French photographer Jean Coquin, the father of the Cokin filter system, started his career by dipping, coating and staining clear filters with honey, milk, coffee or anything that might create a unique effect.

Here are some tips for using soft-focus filters. The larger the aperture the more pronounced the diffusion effect will be. Long focal length lenses require less diffusion than short ones to achieve the same visual effect. Landscape images are usually best with strong diffusion, while portraits are better with a more subtle effect. Bracket your exposures: diffusion filters often collect light from outside the image area that can mislead the camera meter and cause it to underexpose.

A great way to carry all your filters is in a CD pouch, available at any music store.

Neutral Density Filters

Fish don't see water, birds don't see air and we don't see time.

When film is exposed to light, the subject is recorded or captured during the slice of time the exposure represents. For example, a bird in flight photographed at 1/4000 of a second looks entirely different than if it were photographed in the same situation at 1/2 a second. The difference is time. Film can see and capture the passage of time, be it seconds, minutes or hours.

Neutral-density (ND) filters uniformly reduce the amount of visible light that passes through them. They are "neutral" because they hold back all colours equally, giving no (or very little) colour cast to the resulting image—just as if they hadn't been there. By placing a very dark ND filter over your lens you can dramatically increase exposure times. With these long exposures (several minutes), big puffy cumulous clouds will boil and streak into cream-coloured brush strokes across the midday summer sky and wind-blown prairie grasses will become seas of sepia-hued mist. The next time you are photographing, think of the situation and subject in terms of time and imagine how the scene might appear if exposed over several seconds, minutes or even hours (see page 138).

Conclusion

All the filters we've talked about cost money, some quite a lot of money. Neither of us suggests you go out and immediately purchase an arsenal of filters. However, a good basic starter kit should include, in order of importance and versatility: 1) a regular circular polarizer, 2) a Cokin #173 blue/yellow colour polarizer, 3) a two-stop, neutral, soft-edge graduated filter, 4) a two-stop, mauve or blue, soft-edge, graduated filter and 5) a warming filter (81B).

Colour filters come in such a staggering variety that explaining their characteristics and applications could easily fill several books. We hope the opinions and examples we've shown here will help you make informed decisions about their creative possibilities and uses, and will spur you to learn more about them.

—DB & DW

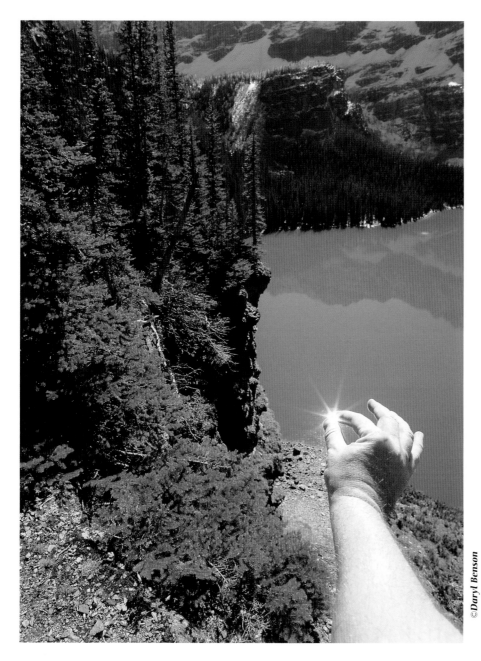

©*Daryl Benson*

Reaching for the light, Lake O'Hara, Yoho National Park, British Columbia –
Whether or not you ultimately choose to use filters is irrelevant; it's the combination
of "Light and Imagination" that create a photograph.

Pentax 645, 45mm lens at f/32 (using small lens apertures will help turn any bright
point of light into a "sunburst," as in this image of the sun reflecting off the surface
of Lake O'Hara), Fuji Velvia film.

Props

Sometimes nature makes love to you and sometimes it kicks you in the head with its big pointy toes.

Daryl Benson

Reality for the landscape and nature photographer can be mundane: rainbows, butterflies and dancing bears don't jump into the viewfinder every time we go out in search of the perfect photograph. Often nature simply does not co-operate.

Faced with this total indifference, by nature, to our desire to create interesting and memorable pictures, we need to be imaginative and exercise a little creative licence.

Fortunately, there are many tools at our disposal for this purpose, one of which is props. When they are used with imagination and purpose they can help the photographer turn the bland into the sublime. A prop can be anything from a single red maple leaf to the extravagance of a full Hollywood movie set. For the environmental photographer, it might be a canoe, a mountain bike, a tent, a backpack, an umbrella or even a rustic chair—whatever's needed to give the scene a caress or a sharpening touch.

Props also allow one to inject a huge helping of one's personal vision into an image. A carefully placed starfish on a beach or the whimsical display of the annual pink flamingo migration allows the photographer to display their creativity in an imaginative manner. Perhaps a touch of symbolism is called for: Canoe Lake is in Ontario's Algonquin Provincial Park—what better place to use a canoe as a prop (see page 65).

So the next time you're out photographing and the rainbows are making graceful arcs, the bears are dancing happily and nature is making love to you, open your arms wide and embrace all that is being offered. But when the skies are an ominous grey, the winds are hard and cold, and nature is getting ready to kick you in the head—quickly grab a prop to help deflect the blow; or, better yet, just duck.

—DW & DB

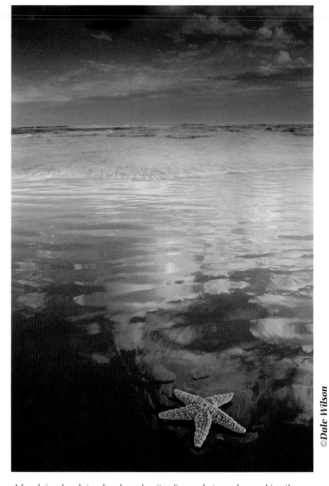

©*Dale Wilson*

A beach is a beach is a beach, and quite often a photographer working the shoreline needs to introduce a prop to promote the scene to more than "just another beach." A starfish purchased from a prop supplier did just that here on Conrad's Beach near Dartmouth, Nova Scotia. I have also used a brass sundial (to suggest the washing away of time, the sands of time, etc.) and bare feet in the sand at this same location. Let your imagination lead you to the next level in your photography and, as we say in Nova Scotia: Dance to your own fiddle.

Nikon F90, 28mm lens, f/22 at 1/8 s, Cokin blue/yellow polarizer and two-stop mauve graduated filter, Fuji Velvia film.

©*Daryl Benson*

▲

While on their annual migration, Mom and Dad Pink Flamingo take the kids for an evening walk in Patricia Lake, Jasper National Park, Alberta. There doesn't always have to be a meaning!

Pentax 645, 45mm lens, Cokin two-stop mauve graduated filter, fill-flash with pink gel over flash head, Fuji Velvia film.

▶

Create (kre-at): To produce or bring into existence through action, imagination and skill. I like to carry a variety of small props with me while travelling, to include in a scene when the mood or inspiration strikes. For over a year I carted this "Create" stone around and included it in a number of photographs. In this example I combined it with another prop, the snake skeleton, while shooting in the Badlands of southern Alberta. More often than not these props are collected with no idea whatsoever where they'll be used; over many years of shooting I've found it's just best to be prepared when inspiration strikes. A flashlight was used to illuminate the Create stone from the bottom left.

Pentax 645, 120mm lens, #85 orange filter, Fuji Velvia film.

©*Daryl Benson*

Location scouting turned up this ideal setting: it allowed perfect positioning of all props—tent, kayaks, firebox and models—with care, so the camera could face west during those few magic moments of sunset. The props were carefully selected for colour and size, and the models' wardrobe was also coordinated. The glow from inside the tent is produced by a double-mantle Coleman lantern (see page131). The one element a photographer can't control is the drama, or the lack thereof, of the setting sun. When everything falls into place you must be prepared to work fast, so pre-envision the look and mood you want. A few dry runs made earlier showed me exactly where to place my equipment along the beach, and I was able to expose three rolls of film in about five minutes. Practice, practice, practice. This photo was made on assignment in Terra Nova National Park; special thanks to Parks Canada (Newfoundland) for allowing its inclusion here.

Nikon F90, 28mm lens, Cokin blue/yellow polarizer, two-stop mauve graduated and Howard Ross Colour Enhancing filters, Fuji Velvia film. Exposure unrecorded—we were too busy!

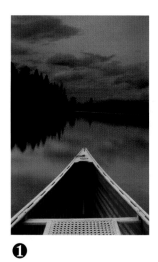

❶

❷

❸

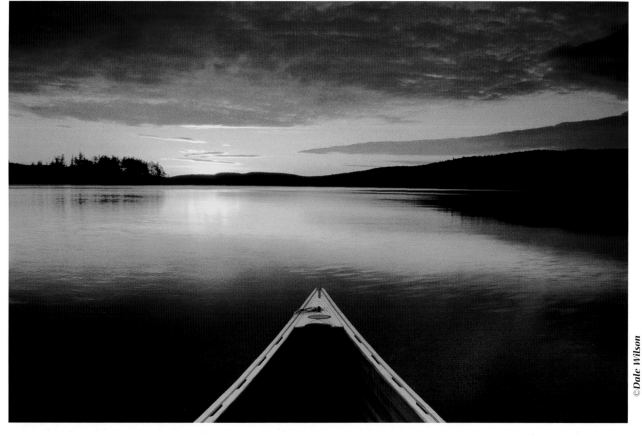

Props can be anything you introduce into a scene, whether they are included at the time of shooting or added later digitally, as I did here. Digital imaging tools mean that one no longer needs to carry a truck-load of props to build that special photograph on the spot, and photographers now often shoot individual components: elements they'll introduce into other images in order to create something new. Each component must be photographed with excruciating attention to light quality and direction if the final product is to be believable. Digital techniques can also make a successful composite from two not-so-successful attempts. For example, I spent a lot of time trying to get a great canoe shot in Ontario's Algonquin Provincial Park: some attempts were good, others—like this one (photo 1)— weren't. I awoke late one morning and caught just the tail-end of the best sunrise of my two-week stay at Lake of Two Rivers: there was no time to get my canoe into the scene. But Adobe Photoshop's "paths and layers" functions allowed me to cut a canoe (photo 2) from an image destined for the garbage can (photo 1) and add it to a so-so sunrise shot (photo 3).

Photo 1: Nikon F90, 28mm lens, Cokin blue/yellow polarizer, two-stop mauve graduated filter, exposure unrecorded, Fuji Velvia film.
Photo 3: Nikon F90, 28mm lens, Cokin blue/yellow polarizer, two-stop grey graduated filter, exposure unrecorded, Fuji Velvia film.

Digital Enhancement

We've taken a bit of a chance including computer-altered images in this book. The idea of using a computer to enhance or modify photographs does not sit well with all photographers.

In the past, what could be achieved was limited not by the photographer's imagination and ability but by the whims of the environment and the tools available with which to create. As digital imaging continues to evolve it liberates the way we can think about images and about photography. What is now possible becomes defined by the imagination, not by uncontrollable forces or the limitations of the tools at hand. (Besides, if we didn't include digital imaging, there would be some cool pictures we wouldn't be able to use.)

Whatever your views are at the moment, it's important to be aware of all the creative possibilities so you can make informed choices and express your own opinions and ideas.

There's a lot of image-editing software available today that's both affordable and accessible to anyone with a mid-range computer system. Even if you don't have access to a computer, almost all professional photo labs can provide you with customized digital services (correcting or altering images, making composite photos or creating personalized calendars, postcards or Christmas cards from your own images). Allow yourself to consider some of these options while you're out shooting; it will open up a whole new realm of creative possibilities for you.

When I first started working digitally, I couldn't tell a pixel from a pylon. Now the computer has become an invaluable tool to help get those restless ideas and images out of my head and onto film where they belong, so I can sleep at night.

Like anything else, the technical part of digital imaging is just the application of experience and knowledge, both of which are attainable. It's the introduction of your own imagination into the process that turns knowledge into art.

—DB

Images in this book that were massaged, finessed or in one way or another digitally enhanced may be found on pages 9, 27, 41, 59, 119, 129, 135, 147 and 149.

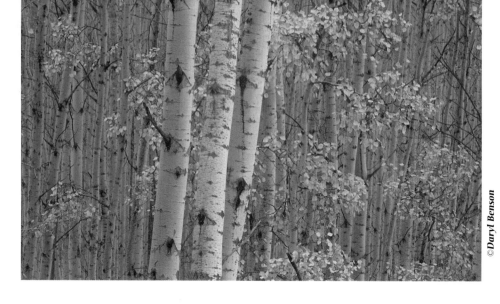

©Daryl Benson

Before *— Autumn, Aspen, near Fort St. John, British Columbia*

Pentax 645, 200mm lens, Fuji Velvia film.

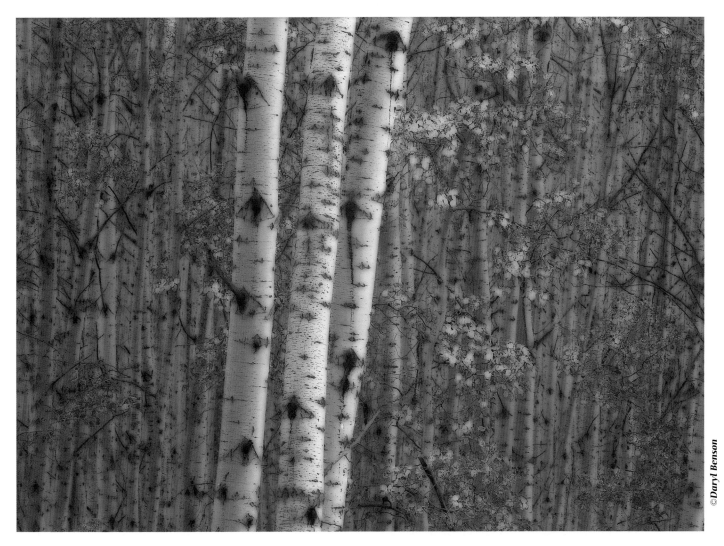

©*Daryl Benson*

After – *For those who are interested or who already have Photoshop particles embedded under their fingernails, here's one quick Photoshop (3.0 or higher) technique for applying a soft painterly glow to an image. Open the image in Photoshop and make your "layers" palette active; then duplicate the image, floating the new copy above the other. Apply the "Gaussian Blur" filter to the top image (try a setting of 20 to 30 pixels; the larger the file the more blur you'll need). Now change the "Blend Mode" (in your layers palette) from "Normal" to "Darken." Voilà! You can alter the look by using the "%" slider to bring more of the sharp original image into the new composite, or try painting specific areas of the original back, using a "Layer Mask." A few other Blend Modes I like to use with this technique are Hard Light, Soft Light, Lighten, Overlay and Multiply.*

You can accomplish similar results with other image-editing software packages, such as Live Picture, PhotoImpact, PhotoSuite, PictureIt, Photo Deluxe, and so on.

If this technique seems to be in a foreign language to you, don't worry. A few years ago I wouldn't have understood it either.

Resources and References

Tourist Information for the Provinces and Territories

British Columbia • 1-800-663-6000
http://www.travel.bc.ca

Alberta • 1-800-661-8888
http://www.exploreAlberta.com

Saskatchewan • 1-877-237-2273
http://www.sasktourism.com

Manitoba • 1-800-665-0040
http://www.travelmanitoba.com

Ontario • 1-800-668-2746
http://www.travelinx.com

Quebec • 1-800-363-7777
http://www.tourisme.gouv.qc.ca

New Brunswick • 1-800-561-0123
http://www.gov.nb.ca/tourism

Prince Edward Island • 1-888-734-7529
http://www.peiplay.com

Nova Scotia • 1-800-565-0000
http://www.explore.gov.ns.ca

Newfoundland and Labrador • 1-800-563-6353
http://www.gov.nf.ca/tourism

Yukon • 1-800-789-8566
http://www.touryukon.com

Northwest Territories • 1-800-661-0788
http://www.nwttravel.nt.ca

Nunavut • 1-800-491-7910
http://www.nunatour.nt.ca

Other Websites

http://www.parkscanada.pch.gc.ca
The home site for **Parks Canada**, with telephone numbers and e-mail addresses for all Parks Canada destinations.

http://www.ec.gc.ca/cws-scf/
This **Canadian Wildlife Service** site provides a great listing of Canadian fauna. Of particular interest to photographers is the "Hinterland Who's Who" section, with very detailed information that includes geographical range and seasonal habitats for many of the animals found in Canada.

http://www.tripquest.com
This is one of the neatest little sites on the Web. Simply key in two locations in North America and viola, up comes a detailed description of either the quickest or the shortest route between them.

http://www.cis.ec.gc.ca/free/index.html
The **Canadian Ice Service** site is the one to visit if you're interested in photographing icebergs. It's designed primarily for mariners, so it will give you a taste in advance of your trip of how to read and interpret "weather-man-looking-stuff" as it pertains to ice in northern waters. There's an e-mail address to contact meteorologists for specific questions, and a toll free number: 1-800-767-2885.

http://www.sec.noaa.gov
This Web site for the **Space Environment Center** in Boulder, Colorado is the place to go if you're interested in photographing northern lights. Click on "Latest Space Weather" and then on "Auroral Activity Estimates." Solar activity is rated by the Center on a 1 to 10 "K" scale going from K1 (very quiet) to K10 (severe storm; there should be a great show). See the section on photographing the northern lights on page 128.

Note: *All URLs provided were correct when we went to press, but the Web changes constantly, and you may need to search for current locations.*

Maps

Natural Resources Canada
1-800-465-6277.
The detailed topographical maps listed in this book can be purchased at local map stores. These maps are produced and updated by Natural Resources Canada (formerly Energy Mines and Resources),

Metric Conversion

Metric (or SI, for "Système international d'unités") units are in common use in Canada, with a few exceptions (aircraft altitudes, Canadian Football League measurements, and certain gun calibres come to mind) so we've used them throughout the book. Readers unfamiliar with metric length units may need a little help.

1 metre = 39.37 inches
1 kilometre = 0.621 miles

So a metre is a little more than a yard and a kilometre is about five-eighths of a mile.

Temperatures are a little more complicated. On the metric Celsius scale, water freezes (under all the appropriate conditions) at 0° and boils at 100°. A comfortable summer evening temperature is 20°C (68°F), 30°C is a bit on the warm side (86°F) and 10°C is chilly (50°F). The Celsius and Fahrenheit scales coincide at –40°, but we hope you don't ever have to verify that in person!

Suggested Books and Periodicals

The Creation
Ernst Haas
Penguin Books, ISBN 0-14-00.4284-9
Ernst Haas was a pioneer of colour photography
and his images still inspire.

Canada, A Landscape Portrait
edited by J.A.Kraulis
Hurtig Books, ISBN 0-88830-220-7
and
The Last Wilderness
text by Freeman Patterson
Key Porter Books, ISBN 1-55013-251-2
▲
*These two volumes contain some of the best exam-
ples of Canadian landscape photography by many of
its top photographers.*

Beyond the Basics I
George Lepp
Lepp and Associates, ISBN 0-9637313-0-0

Beyond the Basics II
George Lepp
Lepp and Associates, ISBN 0-9637313-1-9

**The Nature Photographer's Complete Guide To
Professional Field Techniques**
John Shaw
Amphoto Books, ISBN 0-8174-5005

The Art of Photographing Nature
Art Wolfe
Crown Publishers, ISBN 0-517-88034-2

Photography Of Natural Things
Freeman Patterson
Key Porter Books, ISBN 1-55013-097-8

Photography for the Joy of It
Freeman Patterson
Key Porter Books, ISBN 1-55013-095-1

Photography & the Art of Seeing
Freeman Patterson
Key Porter Books, ISBN 1-55013-099-4

Photographing The World Around You
Freeman Patterson
Key Porter Books, ISBN 1-55013-590-2
▲
*These eight books are excellent sources for specific
information on flash, composition, exposure and
equipment.*

Using Filters (from the Kodak Workshop series)
and **Handbook of Kodak Photographic Filters**
Both are informative books describing a wide
variety of filters and their uses. The first shows
many examples of filter use; the second is a
compendium of technical information.

Aurora, The Mysterious Northern Lights
Candace Savage
Greystone Books, ISBN 0-8715637-4-6
This is a good reference book for the northern
lights, with interesting information about the
mythology that surrounds them.

Under The Whirlwind
Arjen and Jerrine Verkaik
Whirlwind Books, ISBN 0-9681537-0-4
In chapters two and three, Canada's best-known
weather chasers guide us through the make-up of
storm clouds and the anatomy of the tornado. This
is a good book for anyone seriously interested in
photographing weather.

Photo Life Magazine (published 6 times a year)
1-800-905-7468; *http://www.photolife.com*
Yes, we both write regularly for this magazine and,
yes, this may look like an obviously biased promo-
tion of it, but hey, when you write and publish your
own book you can promote whomever you want
in it. Besides, Photo Life is Canada's best photo
magazine!

Filter Manufacturers and Distributors

B+W Filters are distributed in Canada by
DayMen Photo Marketing Ltd.
100 Spy Court
Markham, Ontario, L3R 5H6
1-800-432-9636
http://www.daymen.com

Cokin Filters are distributed in Canada by
Minolta Canada Inc.
369 Britannia Rd. East
Mississauga, Ontario, L4Z 2H5
(905) 890-6600

Harrison and Harrison Filters
P.O. Box 1797
Porterville, California, 93258-1797
(559) 782-0121; ask for Heidi

Howard Ross (Colour Enhancing filter)
25319 Stonycroft Drive
Southfield, Michigan, 48034
(248) 356-3918
http://www.smu.edu/~rmonagha/mf/filters.html

Lee Filters
#103-7 Labatt Ave.
Toronto, Ontario, M5A 1Z1
(416) 361-9390
http://www.leefilterscanada.com

Singh-Ray Filters
2721 Southeast Hwy 31
Arcadia, Florida, 34266
1-800-486-5501; ask for Bob (the magic man) Singh
http://www.singh-ray.com

Tiffen Filters are distributed in Canada by
Nadel Enterprises Inc.
565 Fenmar Drive
Weston, Ontario, M9L 2R6
(416) 745-2622

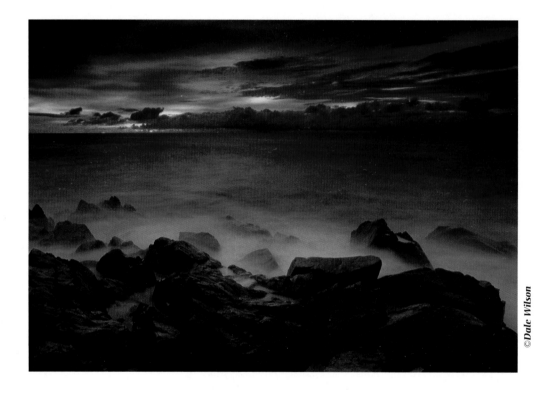

©Dale Wilson

Encore!

A great book deserves one last shot.
Congratulations to Daryl and Dale from Fujifilm Canada.

Simply More Advanced